# ROCK'N'ROLL RADIO
## MILWAUKEE

BOB BARRY

# ROCK 'N' ROLL RADIO
# MILWAUKEE

## STORIES FROM THE FIFTH BEATLE

THE
History
PRESS

Published by The History Press
Charleston, SC
www.historypress.com

*All images are from the personal collection of the author.*

First published 2018

ISBN 9781540228987

Library of Congress Control Number: 2017963223

*Notice*: The information in this book is true and complete to the best of our knowledge. It is offered without guarantee on the part of the author or The History Press. The author and The History Press disclaim all liability in connection with the use of this book.

# DEDICATION

Everybody loves a good story. Many, many times I have been asked to tell the same stories, especially about my two days with the Beatles. To my friends and family, please forgive my repetition.

I started writing this book, which took years, for my wife, Nancy, and for two of the best things we ever did, our son, Rob, and daughter, Heidi. And to be honest, it might sound selfish, but I also wrote this book for myself because I love history and looking back at radio in Milwaukee gives me great pleasure.

This book is dedicated to the above and to many others for the encouragement they gave me. My advice to you is to give honest compliments whenever you feel they are deserved so that person might have the incentive to pursue their dream. I always felt most proud when I could help a young person pursue his or her goal. Kitty Kallen sang "Little Things Mean a Lot," and they do.

This book is also dedicated to my fans, who never forgot those great radio days.

# CONTENTS

# FOREWORD

I'd like to thank Bob Barry for all the fine things he's done for me and so many other great entertainers throughout the years. Bob and I go back a few years. The first time I met him he was playing my song "There I've Said It Again." He's the one that got it started for me and made it happen. Milwaukee has always been my town, and even the songs that bombed every place else Bob would play and they'd seem to make the Top 10 in Milwaukee. Bob, I'm delighted that the Wisconsin Broadcasters honored you and that you've been such a big success all these years.

One of my favorite Bob Barry stories is when they called me from the station and said, "Seeing you're in town, would you meet Bob and be a part of his promotion?" I said, "I'd be more then glad to. Have him call me." They said, "No, no he doesn't want to do it on the phone. You need to come by." So we're driving to the station, and we pass the station. I said, "There's the station—where are we going?" They said, "Where he's at." We finally get there. It's starting to rain and you know Milwaukee, it's always cold. I asked, "Where is he?" Finally, they stopped in front of an enormous billboard. It said WOKY, Bob Barry. And there's Bob up there—I said, "What am I supposed to do?" They told me I had to climb up there. I said, "I don't know if I want my record played that badly." I'll never forget that. It must have been forty feet high. I went up, and everybody looked like ants. That was some promotion, and that's what we used to do in those days. It was a lot of fun, and Bob, you're still having fun. I'm still having fun being a friend of yours. Thank you for all of your help.

—Bobby Vinton

# ACKNOWLEDGEMENTS

I n the end, it's all about people. I would like to thank the people who helped me through this book, those who provided support, offered suggestions, made comments and told stories.

And how would we make it through life without family and friends? I've been privileged to experience so many wonderful moments, and the list of people who touched my life and helped me along the way is heartwarming. I hope that all those people know how grateful I am for their encouragement. I especially want to thank my wife, Nancy, our son, Rob, and daughter, Heidi, for their support and for putting up with all of the time my career took away from our lives. Thanks to Bob Lewis, Jack Lee, George Wilson, Gene Phillippe, Arline Quier, Terry Moorehead, George Crowell Jr., Kipper McGee, Rick Schabowski, Bill Povletich, Mark Heleniak, Paul Patterson, Jim Schuh, Pete Wood, Willie Wells, Tom Andrews, Ted Schaar and Dobie Maxwell for their assistance.

Also thank you to the *Milwaukee Journal Sentinel*, Jack Pearson and *50 Plus*, the Wisconsin Historical Society, *Billboard* magazine, Wisconsin Broadcasters Association, Milwaukee Public Television, Facebook and LinkedIn friends and all of you who made this book possible.

A lot of people went into the making of this book, and at the risk of leaving some of them out, I'd like to thank a few special ones. Bob Buege, my editor, guided me, believed in this manuscript and kept after me to get it published. A few years ago, Dennis Krause saw the potential of this project and a vision of what the book should be. Joel Whitburn said, "You should write a book

about your career, the music and the glory days in Milwaukee radio." Also, this book could never have been written without my peers whose support over the years encouraged me to take on this labor of love. And thanks to all of you for your patience in waiting for me to finally complete this book.

There were others I was able to keep in touch with and others I wish I had been able to spend more time with. There were certain years that you never forget only because of the people you meet. It was an unbelievable pleasure to recall many of those who crossed my path. And I apologize to those I may have missed. It was not intentional.

Life is really not about what you know or what you can do, but the people you knew. I met some wonderful people who meant the world to me. Many of them are gone now, but they are certainly not forgotten by me. I think of them often and remember those good times. I hope I'll be remembered as a person who cared about family and friends and had a great time along the way. I was fortunate to live an exciting life and make a living at it. It was an honor and pleasure to be on radio and TV all of those years and to meet so many wonderful folks. Thank you for listening and watching—and most of all for your friendship.

As I mentioned in my video for the Wisconsin Broadcast Association, "If I had it all to do over again, I wouldn't change a thing."

# INTRODUCTION

I was elated to learn that Bob Barry has written a history of Milwaukee radio and his career. But there are a couple of things that he can't tell you.

First, in that Bob is a Milwaukee native who spent his entire career in broadcasting in the city and nearby stations, he can't fully appreciate how unique Milwaukee radio has historically been compared to similar cities. The difference is primarily in on-air and programming talent and music. In the golden years of AM Top 40 Radio, WOKY and WRIT succeeded with a broader and more adult mix of hits and, consequently, attracted a larger audience. Teenagers and parents more often enjoyed the same station around the breakfast table or in the car. Record companies looked to break or expose more left field or country crossover product on Milwaukee stations. This may have a little to do with the ethnic roots and demographics but seems to me to be because of program directors (brand managers) who were more attuned to the listener and were more intuitive, adventurous, gifted or, at least, strong-willed.

In both programmers and on-air performers, Milwaukee has had more than a reasonable share of graduates who went on to other and larger playing fields to contribute to the rich history of radio in our nation. I think the proximity to Chicago has been a factor. Chicago signals flood the Milwaukee airwaves and provide competition for audience. For air talent and programmers, the move up the career ladder is less than an hour's drive down the road. Chicago people, including broadcast managers, have been known to drive through Milwaukee to check out the local talent. These

factors seem to make Milwaukee stations a little better sounding than others in similar-sized markets. But the primary thing Bob Barry can't tell you is how big he was, how good he was or how hard and smart he worked. Even radio personalities can be modest. Especially Bob.

When I retired at age seventy-seven, I had been hanging around radio/TV stations since 1940, singing, acting, hosting, programming, selling, managing, consulting and wearing women's hats. (Bob will cover that.) The last fifty years were in Milwaukee, including eighteen years as the president of the Milwaukee radio trade association, MARS, where I was the spokesperson for all commercial stations. I have known Bob forty-eight of those years.

In late 1965, I left a management position at struggling WAUK to go back on the air at WOKY following Bob's afternoon drive show. Already he was Beatle Bob and the hottest personality in Top 40 radio in Wisconsin. I was prepared for him to be aloof and maybe a bit full of himself. But the Bob Barry who showed me the ropes and buttons and switches was anything but. He was almost shy off the air. Within the first week or so he had set me up to do my first bar mitzvah because he was in such demand he couldn't fill all the dates.

Now is probably a good time for me to tell you that after five years at WOKY doing CYO dances, band battles, teen clubs and thirteen-year-old parties—sometimes as many as NINE a week—I always knew that I got booked and was warmly received because Bob Barry was not available and at least I worked at the same station as Beatle Bob.

Later, as program manager for WTMJ/WKTI, I felt the competition as Bob, who on my parting advice to WOKY management, replaced me in morning drive, "called the world" and took WOKY to new levels of popularity and national recognition. I will leave it to him to fill you in on the later difficult years when he worked for me at WEMP and those special challenges for both of us, which resulted in our enduring friendship and respect.

Bob has always done it the old-fashioned way. He was Milwaukee's Dick Clark, boy-next-door handsome, wholesome and ageless. He worked harder and prepared better than anyone I have ever worked with or observed. He always seemed to have a tape recorder and found a way to get the best interviews, show material and guests. The Beatles had relationships with top radio personalities in several cities as a result of their first big tour. Bob Barry made the most and best use of that of any market. The audience knows a phony. He really *was* eligible to be called the Fifth Beatle, and his fans loved him for that.

# INTRODUCTION

From local garage bands to stars in all fields, Bob Barry was the show host or MC of choice. It was not just his popularity, which was huge, but he developed real friendships and relationships and maintained them over time. He was always prepared and asked good questions and cared. And he made notes and kept pictures. Lucky for us.

Radio people used to joke and say, "Radio is a world where the air is foul and the halls are filled with liars, pimps and thieves. But, on the other hand, there is the bad side."

And then there is Bob Barry. This is his story.

—Jack Lee

# CHAPTER 1

## RADIO ROOTS

When I was a young man, we lived on Fifty-Fourth and North Avenue in Milwaukee in a small house with two bedrooms, a bathroom with no shower (only a bathtub with feet) and my room (converted to a third bedroom in the attic). I didn't have a closet, but that was not a problem because I had no clothes to put in one. We had a coal furnace, and it was my job to keep it stoked. The coal was delivered through a basement window into a bin on the floor. Sometimes the door would break on the bin and the coal would scatter onto the basement floor.

We lived near Steuben Junior High School, where my buddies and I would play baseball. Former Milwaukee Brewers owner and onetime MLB commissioner Bud Selig and former senator, Milwaukee Bucks owner and department store magnate Herb Kohl went to school there. One of my ambitions was to become a professional baseball player. I was a big fan of the Milwaukee Braves. I would play catch with myself by throwing a tennis ball against the house in my backyard and then field it and throw it back against the wood siding to make the out. I would provide the play-by-play chatter throughout the game. Being an only child, I had to amuse myself. I made it to the *Milwaukee Sentinel* All-Star Game at County Stadium, where major league scouts were in the stands. They saw me strike out, ground out to short and lose a fly ball in the lights. That ended my big-league baseball career.

Sharing a laugh with Baseball Commissioner Emeritus and Hall of Famer Bud Selig.

My mother, Margaret Dumke Doerfler, was a great cook and took good care of me when she and my father separated. At a very young age, I had to painfully testify in court against my dad. My mother won the case and would not give my dad a divorce until the required five-year waiting time was up. She was a strict Catholic. My dad would make alimony and child support payments every few months but was always behind. Surprisingly, my dad once bought me an accordion. I didn't like it and traded it in at Beihoff music store for our first television. My mom was very upset. They had spent their hard-earned money for the accordion and lessons. They even took me to see Lawrence Welk at George Devine's Ballroom in the Eagles Club, thinking that would spark my interest in the squeezebox. Then when my parents noticed me imitating radio personalities and play-by-play sports announcers, they bought me a Wilcox Gay record recorder. The records were cheap plastic discs and the grooves were very fine, so the playback needle would slide across at times. The first time I ever heard a disc jockey, I thought it was fantastic—I had to do this. I told my mother what I wanted to be. She said, "Why not, son?"

When my mother and I took the train to Appleton to visit my aunt, uncle and cousin, I would listen to Bob Bandy on WAPL. It was 1955, when Elvis Presley was making his big splash, and Bob refused to play his records. He would break them on the air. Whatever he did, it made an impression on me. I had a fascination with singing groups like the Four Lads, Platters, Four Aces and Four Freshmen. In my recorder, I would introduce songs like "Love Is a Many Splendored Thing" (The Four Aces), "Sincerely" (McGuire Sisters) and "Cherry Pink and Apple Blossom White" (Perez Prado). In between the music I imitated radio commercials: "Brylcreem, a little dab'l do ya"; "Look sharp, feel sharp, be sharp with Gillette blue blades"; and so on. In high school, we would form groups and sing in the variety shows. We'd record those songs on the home recorder and spend hours imitating radio personalities and singing groups. The microphone and what it could do fascinated me and most likely piqued my interest in a future career in radio.

My high school life was weird. I spent two years at St. Francis Seminary. There was a priest at St. Sebastian's grade school at Fifty-Fifth and Washington Boulevard in Milwaukee who thought I would be great for the ministry. I found out later that talking to young men about joining the clergy was a regular ritual for the parish priests. I would spend over three hours each day on buses to get from my house to St. Francis. Then one Friday night I attended a CYO dance at St. Robert's grade school in Shorewood, at the encouragement of my buddies, which was against regulations at the seminary. I met a nice girl, Mary Papin, and that was the end of my religious vocation. After we broke up, Mary, God bless her, became a nun. I went on to Messmer High School for my last two years of high school and after graduation attended a broadcast school at MATC. It was there that a speech professor encouraged me to pursue a radio or TV broadcasting career.

My first taste of radio came in June 1958 when a grade school classmate, Terry Cleary, told me to call his dad, John, who owned part of WTKM in Hartford, Wisconsin. John Shinners, the local newspaper mogul, co-owned the station. With John Cleary's recommendation, I got the job. It was supposed to be a summer gig to earn a few bucks so I could go back to school in the fall. A few bucks indeed. Would you believe about $600 for the entire summer? My first program director (PD) was Pete Meisenheimer. On my first day in this small town of five thousand, Pete took me to lunch, but before we left, he asked again what my name was. "Bob Doerfler," I said. He told me no way could I go on the air with

a name like that—no one would remember it. He told me I could keep the Bob but change the last name. So out of the blue I thought about two Bs, as in Robb "two Bs if you please" Thomas, a DJ at WEMP, and thus "Bob Barry" came to mind. I didn't want to spell it like the usual Berry so I changed the *e* to an *a*.

WTKM was in the basement of a farmhouse off Highway 83. And you can't beat doing a radio show in the basement on Monday morning when the lady of the house is washing and hanging laundry between the studio and the Teletype machine. You've got to love that added humidity in an already damp basement studio, especially during the hot summer days. I had fifteen seconds to grab the news and get back to the studio before the record ended. One time, a bed sheet got caught in the Teletype and I had to read old news all afternoon. But I shouldn't complain. I was in showbiz!

What an education I had at WTKM. After a few months, I conceived, wrote, sold and emceed a live show while doing a full-time air shift every day of the week. As the summer wore on and one announcer was picked up for embezzling and another was in an auto accident, I got a full-time job. The guy picked up for forgery and embezzling had worked at WRIT in Milwaukee. He had a dynamic voice. We were all wondering what this big-time announcer was doing at our little station in Hartford—until they hauled him away. I talked management into playing some popular records for an hour in the afternoon but had to buy most of them myself. My show consisted of big band, polkas, elevator music and the hour of rock and roll. I also had to announce the local news, bowling scores, births and deaths. If you got any of that info wrong or pronounced a name incorrectly, there would be hell to pay, as the phones would ring off the hook.

I had a Saturday afternoon live show on WTKM broadcast from the Hartford Theatre. We would lower a microphone cord from our second-story studio window through the lobby and onto the stage of the theater next door. This "Badger Teen Time" was sold out every week with bands like El Ray and the Nightbeats, Fendermen, Noblemen, Chuck Tyler and the Royal Lancers, Toni Magestro and Tommy Lane. We used a walkie-talkie to communicate to the studio engineer when to play the commercials.

In 1959, I earned $80 a week on the air and $200 or $300 doing record hops and live shows with local bands on weekends at the local ballrooms. I made anywhere from $9 (really) to $120 depending on the crowd and how much the bands cost. The bands and the weather played a big role in

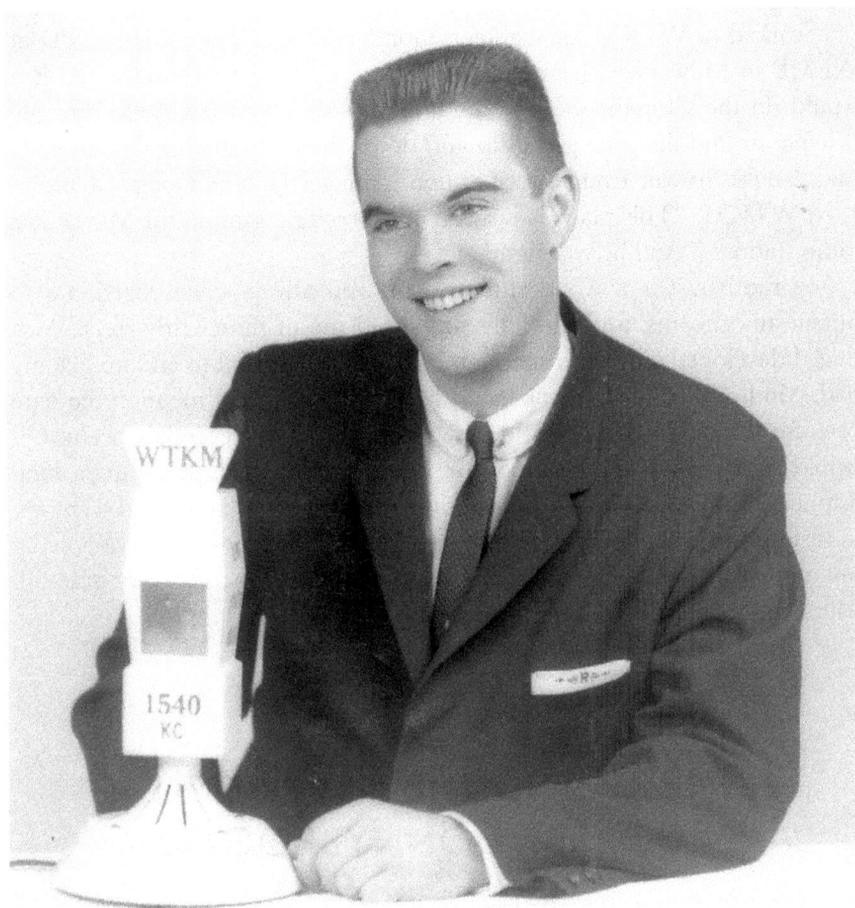

My fate was sealed—I got my first job in radio at WKTM in Hartford, Wisconsin.

determining my income. At first, I played records at the hops, but then, in the spring of 1959, promoter Joe Olla talked me into using live bands. The first was a group led by his singing brother. That was a big mistake because then I had to share the proceeds with the bands. The dances would draw hundreds of teens and adults from all over the area each week.

During the week, I had a show called *Hi Noon* where I played the unlikely format of Dixieland, big band and polkas from noon to one o'clock. The local folks and even some in Milwaukee loved it. And then came easy listening, popular songs and standards, followed by music for dining and relaxing. It nearly put me to sleep, something I got very little of at the time.

I worked at WTKM for eighteen months before Chuck Phillips, PD at WEMP in Milwaukee, heard me on the air in May 1960 and asked if I would do the all-night show at his station. Talk about fate, with this guy driving around the state going up and down the dial listening for someone that caught his ear. I remember station manager George Dodge saying as I left WTKM, "This place is just a damn breeding ground for Milwaukee radio stations." And he was right!

My mother was a wonderful woman who always encouraged me to pursue my dreams, and she fully supported me in those early days. With that, I developed a drive to succeed. I guess I didn't want to end up like my dad. Mother died on December 23, 2000, at ninety-six. I mention the date because she always said she never wanted to die in December because it would ruin our Christmas. God love her, she would stay up all night long listening to my show, making sure I didn't fall asleep. When asked what my most important accomplishment in radio was, I would always say allowing my mother to quit working and buying her a house. She was very grateful, which made me very happy. It was payback time!

# WEMP AND THE NEVER DULL DORSEY DONNYBROOK

I started the all-night show, midnight to six o'clock in the morning on WEMP, on May 7, 1960, as Budd Barry. "Budd" was a name PD Chuck Phillips gave me. He somehow thought using Budd instead of Bob would distance me from the Hartford radio station and cause less confusion.

The highlight of my brief stay with WEMP was meeting Joe Dorsey, my radio idol when I was in school. His clever deliveries fascinated me. He would refer to World War II as "World War eye eye" and open his show with

*Welcome to the Dorsey Donnybrook, my fine, feathered friends. We're going to carry on until eleven do us part, unless we poop out between now and then. We'll play as many of your favorites as the old musical speedometer will allow. And some of our happy tunes will have you dancing in the front seat, but don't try it tonight because the roads are slippery. We're knee deep in memories tonight. Let's get the gold ball*

*rolling and touch your memory button with shades of 1950. Here's that singing rage, Miss Patti Page.*

The first thing he said to me was, "There's no job security in the radio business. Get out while you still can." He said later I was a terrible listener! For a while, it looked like he was right. My job at WEMP lasted for a few months before Bob "Coffeehead" Larson came back to the station from WRIT. Don Bruce Whitney from KOMA in Oklahoma became the new morning man at WRIT. That moved Joe Dorsey back to nights, Jack Baker to all nights and me on the street. My short stint on the all-night show ended at the announcers' meeting when WEMP station manager Hugh Boyce, smoking a pipe, broke the news to the staff and Joe Dorsey got up and said, "Mr. Boyce, if I work another twenty years on the night shift, do you think I'll get another two months on days?" Boyce told him we would all need to work together like one happy family. Joe said, "That's sweet, Hugh; if you kiss me, I'll shove that f***ing pipe down your throat."

Jack Baker began his Milwaukee radio career at WEMP in 1957 on the *All-Night Show*. Later, he had a program called *The Torch Hour* where he would play romantic music and read poetry, a lot like Franklyn MacCormack in Chicago, who had the *Meister Brau All-Night Showcase* on WGN. The WEMP staff, especially Joe Dorsey, loved to play pranks on Jack. One night, they set his poetry on fire. Another time, Joe and his bartender buddy Jim hired a good-looking hooker dressed in a full-length fur coat. Jack was on the air during the 1:00–2:00 a.m. segment, *The Candlelight Hour*, which, like *The Torch Hour*, featured poetry reading and romantic music. Jack was difficult to break up, but Joe and his henchmen never stopped trying. The poems were usually about eight pages long. Joe and Jim lit candles and turned off the studio lights so Jack couldn't see his poems. Then they took the girl into the studio. She took off her coat and had no clothes underneath. Jack didn't miss a beat, staying focused and finishing the poem under candlepower.

In 1947, WEMP's first location was in the Empire Building in downtown Milwaukee and then Fifty-Fourth and Martin Drive before WRIT moved there. The two stations switched frequencies. I moved over to WRIT and stayed there until they switched over to twenty-four-hour automation, with machines doing all the DJ work. Most Milwaukeeans of that era remember Dorsey's popular *Wire Request* show on WEMP that ran from 1947 to 1963. It started out as a one-hour show from eleven o'clock to midnight. For twenty-five cents, boys and girls dedicated songs to one another—my girlfriend and me included—through telegrams to the station. Later, the show was

on for five hours a night, six days a week, from 9:00 p.m. to 2:00 a.m., and it lasted for sixteen years. There was a Teleprinter in the studio that would print out the requests. In 1955–56, I was sending wire requests for songs like "Moonglow," theme from the movie *Picnic*, and "Melody of Love" by the McGuire Sisters. My squeeze and I would sit in the car and wait, sometimes for what seemed to be hours, for our request to be played. You don't think I was going to blow twenty-five cents for nothing, do you? Joe later told me the show wore him out because the record library was in the basement of the station. He had to run down the stairs, pull the requested records and then run back up before the last record ended. Many times, the engineer had to fill time with commercials and public service announcements. That's not all there was in the basement. Besides a lot of technical equipment, spiders and mold there was what many DJs called a casting couch, also used for taking naps and sleepovers when things were not going well at home.

Joe began his commercial radio career at WEMP in 1947, after his peers at *Voice of America* encouraged him to do so. Over the years, he interviewed many performers, including Tony Bennett and Rosemary Clooney. One night, while introducing the latter, he said, "Here's that charming young sinner, Rosemary Clooney." He meant to say *singer*.

Joe had the *Dugout Show* on WEMP when the Braves were here from 1953 to 1965. While he was doing this show one day, Warren Spahn and Lew Burdette stripped him of his clothes, down to his shorts, while he was on the air. They also tied his shoes together and threw them out to home plate. Umpire Jocko Conlan said, "Mister Dorsey, if you get your ass out of the dugout, we'll get the game going." Dorsey replied, "I'm not moving until somebody gets my shoes."

In 1957, one of the sponsors of the *Dugout Show* was Weinberg Shoes. Dorsey gave baseball legend Hank Aaron a coupon good for a pair of those shoes. A few years ago, Hank and Joe met at the Braves fiftieth anniversary of the 1957 World Series win. Hank asked Joe, "Is that coupon still good?" Joe said, "It's as good as the day I gave it to you, but of course they're out of business."

At that time, WEMP did Packer and Marquette football games, and Joe Dorsey did the color commentary for the Marquette Hilltoppers football games with Earl Gillespie. Their signoff was "Be a Hilltopper booster and a Packer backer." One night, he was signing off and said, "Speaking for Earl Gillespie from Crosley Field in Cincinnati, this is Joe Dorsey reminding you to be a Hilltopper booster and a Packer bastard."

When interviewing shortstop Johnny Logan, Joe told John, "It's a beautiful day for Ladies Day." Johnny, in all seriousness, said, "Yeah, Joe, the sun is

*Left*: Sharing a special moment with Hall of Fame southpaw Warren Spahn.

*Right*: Lew Burdette was the hero of the 1957 World Series, winning three games and leading Milwaukee to the world championship.

blowing and the wind is shining." Johnny was also quoted as saying, "I know the name but I can't replace the face." At one Braves event, the wife of team owner Lou Perini told John that he really looked cool. Johnny replied, "Thank you, Mrs. Perini, you don't look so hot yourself."

Dorsey used to ride his headphones sky high, and that's how he lost a lot of his hearing. When Joe got off the air, he would leave the volume control cranked up, and the next guy would plug in his headset and scream in pain. Most of us of that era lost much of our hearing due to the headsets and the huge speakers next to the concert stages where we would stand for hours. Part of Joe's success was his great sense of humor. I told Joe the story of how I was on the air in the WEMP studios at times when the Braves would play late night games out west. One night after the game, I opened my show with "Sing Sing Sing," a jazzy instrumental by Benny Goodman. At the time, I guess this was considered a wild song. One of the station big shots, John Gagliano, called me on the hot line and angrily asked what the hell I was doing playing a song like that right after the game. He told me that I just blew off hundreds of listeners. I mentioned that I thought John had died. Joe's reply was "I hope he did, we buried him."

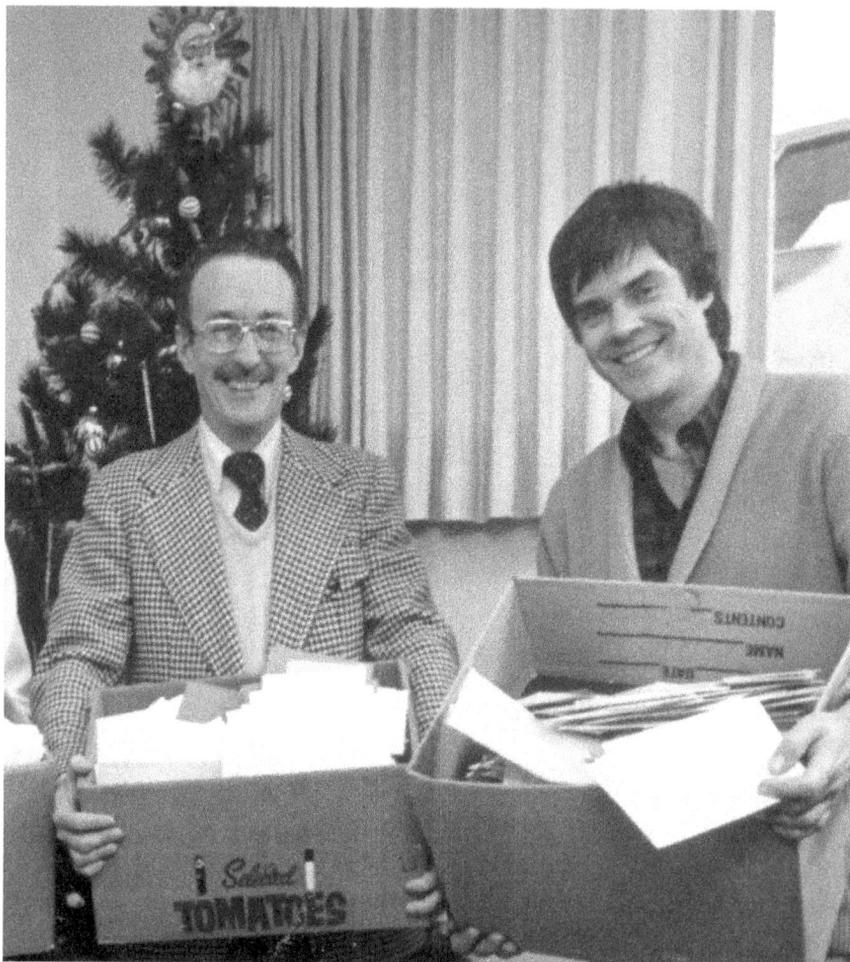

Joe Dorsey and I are preparing to mail thousands of letters from our listeners to the Americans held in Iran during the Iranian crisis in 1979.

Joe was at WEMP for almost thirty years before he was fired in 1976. He later sold advertising and did some DJ work at WOKY, including *Dixieland with Dorsey* from 1991 to 2001. He was inducted into the Wisconsin Broadcast Hall of Fame in 2012.

The last story Joe told me before he died in March 2015 was when he took his dog Mary to Pick 'n' Save and had to hold her in his arms because you can't take a dog into a grocery store. A pretty young housewife came up to them, patted the dog on the head and said, "Oh, you're adorable." Joe quipped, "Thank you, how do you like my dog?" Whenever I would

introduce Joe to someone, he would say, "What a pleasure it is for you to meet me." He thought that line was funny, but it really was true.

# THE WOKY DAYS BEGIN

After my short stint at WEMP and a couple of months at WRIT, I went to work in the *Milwaukee Sentinel* promotion department in 1962. What a job that was. I wrote articles for the events the *Sentinel* sponsored, like the boat races in Fond du Lac and the Sports Show. Later that year, the *Sentinel* went on strike. The *Journal* bought them out, and I was out of work again.

I started sending air checks to stations in Wisconsin. I wanted to get a special effect from my cheap recorder, so I took it into the bathroom. I thought the echo was cool. I took the finished product to a station in Madison, and the PD told me it sounded like the tape was made from the bottom of a can. "It was," I replied. After I did about ten takes, reading news and commercials, he told me I was overqualified. I thought that was crazy, but maybe he was just being kind and didn't want to tell me that I sucked. But it sure turned out for the better in the long run.

After months of being rejected by several stations, I attended a cocktail party for the Schlitz Circus Parade. It was there John Reddy, PD at WOKY, hired me to do summer vacation relief on the all-night show. Shortly after I started working at WOKY, we had a meeting in the conference room. The door was open, and down the hall walks April Stevens with her brother, Nino Tempo. They were promoting their new single, "Deep Purple." April was dressed in a mini-mini skirt and deep (purple) V-cut top. Our attention quickly turned from the meeting to the view down the hall. It didn't take Reddy three seconds to close the door. We never did get to meet April and her brother.

My real radio career began in the summer of 1963 while still handling vacation relief. On a hot Sunday afternoon, popular local personality Lee Gray introduced the song "Girls Are Made to Love" by Eddie Hodges as "Girls Are Made to Lay." He said it was a slip of the tongue. That sunny day brought everyone out to Bradford Beach with most of their radios tuned in to WOKY. Reddy called engineer Paul Leser immediately and told him to turn Lee's microphone off and he would come in to finish his shift. Reddy fired Lee on the spot and called me that night to ask if I wanted a full-time job. It was as easy as that. I stayed with WOKY until 1976 and then returned from 1980 to 1983.

When I did the morning show I got up at three o'clock every morning. It took me awhile to find my body and put clothes on it. You never seem to get used to those early hours no matter what they say. At that time, I was putting in three hours at the station and at least four at home. Sometimes I would get a quick nap, especially if I had an appearance that night. My wife would have to remind me to slow down. To this day, I wake up early and stay active all day. I guess I never recovered from that time. As soon as I got to the station I'd put on a pot of strong black coffee and read the Milwaukee and Chicago morning papers, looking for articles I might be able to use on that morning's show. I'd use my best bits in the ten and forty time slots, supposedly the most listened-to times. Then I would pull the music and commercial cartridges for the first hour and line them up. By the end of the morning, I would have consumed over a pot of coffee by myself. Believe me, I was wired.

I signed my first radio contract with WOKY on December 17, 1963, for $170 a week. It was a one-year contract with an option for WOKY to renew it for two more years, which they did. Part of the Standard Staff Agreement stated that the employee would accept nothing of value either in cash or in material from any source other than the radio station (in other words, payola). The employee had to agree that performances, advertising messages or announcements may be recorded and utilized by the employer at any time as employer sees fit, free from any extra compensation other than payment of the salary agreed upon. In other words, you do the commercials and some personal appearances for free.

In 1965, I got an increase in salary to $225 a week and six months later, $235. Who would want to leave, making those big bucks? The station sales reps took the DJs out to lunch with their clients to show you off and brag how great you are. They would promise that you'd do appearances and commercials for free and then tell us the money will come later. Sometimes it did. Other times you got screwed. But, hey, I was making $250 a week at that time (yep, a $15 raise) and my rent was $75 a month. I thought I was rich. One time, instead of getting paid, a client sold me a partnership in an oil well. He told me it was the investment of the year. I lost $5,000. Expensive lunch!

One minute you were a star on the radio and the next you were doing a free commercial for a pawnshop. All the jocks had to record commercials for the station's clients, most for free. Many of the advertising agencies would show up for the recording session and loved to administer their authority. Many had us do the reading three or four times so they could justify their

Three of my peers (*left to right*): Bob White and Jack Lee of WOKY and Jonathan Green of WTMJ.

salary. Jack Lee remembered some of the lines they would throw at us as we cut their spots. "Do it again, just better." "I know this is a sixty-second spot, but can you do it in thirty, but still sound relaxed?" "Do it just like that, only a little less." I love this one: "Do what you do best, use your rock 'n' roll voice if you need to."

I also found other ways to collect cash in those early days. Clark Weber, a DJ for WRIT, left the station in the early 1960s to work at WJJD in Chicago. He called me and said he wanted me to have a box of hit records. I thought that was nice of him. When I met him, he gave me the records plus the name and address of a young girl about to have her bat mitzvah and said I would need to replace him on Saturday night as the emcee of her "coming out" party. What an experience! Fifty-five screaming thirteen-year-olds, none of them happy to see me replacing the guy their parents had hired, and they complained about everything. They would shout, "Play this record now or I'll tell my mom," or the parents would say, "Turn that music down." The kids told me turn it up and complained, "Why don't you play that game that Clark Weber plays?" I had no idea what they were talking about. I did all that for twenty-five dollars, spinning records for three hours.

Lou Christie never forgot the time he came to a bat mitzvah with me to promote his hit song "Rhapsody in the Rain."

My price gradually went up, and on April 27, 1963, I worked a party for fifty-five dollars. This was the first of hundreds of bar mitzvah and bat mitzvah parties. (Thanks to many of you who, through the years, have come up to me with memories of when I emceed your party.) I'll bet Ann Rothstein never forgot hers. On Saturday, March 5, 1966, at the Hilton Inn in Milwaukee, Lou Christie, at my request, came along with me to her party. It didn't hurt that we were playing and charted his big hit at the time, "Rhapsody in the Rain." Remember, that was the song that had the lyric "we were making love in the rain." The record company was forced to change it to "we fell in love in the rain." You should have seen the looks on the kids' faces when Lou walked through the door. Years later, he told me that he couldn't believe he did a free appearance for just a small birthday party. He said he must have been hard up to have his record played.

I loved the festivals, CYO and high school dances. Soon my record hop fee got up to one hundred dollars, with part of that going to my assistant, Jim Gorak, who would bring the equipment (two homemade wooden turntables, a small amp and a speaker). Sometimes it worked, and other times he had to hold it together with paper clips, tape and whatever else was handy. After a couple of years the price went up, and I would bring in some of the talent coming through town to promote their records: Peggy March, the Lettermen, Neil Sedaka and many others. Eventually, we made quite a production at these record hops with the two professional turntables, two large speakers, a couple of cart machines, a thousand records, plus a couple hundred records and prizes to give away—big stuff like coffee cups, key chains, T-shirts, nightshirts saying "take a friend to bed—WOKY" (all free from the radio station). We eventually had to drop them from our gigs after some complaints. We would have dance contests, hula hoops, musical chairs, change partners and name that tune. Many times I would mirror my radio show with funny commercials, comedy voice tracks and WOKY station jingles and promotions.

The station was very cooperative in letting me use whatever I wanted. Mary and Rich Behrens started a traveling sock hop company called Bandstand on Wheels and would hire me to deejay bookings. Mary knew more about music than most DJs I worked with. She knew how to mix the music to fit the moment. One New Year's Eve, the three of us worked a hop at a hotel in West Bend. I was booked until "Auld Lang Syne" was sung at midnight and was ready to leave when a woman who had way too much to drink started to hug me like a koala bear in heat. Luckily, her husband had more than his share of the bubbly, so he couldn't have cared less. Finally, Rich pulled her off of me so I could head home.

When I think about it, I guess I did almost anything for a buck in those days. Maybe that came from growing up with close to nothing. I would emcee rock concerts, store openings and school hops; make appearances at department stores, beauty pageants, fashion shows and nightclubs; and record radio and TV commercials. At the height of my rock 'n' roll DJ career, I was doing over one hundred appearances a year. I made a lot of money, for those days, but got very little sleep. Of course, my record spinner or the band I was with wanted to party after the gig, so I wouldn't get home until the wee hours of the morning.

The WOKY signal was strong across Lake Michigan and north of Milwaukee, so many times I drove way up north or over to Michigan to emcee a sock hop or concert. One time, Jim Gorak and I were going to take the car ferry across Lake Michigan to a school dance. A late winter storm hit, and we ended up driving in a blizzard with roads as icy as an igloo. Another time, an advertising executive, Ed Buchholz, hired me to emcee an event in La Crosse. He chartered a small plane for the trip. When we left the event, it was very windy. The pilot got the plane up off the ground for a few feet when a gust of wind brought us bouncing to the ground and then up again. I asked the pilot, "Do you think we should be flying in this weather?" He said, "No problem, this happens up here all the time."

I wondered sometimes how I was able to keep burning the candle at both ends year after year. After I was married, that all leveled off quickly.

# CHAPTER 2

## MILWAUKEE RADIO THROUGH THE YEARS

On September 5, 1950, WEXT, which started in 1947 as an ethnic and polka station, became WOKY. Its slogans in those days were "WOKY's Family Hit Parade," "The Friendly Family Entertainment Voice of Wisconsin, WOKY" and "The Center Aisle on Your Radio Dial, Waukee in Milwaukee." Then WRIT signed on in 1955 and cleaned WOKY's clock in the ratings, leading WOKY to change to a hipper, younger, rock 'n' roll format. There was a constant battle between the two stations from the beginning. In the '60s, Mitch Michael at WOKY would listen to WRIT while he was on the air and play every song they played. It would drive the kids nuts, because they would switch back and forth between stations when they didn't like a record. The WOKY-WRIT rivalry would rage for decades, through many a twist and turn in local radio and in music for the whole nation.

Format wasn't the only thing changing in those days. These were also the first years of rock 'n' roll. In 1954, Sheboygan's Chordettes led the hit parade for seven weeks with "Mr. Sandman," sung by baritone Carol Bushman, bass Janet Ertel, tenor Lynn Evans and Archie Bleyer doing the male voice on the record. The recording sold over two million copies. By 1956, Elvis had made his mark on the rock 'n' roll revolution. On September

9 of that year, those fortunate enough to have a TV set saw him for the first time on *The Ed Sullivan Show*, from the waist up. Elvis's pelvic gyrations were considered far too sexy and risqué for Ed's family show. While Heiser Ford showcased the new Edsel, we rocked to hit songs like Buddy Holly's "That'll Be the Day" and Elvis's "Jailhouse Rock." In 1957, there were very few who did not know at least some of the lyrics to Harry Belafonte's "Banana Boat Song." Big hits in 1958 were the novelty tunes like the "Chipmunk Song" and "Purple People Eater" by Sheb Wooley, "Bird Dog" by the Everly Brothers and "Tom Dooley" by the Kingston Trio. In 1959, the hit records included "Mack the Knife" by Bobby Darin, "Kansas City" by Wilbert Harrison and "Smoke Gets in Your Eyes" by the Platters. We entertained ourselves with the Hula-Hoop, sold at Woolworth's for $1.98. This was the year we first heard about payola, the money paid to DJs to push particular records. Also popular at that time was country music with the *Grand Ole Opry* program out of Nashville, Tennessee. The precursor to that show was the *Barn Dance* program, heard on WLS in Chicago.

For me, rock started when I saw the movie *Blackboard Jungle* in 1955, with the song "Rock Around the Clock" by Bill Haley and the Comets. My mother did not appreciate the new music. When I played the record "Rags to Riches" by Tony Bennett on the phonograph, she would yell to turn it down. She liked big band and polkas. She loved Lawrence Duckow and the Red Ravens and Lawrence Welk. She would say, "Someone stepped on the cat's tail" when I played anything close to a rock song with some screaming high-pitched singer. She was not alone. Many adults were shocked when the music changed to rock 'n' roll. Still, she was very encouraging and tolerant of my decision to work in radio and eventually play rock music. Many Wisconsin parents of teenagers did not like rock 'n' roll, my radio station or me. Later, those same listeners called in to request the same songs they once despised.

Even some DJs struggled to adjust to the new sound coming over the radio waves. Bob White was at the station from 1957 to 1967, and he was not happy with the changes that came about in the '60s:

> I was playing Benny Goodman, Harry James, Tommy Dorsey, Glenn Miller, and all of a sudden this came to a halt and format radio came in. They told you what to play, when to play it, and when to say it. So when the Big Bands went out, I did too! Everything came to a screeching halt when Woods Hospital sent a truck to the station and picked up our entire library and we were left with forty records and we played them over and

*over again. Somebody made a determination that the average age of the listener was fourteen, so we needed to appeal to the sponsors, so let's play the kids' music, except I wasn't a kid and not an aficionado of that stuff. Imagination flew out the window because they were dictating how to do your show. The originality was not there anymore, so fun wasn't either. This was not me, not what I got into radio to do. So I exited it.*

With the coming of rock and WRIT's rise with it, the WOKY format changed abruptly from Tommy Dorsey, Nat Cole and Rosemary Clooney to Bill Haley and Elvis. At that time, many DJs, like Bob White, left radio, either forced out or quit. Rock Top 40 was now in.

At the same time rock 'n' roll was really breaking out, in 1959, I remember playing "The Battle Hymn of the Republic" by the three-hundred-plus voices of the Mormon Tabernacle Choir accompanied by the Philadelphia Symphony Orchestra. One of the top tunes of that time was "The Three Bells," which everyone said couldn't make it. Others that surprised the experts included Johnny Horton's "Battle of New Orleans" and the novelty answer, "Battle of Kookamonga" by Homer and Jethro. Add to this other non–rock 'n' roll successes like "Broken Hearted Melody" by Sarah Vaughan, "Misty" by Johnny Mathis and a German record called "Morgen" by Ivo Robic. Illustrating those things that are unforeseeable in the record industry, one of the three top discs for 1958, "Volare," broke all the accepted rules as to what would sell. It ran over three minutes long, broke tempo several times and was in Italian. But it became a hit. Then everybody jumped on the bandwagon and started making Italian records galore. Who knew?

In 1961, new stereo FM radios were blaring away with the sounds of Ricky Nelson's "Travelin' Man" and Bobby Vinton's "Roses Are Red." Then came the Four Seasons' "Big Girls Don't Cry" and Neil Sedaka's "Breaking Up Is Hard to Do." Many radio stations banned "Louie Louie" by the Kingsmen. Wayne Newton's voice had yet to change when he released "Danke Schoen." The Royal Lancers covered a Bobby Fuller Four hit, "I Fought the Law," and it made top ten on the local charts.

WEMP allowed DJs to play only the old standards along with some new releases by established artists like Frank Sinatra, Nat King Cole, Rosemary Clooney and Tony Bennett—no rock 'n' roll. Local music directors were not going to give in to the new sound easily, and although WEMP was one of the top music stations in Milwaukee, it was beginning to feel the pressure of WOKY's increased ratings as it combined '50s music with the new hits that attracted a younger audience with a passion for rock 'n' roll.

But rock didn't completely take over. Up until late 1963, performers Johnny Mathis, Andy Williams, Steve Lawrence and Tony Bennett still appeared on the charts. In fact, the album of the week at WOKY in early 1963 was *Champagne, Candlelight and Kisses* by Jackie Gleason's Orchestra. Music director Arline Quier did admit that pick was chosen to appease management, but toward the close of 1962, the Top Ten was beginning to show more rock and soft rock with the likes of Elvis Presley, Roy Orbison, Chubby Checker and Neil Sedaka. Still, in the mid-to-late '60s WOKY had 30 percent of the audience while playing everything from Engelbert Humperdinck and Tammy Wynette to the Rascals and Marvin Gaye.

One of the reasons rock was so popular with the teens is that, besides having an exciting beat, its lyrics generally told a story of what the teenagers thought, did and felt. Adults just didn't think and do and feel the same way. The lyrics didn't capture them. I couldn't blame them for protesting against the drug-related songs. The PD would say that those songs just reflect what's happening in today's society. "We just play the records," he'd say. "We don't endorse the lyrics."

Remember when you said, "How could a record that bad be so popular?" Because the radio stations played it over and over, many times once or twice an hour all day long. Exposure and repetition were the keys to many a record's radio success. But even the best tracks had to make it through a minefield of rules. No songs in the Top 40 by the same artist. (That rule lasted until 1964 when the Beatles had five records in the Top 40. And that was only after the music director (MD) showed management that the Beatles were huge all over the world.) An unwritten rule was that we play no black artists, no R&B. The MD convinced them that some soul artists needed to be on the playlist. For example, we could play Chubby Checker's "Let's Limbo Some More"; "South Street" by the Orlons (which was restricted from play between 7:00 and 10 a.m.); and "He's So Fine" by the Chiffons. Most of the black artists were restricted to later in the day or night, like "He's Got the Power" by the Exciters, which was forbidden from 7:00 a.m. to 3:00 p.m.

In many cases, payola played a part in what records were played and charted. George Wilson once said that in any other business buyers were given gifts and favors and they found nothing wrong with that, but in the broadcast business it's payola. He thought the reason for that was the glamour of our business. Record companies would also give extra records to the dealers. Then the dealers would report the record selling well, and it would end up doing well on the record charts and selling in the stores. Sometimes, honest record pushers would call and tell the music director to

get off a record because it was bombing in other parts of the country. Other times, the music director would have the jocks try out a record at a sock hop to see what kind of reaction it got. This was of particular importance during the "bubble gum" music era. Some of those records got on the air after the kids reacted positively to them, and we're talking hundreds of young people attending these dances every week. Also, smaller stations within our listening area would hear us play a new tune and then call the promoter and ask that a copy of the record be sent to them.

The record companies would provide all kinds of things to stations. Some of this went to the GM or PD and some to the DJs. It was harder for the disc jockeys to get away with accepting these goodies because we had no control over the records we played. Many times the PD would pass on a gift from the record guy to his top DJ. Payola ranged from money to merchandise, drugs, liquor, ladies and appearances by the top artists from labels that wanted their talent promoted. The record labels would fly in the Supremes, the Monkees, the Lovin' Spoonful and many others. Promoters would hand deliver records to the big market stations and send them out to the smaller markets with a follow-up phone call. Promoters and distributers would set up listeners to call the station, saying how much they liked a certain record and asking the DJ to play it. Most of the time, veteran disc jockeys saw through these scams. Also, the labels would invite program and music directors and DJs to Las Vegas to see famous acts and have dinner in the showroom and meet the stars after the show. My wife, Nancy, and I had great seats for Elvis, Sinatra, Wayne Newton, Tony Bennett, Sammy Davis, Buddy Hackett, Don Rickles and others. You really don't want front-row seats for Hackett or Rickles shows. They loved to pick on those people who were close by. If things weren't going well in the show, Hackett would moon the audience. These perks were not considered payola, only benefits given to me as a bonus from management. We had no way of knowing if the boss was getting payola.

One day in 1966 I had lunch with two record pushers who were promoting the latest Blues Magoos disc. In passing, I mentioned that my snow blower was broken. The next day there was a brand new Snowbee parked in my driveway. I never found out who arranged that. The Blues Magoos song "(We Ain't Got) Nothin' Yet" got to no. 5 on the *Billboard* charts. That was what happened to a lot of those songs that got airplay over and over. But I still had no control over the records played on the station. With some bad tunes, if the record buyers didn't like the song, it didn't matter how many times you played it—they wouldn't buy it, and I believe it caused listeners to tune out your station.

A man who owned a hot teen club, Teensville, in Thiensville, a small town near Milwaukee, told one of the most extreme payola stories to me. A popular local group would never appear at his club due to a dispute between the club's owner and the group's manager, so the owner agreed to buy ten thousand records at a low price to inflate record sales so the band's song would chart high on the WOKY survey. It worked and even made the "Billboard's Bubbling Under chart." The group appeared at his club to an overflow crowd, and the owner told me that he threw all of the records in a garbage dump behind his club.

In 1968, Jerry Lee Lewis was appearing at Monreal's nightclub. I came in with my tape recorder expecting to do an interview during his fifteen-minute break. Lewis asked me if I was playing his new record "What Made Milwaukee Famous," and I told him it was not on the playlist at the time. He refused to do the interview and wouldn't even talk to me after that, with the exception of a few choice words I will not repeat here.

But hits were born of more than glad-handing and behind-the-scenes bribery. Many times, WOKY program director George Wilson would make decisions on the records we played by taking them home and letting his children decide. I guess that's why we played a lot of the bubble gum stuff in the late '60s. Those records included "Sugar, Sugar" by the Archies, "Gimme, Gimme Good Lovin'" by Crazy Elephant, "Yummy, Yummy, I Got Love in My Tummy" by Ohio Express and "Na Na Hey Hey Kiss Him Goodbye" by Steam. They became big hits in Milwaukee, so maybe the kids knew what they were doing.

George set up a playlist consisting of three or four categories from which we could make choices, but the choices were limited. For example, we would program only to women age eighteen to forty-nine during the middle of the day, not caring if we got the men and teens. We would lead in those demographics. We had research teams on the phone and going to homes. They would ask what music they like, what's going on in their community, what we could do to help and what their interests were.

We played a lot of album cuts in the early '60s on WOKY. When one of those tunes captured the ears of listeners, they would let us know, and that's how many singles were born. Many times, the record companies would recommend cuts on an album they felt had potential as hits. Our music director would listen to them and look at music publications (*Billboard*, *Cash Box*, *Radio and Records*, the *Gavin Report* and many more) to see if other stations were jumping on those tracks. The MD would watch for hot records around the country and add them to the playlist. Sometimes, we would play one of

those songs and force the record companies to put it out as a single. The MD would mark the cuts not for play with a red grease pen all around the album. If we tried to play a banned cut, it would skip.

One of our rival jocks would get on the air at WRIT and blast me for playing the bubble gum music. But we played the music the listeners wanted, not what we liked. I didn't agree, but I remember when Leonard Bernstein said, "Five percent of rock 'n' roll is wonderful. Ninety-five percent of it is unlistenable." Case in point, in 1965, WOKY was playing the fatalistic "Eve of Destruction" by Barry McGuire while WRIT banned the song. Call me nerdy, but I liked the up-tempo songs and the mushy love lyrics, not the psychedelic stuff. (I did, however, like some of the more progressive stuff by the Stones and others.) Another time, I thought our music director had gone bonkers when she programmed the Trashmen's record "Surfin' Bird." Remember the lyrics? "Bird Bird Bird, the Bird is the Word," over and over. The record turned out to be a big hit.

How else does a record become a hit? One example is the song "Mack the Knife." It dates back a couple of centuries to an opera in eighteenth-century England. It was the *Three Penny Opera* that revived the song in the twenties. In 1954, *Three Penny Opera* went to Manhattan and met with great success. The record of the opera, at that time, never sold. Bobby Darin knew nothing about the song until he recorded it on an album. "Mack the Knife" was picked by the DJs as the album's top tune. The experts watched the requests flock in, and in five months, the song was converted into a single. It went on to sell more than a million copies.

Dick Clark was also responsible for the success of many artists. He gave new acts a chance to be seen and heard on his *American Bandstand* TV show. He was the nice guy who made rock 'n' roll okay. When he broke a record, we were playing it the next day. Many times we had to wait a week or more because Clark had an exclusive and the record had no distribution. Clark was also responsible for a lot of kids dancing. They'd pick up new dance steps watching the show.

The sale of records in the '50s, '60s and '70s was greatly influenced by music stores like Radio Doctors in Milwaukee. The stores would promote songs and offer deals where after you purchased ten 45-rpm records you'd get one free. Mike Mowers, who worked at Radio Doctors, said, "We always had to keep up with what WOKY was playing, as they sold many records for us." John Galobich, who worked for Columbia Records in Milwaukee, commented that the station sold many records for them through Radio Doctors. Buyers were also persuaded by radio station surveys, magazines,

jukebox play, requests and, of course, radio station play. Sometimes on WOKY we would play the same record at least once an hour. (Was it that good, or was someone getting a few bucks under the table?) Most of the time, these overplayed tunes would make the charts.

Some labels tried to sway DJs by putting their name on the label as co-writer or producer. Bobby Darin had a famous New York City jock, Murray the K, on his record "Splish Splash." Not as famous, but a true story, Milwaukee record pusher Jon Hall put my name on a local record as producer. I never saw a cent—not that I ever thought I would. Local promoters also sponsored battles of the bands and promoted the winners' records, hoping to get the stations to play them. Rick Pries from the Milwaukee "Coachmen" said, "Many of the groups had large families and lots of friends, and the group would get them all to call the radio stations to request their record." Trombone player Gary Nelson, of the group Brethren, recalled that "local promoter Jon Hall talked the station into playing our record 'Happy Feeling' on the Teen Town label." Most of the time, Jon would try to get airplay for these groups so he could book them into CYO dances in Milwaukee.

The record promoters would bring in a new record by the latest hit artists, like the Beatles, and tell the music director not to play it until they got a copy over to WRIT, the other Top 40 station in Milwaukee. They would no sooner close the door and the record was on the air and the announcer, in a heavy echo chamber, was saying, "Here's another WOKY exclusive." WOKY was the powerhouse and, most of the time, got the records first. At night, WOKY would have a 40 rating and WRIT a 10. Of course, WRIT ran on only 250 watts at night. You were lucky to hear them in downtown Milwaukee. In the end, though, the record pushers still tried to be fair to the only two rock 'n' roll stations in town and sent two guys out at the same time, one to WOKY and the other to WRIT, so both stations got the record at the same time. When one of the stations knew they had the record first, they would yell "exclusive" several times during the song so it couldn't be copied. When we received the Beatles' *Rubber Soul* LP, we played the entire album over and over. But for us to do that the record company had to guarantee we would be the only ones to get the album for a specified length of time.

Record promoters were calling constantly to ask us to do interviews with their artists. I have a collection of over a thousand tapes of interviews I had done over the years. Sometimes I would record an interview, and if the artist sounded uninteresting or the record they were promoting didn't get aired, I would ditch it. Many times we would take a chance on a record we thought had hit potential, for example, Bobby Vinton's "There I've Said It

Again." We broke that record in Milwaukee, and it went on to become a big hit for Bobby. He still talks about it in concert appearances every time he comes to town.

The WOKY Lucky Number survey was made up of the songs popular in the Milwaukee area, as reported by the local record stores. There were usually thirty-five to forty songs on the survey each week. When we dropped a record, a new one was added. The survey and the playlist were two different animals. On March 1, 1963, the playlist had 111 songs plus album cuts by Connie Francis, Bill Pursell, Si Zentner, Eddie Heywood, Martin Denny, Julie London, Peter Nero and a local group, the Legends. We played everything from Nancy Wilson to Jackie Wilson, George Shearing, Elvis, the Four Seasons and Dean Martin, all depending on the time of day.

The 1960s saw the biggest diversification of music. We had soul music, R&B, the British Invasion, folk, psychedelic hippie music and surfer sounds. The late '60s and '70s were a tumultuous period in the United States—the Cold War, Vietnam War, the civil rights movement and different attitudes toward drugs and sex. The music of the day brought that out. In 1967, Jayne Mansfield died in a car accident, Muhammad Ali dodged the draft, Martin Luther King Jr. spoke out against the war in Vietnam and Billy Joe jumped off the Tallahatchie Bridge. All of this happened while the Packers marched toward back-to-back Super Bowl titles, a run that included the famous Ice Bowl at Lambeau Field on December 31, 1967, where the Packers beat the Dallas Cowboys 21–17 in the NFC Championship game. The temperature was near twenty below with a wind chill near seventy below zero when Bart Starr snuck into the end zone with sixteen seconds left on the clock.

Before the Ice Bowl came the Summer of Love, when the flower children promoted free love and LSD. The rock stations were playing "Somebody to Love" by Jefferson Airplane, with lead singer Gracie Slick. The opening to that song was enough to wake the dead. This was the beginning of a music revolution with inner-city unrest, hippies and drugs. For a while, I tried to get into the generational thing with Nehru jackets, long hair and chains, but I never got into fast cars, motorcycles, drugs, the unwashed look or facial hair. And that different look, for me, didn't last long.

The year was one of unrest for the United States and for Milwaukee. L. David Moorehead, our new PD, scared the hell out of us when he outfitted the news department with riot gear, helmets and all. Many of us had to sleep at the radio station during the Milwaukee riots because the police were not allowing anyone on the streets. The Monkees show scheduled for August 2 had to be canceled and tickets returned for refunds. On a Friday night

during the unrest, I had a scheduled appearance in Thiensville and was stopped at the Milwaukee County line by the cops. I tried everything to get them to let me through the barricades, even an attempt to bribe them with records, but they said no. In my trunk they found only the usual prize giveaways, including records, WOKY T-shirts, key chains and such. You know, all that priceless stuff. After they searched my car, inside and out, I pleaded that the teens were waiting for me, so they let me go through.

In the '70s we heard from Neil Diamond, Carly Simon, Jim Croce, Barry Manilow, Bread and the Carpenters. Others were heard on both AM and FM: Blood, Sweat and Tears; Creedence Clearwater Revival; and Led Zeppelin. The "black" stations were breaking records by War, Donna Summer, Stevie Wonder, the O'Jays and the Staple Singers. The "white" stations later added many of these artists to their playlists. Others played mostly by Bob Reitman and crew on WZMF included Janis Joplin, Kiss, Jefferson Airplane and Bob Dylan (Reitman's favorite.) Sometimes Bob would go out on a limb and play an unknown artist (Melanie, for example), and the song would become so popular in Milwaukee that it would wind up on the AM stations.

Most of the time, records started by AM stations would not end up on FM radio, and some were never heard on my program or any AM station: Grateful Dead, Phil Ochs and Mothers of Invention. The easy-listening records were played during the day and the hard-driving stuff at night when the teens were listening. There was a lot of money to be made for stations that had the ratings, and those ratings came mainly from the teenagers. The national sponsors only looked at the numbers, and we needed the national business. No way a station in Milwaukee could make it on the local advertisers alone. The problem the program director had was trying to get all of the commercials played and still sound like a rock music station whose slogan was "We Play More Music."

By 1971, WOKY was playing a lot more soul songs. In May of that year, we had a Motown weekend when every other record was from the Motown, Soul, Gordy or Tamla label. We were told to lay heavier on the Jackson Five and the Supremes rather than Junior Walker, Four Tops and so on because they were more soul than pop. The top ten at this time consisted of Dion's "Ruby Baby," the Four Seasons' "Walk Like a Man," Eydie Gorme's "Blame It on the Bossa Nova," Bobby Darin's "You're the Reason I'm Living," Paul and Paula's "Hey Paula," Johnny Mathis's "What Will Mary Say," the Cascades's "Rhythm of the Rain," the Rebels' "Wild Weekend," the Rooftop Singers' "Walk Right In" and Tony Bennett's "I Wanna Be Around." This list was accumulated by calling record stores and distributers

for sales figures and talking to record promo reps. Many times, these sources would inflate the numbers, so often the survey was not a true picture of the most popular records.

Inflated ratings and other behind-the-scenes moves notwithstanding, the music we played reflected the times, such as with protest artists like Bob Dylan and Joan Baez. Later came heavy metal, punk rock and progressive rock. In 1975, we had a playlist of thirty current records plus the oldies. We would wait until new records were well established before we played them. The exception, "Melody of Love" by Bobby Vinton, was natural for the Milwaukee market because Milwaukee has a big Polish population. There was also the disco craze in the '70s. It's difficult to name the worst disco record because there were so many. "Disco Duck" by Rick Dees probably deserves to be number one, followed by "Macho Man," "Shake Your Booty" and "Boogie Oogie Oogie." There were many others. The dance craze that went along with the music made it a bad time in radio history. One radio station handed out buttons that said "Death Before Disco." What else can you say about an era when record buyers made "You Light Up My Life" by Debbie Boone a number one hit and when the Bee Gees, Abba, the Village People and the Queen of Disco, Donna Summer, each sold millions of records? You could hear all this music on Disco 99, which played nonstop disco on 99.1 FM. The many anti-disco crowds trashed the Disco 99 booth at Summerfest in 1978, and the station kept that format for only a few months and then went back to the WNUW call letters before changing to WMYX, The Mix, in 1981.

Fortunately, the music was not all bad during that period. There were talents like Chicago, the Eagles, the Doobie Brothers and Springsteen. There were great songs like "Band on the Run" by Wings, "The Way We Were" by Barbra Streisand and "Sundown" by Gordon Lightfoot. And there were albums like John Lennon's *Imagine* and *Tapestry* by Carole King. The only drawback was the number of times we heard some of these songs.

How about a record that got the most requests but you couldn't buy it? In 1972, WOKY MD Tex Meyer reported to the trades:

*Bob Barry, AM drive man, got a record from Australia called "The Red Back Spider on the Toilet Seat." It was number one in Australia for four weeks. Bob played it once a morning for two weeks. The phones exploded every time it was played. There was no stock; you couldn't buy it anywhere in the U.S. A group from the Midwest, Brownsville Station, covered it, but it never got off the ground. The audience only liked the original from "down under."*

For much of the '70s, the rivalry between WRIT and WOKY was at a fever pitch. In 1970, PD George Wilson moved over to WRIT, and a procession of ex-WOKY jocks followed him. WRIT's lineup of WOKY alums included Carl Como, Ron Knight, Robert L. Collins and Ron Richards. Richards had been a disc jockey on a Milwaukee classical FM station at age sixteen. A grad of UWM with a history major, he progressed through several smaller Milwaukee area stations before latching on to a key time slot at WOKY. Ron was the first of Milwaukee's DJs to include progressive rock in WOKY's general contemporary music format. George also hired Robb Edwards to do the all-night show. I was under contract to WOKY but didn't want to bail out anyway because I had a good thing going. George brought all of his ideas from WOKY to WRIT. He added *WRIT Rock Festival* on Monday nights, programming five hours of album cuts. They cut out commercials, and Como awarded a new car to the person whose guess came closest to the Brewers' attendance for the day.

The rivalry between WOKY and WRIT was venomous. DJs were told not to talk to personalities from other radio stations and would bad mouth their cross-town competitors live on the air—and sometimes off the air. If one station gave away $100, the other would give away $200. If a record company gave one station a record by a popular artist before the other, the other station would stop playing all records distributed by that company. During the battle between WOKY and WRIT, Bob Collins came up with a "Name the Puppy" contest in 1973. He put a picture of the dog on the WOKY survey and played sound effects, which gave the impression the dog was in the studio. The idea was that being a rock 'n' roll disc jockey, he wouldn't have time to take care of the puppy, so he was giving it away to someone who could provide a good home. The best name would win the puppy. Then on the last day of the contest, when he was ready to name the winner, he announced that the puppy had gotten loose and that Steve York at WRIT had run over him with his car. WRIT got a ton of calls, and Bob Collins had driven another nail in the York-Collins rivalry. GM Ralph Barnes did not approve, and it was announced that the dog survived.

In February 1976, after I had been on the air at WOKY for almost fourteen years, Arthur Wirtz talked me into moving from WOKY to WEMP. This was a big mistake. I was given a contract that guaranteed more money than any other radio personality in town, but they had no idea which direction they would take the operation. They also added five dollars for every commercial run on my program, printing and mailing of my newsletter sold to radio stations throughout the United States, a company car, a show producer,

insurance, heavy promotion of the show, an office, promotion of personal appearances, prizes for my appearances, a personal secretary, no working holidays and a five-day workweek 6:00 a.m. to 10:00 a.m., Monday through Friday. There were other things they promised but never delivered. The promised offer was impossible to turn down, but it was a move I regretted.

In the months following, the ramifications of my decision sank in. In my eagerness to get this contract, I ignored the warning signs. It was Friday the Thirteenth when I signed the contract, after thirteen years at WOKY. I should have known. I felt the repercussions immediately. WOKY GM Ralph Barnes was quoted in the paper saying, "WOKY made Bob Barry, Bob Barry didn't make WOKY." That statement is not far off the mark. When you switch stations, no big ad campaign will change the minds of listeners who have been loyal to a radio station for many years. My success was with WOKY and nothing was going to change that, although it would have been nice if WEMP had let me have some say about the format.

At the same time, the placid and stable Milwaukee radio scene took on a new look. Cliff Barborka came to town in January to replace veteran Andrew Spheeris as vice president and general manager of WEMP. Spheeris had been at the station for thirteen years, but the loss of $300,000 the previous year didn't make Wirtz very happy. A sales rep for WEMP, Wells Hutchinson, arranged a meeting with Cliff and me. The final meeting to seal the deal took place on February 11, 1976, a day after we received a proposal from Wirtz, at Lohmann's Steak House in Menomonee Falls. Cliff signed an agreement on February 12. On July 22, 1976, we found out that he did not have the blessing of Wirtz in signing the terms of the agreement. Therefore, many of the promises were broken, including insurance, promotion and vacation time. On September 10, we received a letter from Wirtz, stating that he knew nothing of the side agreement signed by the GM and there was no way he was going to pay for any side deals when he had paid for them up front with the $50,000 signing bonus.

Barborka's first move was to lay the groundwork for a format switch for WEMP, a longtime middle-of-the-road station. He announced the station would be all rock, aiming at the longtime king of rock in Milwaukee, WOKY. Unknown to me at the time of the signing, Joe Dorsey, veteran of twenty-eight years in Milwaukee radio, all at WEMP; Robb Thomas, over twenty years at the station; Michael Jay, nighttime DJ; Mannie Mauldin, weekend announcer for many years; and Ted Moore, sports director, were fired. Barborka's assistant Rick DeGrave said, "You can do these things surgically; this was handled with a rusty meat cleaver."

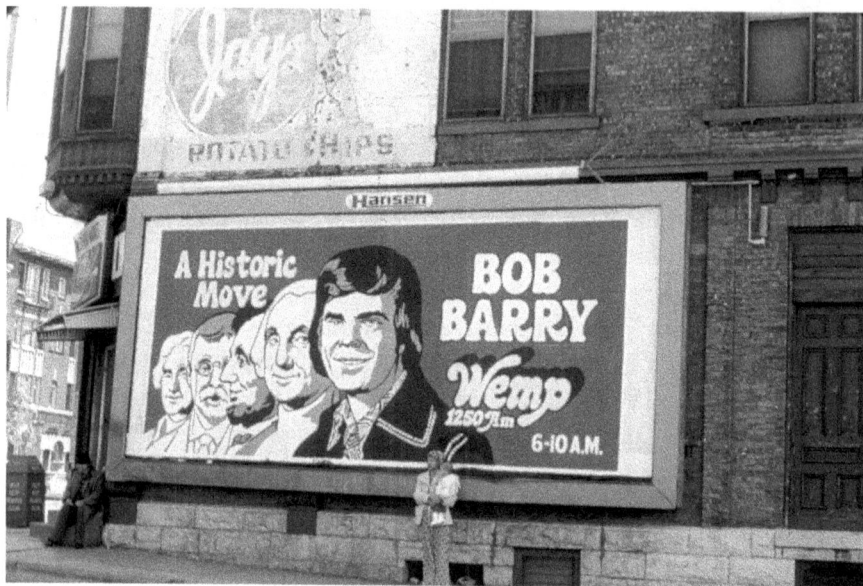

WEMP billboard in downtown Milwaukee.

Barborka claimed the station received only one hundred letters of complaint. I never believed that. Those former personalities had a huge older following that I'm sure put up a stink. Tom Shanahan was the only one who remained at the station. We had a solid staff with the exception of Roger St. John, formerly of WNUW and WZUU, who became our new program and music director. This was a huge mistake. He was used to programming hard rock and therefore played music my audience was not accustomed to hearing early in the morning. Can you imagine interviewing Tony Bennett and following it up with Led Zeppelin? We got fair ratings at first, but after the format change, we took a huge dip.

In July 1976, Barborka was fired as GM. (This must have made for interesting family dinners, because he was married to Wirtz's daughter.) Ironically, Barborka was the one who caused all of the above commotion in the first place. Before he hired me, he said, "I generally like all the WEMP personnel and don't contemplate specific changes." Within a few weeks, he had fired the veteran disc jockeys.

A 1977 newspaper read, "A new format is brewing at WEMP, and disc jockey Bob Barry, Beer Town's highest paid D.J., has switched to country." That year, PD Jack Lee came to me and asked what I thought about playing country music. I asked if it mattered what I thought, and he said no, the

station was going to change to "New Country Music." The station had been plagued with sagging ratings due to many circumstances beyond programming control. Jack had come from programming WTMJ to leading WEMP. I never forgave myself for recommending poor Jack for the job. I never thought running that station would be such a mess. To Jack's credit, the station did well with the country and western format.

I stayed at WEMP for three years before returning to WOKY in 1979. When I went back, Jim Brown was the PD, and to help me out, he hired newscasters Debbie Young and Steve Silverman and sportscaster Ted Moore. The WOKY Public Relations department set up a lot of charity promotions for me: Playboy Club bike-a-thon, a bunny softball game, Christmas tree lightings, a Christmas parade and even a big Elect Bob Barry for President campaign.

Those were good times until more changes came. On Saturday, January 16, 1982, at one o'clock in the morning, WOKY signed off the old rock 'n' roll format and signed on at six o'clock in the morning with an

Wisconsin radio icon Ted Moore became my sports director at WOKY.

all new format called "The Music of Your Life." (Tom Collins called it "Music of Your Terminal Life.") Steve Sands, who replaced Jim Brown as program director, was the first voice heard on the new WOKY. Brown told management that this MOYL format would never work and was fired. Sands was a former musician, rock jock and TV director in Los Angeles. He told us in his first programming meeting that radio is all smoke and mirrors. He was the strangest PD I ever worked for.

Musician–record producer Al Ham created the MOYL format. He had quite a background of active participation in various phases of music production for all media. He got his start at age seventeen by playing bass guitar with the Artie Shaw orchestra. He produced Johnny Mathis's first hits, including "Wonderful, Wonderful" and "Twelfth of Never." He came up with MOYL in 1978 while touring across the United States. He found that failing AM stations across the country welcomed this change. Al spent the next couple of years researching and fine-tuning the format. He started with a small station in Springfield, Massachusetts, and soon 130 stations all over the country joined in. We played music of the '40s, '50s and '60s. You heard Count Basie, Frank Sinatra, Patti Page, Bing Crosby, Johnny Mathis, Glenn Miller, Tony Bennett, the Dorsey bands and many more of that era.

It was forty-six hours of pre-recorded tapes and 140 supplemental songs, inserted on cartridges preprogramed for six weeks in advance. Listeners offered to bring in 78s, 45s and LPs but were turned down. When we were not on the air live, announcers in Los Angeles would do the breaks and such for all of the stations on the network, sounding like they were broadcasting at our studio in Milwaukee. The record would end; then they would tell you who the artist was and push a button that triggered a break at our station, "You're listening to the Music of Your Life on WOKY in Milwaukee." They'd continue with some story about something happening in another part of the country that was interesting and relevant to all listeners wherever they might be. They would be doing the same thing for another three hundred stations. They sounded so much like they were in Milwaukee that people would call in and ask to speak with them.

The next year, 1983, WOKY did not renew my contract. GM Mike Jorgenson said I had priced myself out of the market. WISN GM Lee Dolnick then hired me to replace Jeff McKee. In October 1985, PD Mike Elliott decided I should host a show called *Bob Barry Remembers* from 6:00 to 9:00 p.m. Monday through Friday. I played '50s and '60s music, interviewed recording stars from that era and accepted phone dedications. When Bobby Vee, Bobby Vinton, Marie Osmond and others were in town, they'd stop in

and talk about their current record and tell stories about their past hits. I would also take taped snippets from past interviews and voice tracks and tie them in with the oldies I was playing. Mike was right about the show because it turned out to be a successful three-hour program.

That same fall, WMGF was looking for a newsperson, preferably female, to join Girard and Luczak. That is when Tom Joerres, while on an after-work run with his Walkman on his head, heard the smooth voice of Carole Caine doing traffic reports from a Ford Bronco for WBCS, a country station at 102.9, later to become Lazer 103 in 1987. She had been there less than six months and was only doing traffic reports, working only part time and making just over minimum wage. Joerres said, "During our conversation there was nothing that would prevent us from approaching her, including no non-compete clause." But Tom sensed she was resistant to any change in her life. She seemed exceptionally loyal to her current GM even though they had a brief working history.

Tom decided to arrange a lunch with her, along with Girard and Luczak, who for the previous year and a half had tremendous exposure with a huge TV campaign. Joerres thought that Carole might be a little reticent or maybe even intimidated by these radio figures, made larger by significant TV exposure. He scheduled a lunch at the very classy Boulevard Inn. The lunch went well, but afterward it was still clear she was not convinced or willing to change jobs. They gave her an offer to be a full-time newscaster on a prominent station with a familiar morning show, with stable ownership, paying comfortably more money than she was currently making. Yet she still talked about her current GM, to whom she felt loyal. At this point, Tom said, "It was no longer her talent that interested me, but it was her loyalty that I wanted on our team. After a bit more communication and persistence, she agreed to terms of employment with us."

Two years later, in August 1987, GM Steve Downes hired Bob Irwin as program director at WISN. It was at a meeting with Downes that I was asked what I thought about talk radio. I told him it would never work at WISN. That was the last thing I ever said in that building. The station switched to an all-talk format soon thereafter. Ask Mark Belling if the talk format worked in Milwaukee. AM radio started going south in the late '80s, and it was personalities like Belling and Charlie Sykes who brought it back.

After WISN, I moved to the morning show on Star95 WZTR (95.7 FM) from 5:30 a.m. to 10:00 a.m. on weekdays. Michael Zahn, the *Milwaukee Journal* entertainment reporter, wrote:

*The station hired Barry as part of a total makeover. For a year the station has received dreadful ratings with its hybrid sound, combining Top 40 songs with soft rock. WZTR is switching to a new format: hit songs from the '60s and '70s. Tim Medland, vice president and general manager of Star95, said he wants the station to "ooze Milwaukee." Under the previous management team, all of the WZTR deejays oozed Texas or Oklahoma.*

After a few more years, it was announced in June 1991 that WZTR was being sold to a Madison couple, Terry and Sandra Shockley, for $4.9 million. This proved to be the beginning of the end of my radio career. On July 30, my contract was terminated, with the new management saying I had priced myself out of the market. My last day on the air was August 23, 1991. This was officially the end of my radio career. After some of my rough years in radio, at Thanksgiving time, I asked my wife, "How do I pick out a good turkey?" She said, "You ought to know." I was offered an air shift at WOKY but decided against it.

I saw radio change a lot in my years in the business. In the 1960s and early 1970s, there were only five big stations in Milwaukee, all on AM. The morning drive-time rating at WOKY was 26.2; WTMJ, 23.5; WEMP, 12.5; WISN, 12.5; and WRIT, 7.6. The FMs were way behind then. WTMJ-FM, for example, had 1.7 in 1971. Then WEZW-FM Easy got the ball rolling playing elevator music, followed by the underground rock stations WQFM and WZMF. WTMJ's sister station WKTI-FM started a rock format, and then FM came of age in Milwaukee. By the late 1970s, FM had more than half the radio audience in Milwaukee. In the '80s and '90s, it went to 75 percent of the listeners. Over the years, radio stations changed formats, personalities and music, leading to large swings in the ratings. Those who refused to change were left behind.

# PEOPLE AND PERSONALITIES

In 1955, radio pioneer Gordon McLendon came to town and started WRIT on Martin Drive in Milwaukee and WEMP in Hales Corners. McLendon was the announcer who called Bobby Thomson's famous "Shot Heard 'Round the World" in the 1951 National League playoff between the New York Giants and the Brooklyn Dodgers. Bob White was the first DJ hired

at WRIT and used his real name, Irv Miller, on the air. Jerry Bartell hired Bob at WOKY in 1957. Bob said, "At that time management didn't care if you stood on your head and whistled for three hours as long as you got the ratings." They had 30 percent of the audience when he was hired.

Bob told me the story of when he introduced Christine Jorgensen, a famous transgender woman, and after the interview, she saw a stack of LPs and said, "Wow, what a great collection." They were stacked up for the Bob Beringer *Lucky Logan* show. Beringer later asked Bob, "What happened to my show?" Jorgensen had taken the albums, got into a cab and left for the hotel. Beringer was left with nothing to play on his show.

Gordon Hinkley was doing his *Top of the Morning* show on WTMJ, and he began *Ask Your Neighbor*, a program that had listeners calling in with questions about gardening, getting spots out of clothes and so forth, and other listeners would call in with the answers. Gordy gave this example: "How do I get Preparation H stains out of my husband's slacks?" He didn't need to know anything because the listeners did all the work. Gordy admitted that this was an easy way to make a living, and sponsors loved the program.

Many radio programs at that time used theme songs to open their shows. Coffeehead Larson's was "Sunny Side of the Street" by Tommy Dorsey's Orchestra, Robb Thomas's was "Mama's Gone Goodbye" by the Dick Jurgens Band and Joe Dorsey used "Eager Beaver" by Stan Kenton.

Earl Gillespie began doing play-by-play for the Triple-A Brewers at Borchert Field in 1951 and then for the Braves when Lou Perini moved them to Milwaukee in 1953. He said that the 1957 World Series was the highlight of his career. He and his sidekick, Blaine Walsh, provided a lot of humor when some games were not so exciting to listen to. Remember the Braves jingle on WEMP? "There's a game today. The Braves are playing, so stay right here for now. Here's Earl Gillespie's play by play, it's back, back, back, back, holy cow! There's a game today, the Braves are playing and here's where you should be. We'll take you out to the ballgame on WEMP, Milwaukee...Wisconsin."

One of Milwaukee's most popular broadcasters entered the radio scene in 1971. Milwaukee native Bob Uecker began his long career announcing Milwaukee Brewers baseball games on WTMJ, and he became one of the best-known personalities in America. He appeared on *The Tonight Show* with Johnny Carson more than eighty times. He was one of Carson's favorite guests. A sample of Bob's self-effacing humor: "I signed with the Milwaukee Braves for $3,000. That bothered my dad at the time because he didn't have that kind of dough. But he eventually scraped it up." Bob

Hanging out with some of my radio and TV peers: (*left to right*) Joe Dorsey, Jack Lee, yours truly, Tom Shanahan, Gordon Hinkley and Carl Zimmermann.

had done standup. Musician Al Hirt arranged for Bob's first appearance on the Carson show.

During my first years at WOKY, I joined *Your Men in Waukeeland*: Steve O'Shea, Bill Henry, Bob White, Mitch Michael and Bill Taylor, "the man with the million voices," including his Grandma Busia character. He also had a popular "Voice Your Choice" feature on his nightly program. Listeners would call in to request their favorite record, and at the end of his program, he would play the song that received the most votes. Meanwhile, over at WAWA, Gordy Miles made history by hosting the Jaguars, the first Milwaukee rock band to play live on a Milwaukee radio show.

Also on WOKY in those days was Raymond E. Spencer with his familiar "This is Raymond E. Spencer and I have news for you." This was an introduction known to Milwaukeeans and the forerunner of Spencer's highly individual and forthright newscasts. Spencer was supplementing his income at WOKY by selling real estate and signing up young radio announcer wannabes at Career Academy. While selling real estate, he found a young

woman renter for my mother's upstairs apartment on Fifty-Ninth and Lloyd Street. My mother, who lived downstairs, kept calling me to report that there were strange men coming in and out of the place at all hours of the day and night. Turned out this young lady was a hooker. She probably thought that at my mom's age she wouldn't know what was going on. The young lady was out of there quicker than you could say Heidi Fleiss. Ray swore he knew nothing about her part-time occupation.

Art Zander did the traffic reports. Art was the pilot-observer for the WOKY Skywatch Patrol, flying a Cessna 172. He logged over seven thousand hours in eleven years. He did five reports per flight, morning and afternoon. He would also take flight for news stories and special events. He covered President Kennedy's visit to Milwaukee, getting special permission from the FBI to fly over the parade. How times have changed!

My closest encounter with President Kennedy was introducing his speech in Milwaukee on the radio on May 12, 1962. A year later, after the president's assassination on November 22, 1963, we played classical music on our rock 'n' roll station for days. A sales executive for WRIT, John Turner, told me that GM Bernie Strachota and Sales Manager Parker Daggett asked him, "What should we do?" That's how shocked and confused we were. We never had to deal with something like this on the radio before.

Stan Major was the controversial host of *WOKY-Talky* in the mid-1960s. He would say that anybody who owns a dog is stupid. And then he would add, "All dogs should be gassed because they're dirty animals." Stan was asked to leave the station after he asked for a raise on the air. He was hated by many listeners and kept a gun in his glove compartment for protection. He worried so much that he carried that gun with him coming and going to and from the building. One time, he wrote the entire staff a letter: "I demand that each one of you send a dollar to my campaign. I'm running for Congress." After Major's departure, Jack Lee had to do morning drive plus the *WOKY-Talky* show from 10:00 p.m. to midnight. Soon, Bob White took over the talk show. Management told him to be controversial, but he never matched the venom that came from Stan.

We always seemed to have a rabble rouser on the staff. In late 1964, Barney Pip joined us from WATI in Indianapolis. Barney was well known in Milwaukee radio for blowing his trumpet, off-key, and shouting "Peanut butter forever!" He loved doing bits about morbid songs. He would play "Leader of the Pack" by the Shangri-Las, where Betty is dating Jimmy, the leader of a motorcycle gang. They fall in love, but her parents don't approve, saying, "He's from the wrong side of town" and asking her to break up

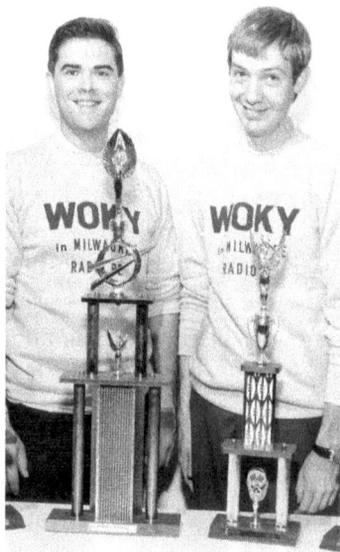

Popular WOKY DJ Barney Pip and I posed with the trophies from the Great Lakes Dragaway.

with him. Betty ends the relationship and an upset Jimmy speeds off on his cycle and crashes. That's when Barney would open up the microphone and say, "Betty, I have some good news for you, the football team won tonight. It was a great game. We scored a touchdown in the last five seconds…oh, by the way, Betty…Jimmy was in an accident with his motorcycle and he's dead."

In February 1966, the WOKY staff included Tony Carr, who came to us from Fort Wayne, Indiana. He auditioned on the air as many DJs did in those days. They were not paid to work weekends during their trial period. Remember when he promoted paper clips on his show? Milwaukee's Nike base group built a forty-foot paper clip out of copper tubing and presented it to him. They had entirely too much time on their hands. One night, he complained that fall was his favorite time of year, but he and his neighbors had no trees and therefore no leaves in their yards. He begged listeners to send him leaves so he could distribute them in his neighborhood. Big mistake!

"Incisive and authoritative" newsman Bill James came to WOKY from WTTN in Watertown, where he had been news director since 1950. Bill spent his thirty-ninth birthday in South Vietnam, November 28, 1968. He brought three tape recorders, recording over thirty thousand feet of taped interviews with Wisconsin's fighting men. The interviews were later featured on WOKY. He went on combat missions and visited Wisconsin servicemen and women in foxholes, rice paddies and hospitals, delivering mail and packages and recorded interviews from relatives and friends. This was one of the main reasons we were first with local news stories.

Another reason was George Pitrof, a full-time police reporter with fifty-two years of newspaper and radio reporting experience, based at the Milwaukee Safety Building. He was our Deep Throat, getting information from high-up officials who wanted to remain anonymous. George was very outspoken and freewheeling. One day, George invited me to the courthouse for a personal tour. He took me into Judge Christ Seraphim's courtroom, marched me up

to the bench and said, "Christ, I want you to meet Bob Barry from WOKY." This happened in the middle of a trial. I couldn't believe it.

One of the more interesting DJs I worked with at WOKY was Gene Johnson. Gene was our jack-of-all-trades, doing disc jockeying, news, engineering and outside promotions for the station. He started in radio in 1943 at age sixteen, making sixty-five cents an hour. His first big job was a Lawrence Welk remote in his hometown of Ottumwa, Iowa, using a little amp and a cheap microphone on a 100-watt station. That was when Welk went from town to town in an old broken-down bus and Jayne Walton was the Champagne Lady. To get to the bandstand, the young Johnson had to go through the pool hall. They said, "Hey kid, you're too young to go in there." He told them he was doing a remote with a six-piece band. They let him go in to set up and to do the "pop" sound effects for the theme song, "Bubbles in the Wine."

Gene also worked at heavily promoted broadcast school Career Academy, on North Jefferson Street, which was headed up by President Wes Pavalon, the founder and owner of the Milwaukee Bucks. Gene was paid $300 for each student he recruited. Tuition was about $2,000. The students at the school would make an audition tape. The only problem was, there was no tape in the recording unit. Gene told me they would tell the potential enrollee, "We'll listen to your tape, along with Earl Gillespie, John Cameron Swayze, Fran Allison and other well-known radio personalities and let you know if you're qualified." Even if he or she had a high voice, they would be told they sounded great. Most would be cleared, and their parents would pay the tuition. This turned out to be a very lucrative business for years. One of WOKY's announcers made enough on Career Academy stock to buy a home.

Gene was fired twice from WOKY; the second time he sued and got $50,000 minus legal fees. He left radio in 1964 to work for the government or, as he called it, "the public trough." He eventually settled down in Arizona with former WOKY music director Arline Quier. They are very dear friends of my wife and me, and we visit them every spring.

In the late 1940s, Tom Collins met Ted Moore, the sports director of WNAM in Neenah. After a few drinks, Tom told Ted that he had the easiest job in the world. He told him that all he had to do was sit down at a microphone and talk. Ted told him if he thought it was that easy he should come into the studio and try it. Tom went in and sat down at the mike, the red light went on and he started talking. Ted hired Collins on the spot. He was the sportscaster for all of the local teams and had a show where he

Gene Johnson is
on the phone with
George Pitrof
while Bill James
checks the morning
*Milwaukee Sentinel.*

played big band music of the '30s and '40s. Collins said that he also hosted a polka and country western music program that was a hit, especially in the small towns in Wisconsin. He hated that show and messed it up so badly that he thought they would cancel it. But the more he tried to screw it up, the more fan mail, calls and requests he got. It became the most popular show on the station. In 1951, his popularity brought a phone call from Tom Shanahan, who offered him a job at WEMP. He ended his career as a DJ at WOKY in 1993.

At WEMP, Collins would work with Ted Moore again. Ted began sports announcing in 1948 at WHA in Madison. He became sports director at WNAM in Neenah-Menasha, staff announcer at WTMJ, sports director at WEMP and sports announcer at WOKY. He was the radio voice of the Green Bay Packers during their "Glory Years" and spent twenty-three years as the basketball play-by-play voice of the Wisconsin Badgers. Moore broadcast Super Bowls I and II for the Packer radio network in 1966 and 1967 and was the radio announcer for the famous Ice Bowl NFL Championship game.

Bob Collins joined WOKY in 1967. Bob rode his motorcycle to Milwaukee from Tampa, Florida, where he had worked at WALT. He was a southern boy who knew how to charm an audience with his down-home drawl. He started out on the nighttime talk show *WOKY-Talky* from 10:00 p.m. to midnight. This is not what he wanted to do. He had never done a talk show and said he wanted a job playing rock 'n' roll and talking dirty. That finally happened when he called his friend Sue Riordan at Marquette

University and asked her if she knew anyone interested in doing a talk show. Joe Staudacher, radio name Joe Landry, who was in the MU broadcasting department and did a Saturday night jazz show, was interested. The show was eight hours; Joe received no pay but got to plug the local bars and always drank for free when he would frequent them. He had fun, going through a six-pack of beer during every show.

Bob was never a conformist. His dogs were named Dammit and Booger. The welcome mat at his house said "Go away." He loved to play on words and often introduced Gary Puckett's songs with "Here's Mother Puckett's son, Gary." He was the first guy I heard use the word *jockstrap* on the air. Bob really got into the lyrics of songs. To best describe this, here's what Collins fan Mike Osenga had to say in the book *I Remember Bob Collins*, by Vicki Quade:

> *One day we got in the car, opened the windows, turned up the radio and heard "Darling Be Home Soon" by the Lovin' Spoonful. A neat ballad, yeah sure. But Bob Collins? "Darling Be Home Soon" at 3:00 P.M.? I don't know if Bob was having marital troubles or was just sad over a lady, but when the song ended he came on the air in a raspy, sad voice we hadn't heard before and said, quoting from the song, "A quarter of my life has almost passed and the time that I have wasted is the time I spent without you."*
>
> *There was a pause that seemed to last forever. And then he played "Darling Be Home Soon," again. We went nuts. The same song twice in a row! On A.M. radio? Outta site! Cooool!!!! But at the same time, I also realized, maybe for the first time, that there was a person behind the voice. A real live person, who while we were in the parking lot at Muskego High School, was sitting behind a microphone somewhere. And he was hurting, and it sounded like he was hurting badly. Behind that entire brash persona was an emotional down-home boy.*

Bob and I hung out a lot. One of our hangouts was Frankie's on Brady Street in Milwaukee. It was a favorite watering hole of his because it had a great jukebox. He loved to play the Lou Rawls bluesy stuff, like "Show Business" and "Love Is a Hurtin' Thing." At the time, I was dating an airline stewardess who was really good looking. Bob loved to tell her half-true stories about me. He said that I told him that she was great in bed (although Uncle Bobby didn't put it in those words). He did it because he wanted to date her. She ended up dumping both of us. By the way, I never got near anything

that looked like bed or breakfast with her. All of the B&B partying together ended after I got married in 1968.

One day, Bob introduced me to Sambuca, an Italian anise-flavored colorless liqueur. I thought those were raisins in the bottom of the glass, but after I bit into one, I found out it was a coffee bean. Maybe I needed glasses? Bob loved razzing me about that. "Ever drink before, Beatle Bob?" I can still hear Collins say, "Boys and girls, you can always tell the success of a radio Top 40 disc jockey by the size of his…U-Haul trailer he hauls behind him." He prided himself with being the kind of guy who was going through all of the same crap we all go through on a day-to-day basis.

In 1974, Bob took a job working a split shift (afternoon and evening) at WGN in Chicago. Later, after Wally Phillips left the station, Bob began a successful career as the morning show host. His last contract was for five years at $2 million. He died in a tragic plane crash on February 8, 2000, shortly after signing that contract. I told him before he signed that deal that he had enough money and a beautiful home he was building in Scottsdale. "Why don't you and Chris settle down and enjoy life?" He said he loved the business and would continue until it wasn't fun anymore.

I can't mention Bob Collins without naming his list of the worst songs of all time, in no particular order: "Dead Skunk," by Loudon Wainwright; "I Never Went to Bed With an Ugly Woman, But I Sure Woke Up with a Few," by Bobby Bare; "Put Another Log on the Fire," by Tompall Glaser; "I Wouldn't Take You to a Dog Fight, Even If You Had a Chance to Win," by Charlie Walker; "My Name Is Eugene," by the Variable Speed Band; "Dolly Parton's Hits," by Bobby Braddock; "She Got the Goldmine and I Got the Shaft," by Jerry Reed; "I'm Washing Harry Down the Sink," by Jack Blanchard and Misty Morgan; "Get Your Tongue Out of My Mouth, Cause I'm Kissing You Goodbye," by Don and the Donuts. Bob would not play that last one for fear of it being the last record he would ever play on the radio.

Our staff in 1968 was called the WOKY Swingin' Seven Go-Guys of the Mighty 92, named by then PD L. David Moorehead. Moorehead worked for three years as programming executive at CBS radio in New York and was a successful PD and GM of several radio stations during his career. On the air, as Guy Williams, he was fired eight times by stations all over the country. He had a reputation of being risqué. "Once," he said, "I was fired for reading this poem on the air: 'There was a little girl, who had a little curl right in the middle of her forehead. When she was good, she was very good. When she was bad she had lots of dates.'"

Another radio man with the gift of risqué gab, Jim Brown, came to WOKY from WTRY in Troy, New York, on January 1, 1969, and eventually held the local record for the number of times he worked at one radio station during his career, fired and rehired seven times at WOKY. Three of those times he was the station's program director. He loved the radio business and had a great ear for hit records and talented radio announcers. He even helped local groups get recognized by playing their records. Jim hired talented DJs, including Tomm Rivers and Jonathan Brandmeier. Jon was doing well at WOKY, and GM Bill Jaeger said he couldn't afford to keep him. Brown was very upset. He said all Brandmeier wanted was a twenty-five-dollar-a-week raise. Jonathan left for a job at an FM station in Phoenix. They doubled his salary. A short time later, he became a big-time radio-TV personality in Chicago.

In 1969, Brown recommended that WOKY hire a newsman he had worked with at a station near St. Louis. Jim brought him over to our house to introduce him to our PD, George Wilson. Jim said, "George, this is Bruce Haines." George quickly said, "Bruce? Who in hell gave you a name like Bruce? I hope to hell it wasn't your mother. Nobody with a name like Bruce is going to work for my radio station." Bruce then changed his name to David Haines. He stayed at WOKY until, among other things, he was mocked in front of the entire office staff. David was nearby and heard it all.

David was imitated a lot due to his wild style. He was one of the best newsmen I had during my entire career. His popular feature on my show was a fifteen-minute five-day-a-week report at 8:00 a.m. He was sharp and quick witted, a colorful news personality. When I was on the phone, on the air, trying to reach some hard-to-get personality, David was always there with weather, a comment or a quip. And he took pride in taking the end of his newscast right up to the vocal of the record coming out of the news. He would always ask me how many seconds until the vocal.

Some of his on-air antics included a story about a young girl who was shot to death in Milwaukee. His lead line was, "She was shot in the head with hot lead and now she's dead." Hundreds of listeners petitioned the FCC, asking for WOKY to apologize. David said the phrase was taken out of context. To this day, people still mention that incident to me.

David had a way with words: "The seat belt might have wrinkled her dress, but the windshield sure wrinkled her face." His glossary of news clichés included cop shop (police station), Mom Nature (the weather), money hungry bandits (robbers who hold up restaurants), barbed wire hotel (jail)

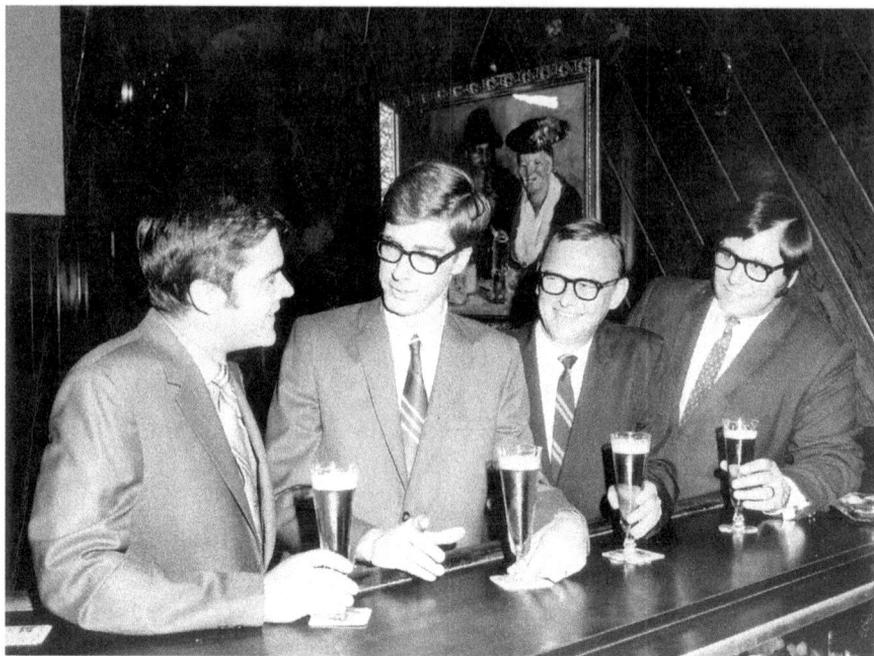

Enjoying a Miller beer at a brewery event with my colleagues (*left to right*) David Haines, Bob Betts and Bob Sherwood.

and the good guys in the blue hats (police). His colorful prose included examples like these: "While you were sleeping the long blue arm of the law reached out and collared a no-good punk, put some wrist warmers on him and threw him in the slammer," or "Hungry tongues of red hot flame licked away an apartment building on the east side last night." David might proclaim, "Ten new toes in the morgue this morning," or "HoHoHo Chi Minh is dead" or "The WOKY weather this morning is a four-letter word. No, not that word. The one I'm thinking of is C-O-L-D." On a rainy day, it was "a symphony of windshield wipers can be heard all over town." One he used over and over was "burnt toast and coffee time."

One person responsible for my success, and that of a lot of other radio personalities, was George Wilson, WOKY-WRIT program director and my boss in the late '60s and early '70s. During that time, he was chosen Top 40 radio program director of the year by *Billboard* magazine. *Billboard* called him "probably the most successful Top 40 program director that ever lived."

GW had a systematic approach to programming that included a specific mixture of music, news, DJ talk segments, commercials and public service

My career might never have taken flight if not for my mentor and friend, award-winning program director George Wilson.

announcements. He kept commercial clusters to no more than seventy seconds, much to the chagrin of the sales department. We had a program clock that showed the program elements and how they would fit into each hour. That clock included a list of the top hits of the week and older hits that had recently fallen off the charts, a new release and songs gaining in popularity. We also had musical jingles that were written and approved by Wilson, and these had to be inserted at certain times on the clock. We also had three-by-five cards that we were required to read during every break. If you did what GW told you, you had a job forever—if not, you were gone the next day.

One weekend when George was out of town, he put me in charge. In those days, whenever a new Beatles record came in we played it immediately. When the Yoko Ono record came in, different from the usual songs put out by one of the Fab Four, I put it in my mailbox, thinking I would let George hear it before we put it on. One of the jocks saw the record and put it on the air. There was a controversial phrase in the song "Christ It Ain't Easy." When George got back from San Diego, he stopped at the bar across the street, like he always did. Some guy came up to him and said, "What kind of garbage are you playing on your radio station? My kids are listening all the time." Unlike radio today, there were some songs we wouldn't play due to the lyrics. After this bar patron explained what he heard in the John Lennon song, George called me at home and told me he was suspending me for a week with pay and then called all the staff and said they would need to cover for me. Then he called back and asked what my wife and I were doing that night. After telling him we had no plans, he said he and his wife, Esther, were coming over for a drink. When they got to our place, he acted like nothing happened. I told him, "If you suspend me for a week, you could suspend me for good." I didn't do anything to deserve the suspension. He then asked to use the phone, called the staff back and told them to do their regular shifts. Apparently, my time out was over.

A lot of people didn't like George because of his attitude, but once you got to know him, you understood his philosophy. He would work three to

four hours a day and then go to the bar (the Annex) across from the radio station at Sherman and Fond du Lac Avenue. He even had his own red phone at the tavern. Doug Herman called it "the chief joint of staff." If you or anyone else wanted to talk to him, you'd call the red phone or visit him at the bar. There were many days when George's secretary, Mardi Nehrbass, took his mail over there so he didn't have to come into the office at all. George said that anyone who worked in radio more than four hours a day didn't know what he or she was doing. The truth is George never forgot about radio, at the station, the bar or when he was at home, which was seldom. He was always thinking about his next move, promotion or crazy stunt. Rochelle Staab said that he went through five secretaries at WOKY. "He was not the easiest guy to work for. But, being secretary to George Wilson was a plush job, consisting of answering phone calls and telling whoever was on the phone that he was out of town, which he usually was."

When he came to Milwaukee in the late '60s, he was on the air from 9:00 a.m. to noon. One morning, he said, "I want everyone to get to know me because I'm the new guy in town, so the first one thousand listeners sending me your name and address, I'll send you a five-dollar bill." George sent listeners who replied a mock bill that read, "You owe me $5.00." Listeners complained to the FCC, and the station ended up sending out $5,000. GM Dick Casper was not pleased.

George had the station giving away thousands of dollars. One morning, he called and told me to give away $1,000 before my shift was over. I asked how he would like me to do that. "I don't care, just give it away." I made phone calls nonstop, except for commercials, for almost three hours until I finally found a person at home who answered the phone, "I listen to funlovin' WOKY."

In August 1970, Wilson moved over to WRIT as program director. George had installed a successful format at WOKY and then had to better those winning ideas at his new station. Following his move, Pierre-Rene Noth of the *Milwaukee Journal* quoted Wilson: "It's a funny thing to fight your own self." George took some of the WOKY staff with him, including Ronnie Knight, Ron Thompson, Tex Meyer and Carl Como. At WRIT, George continued his wild ways. He had GM Bernie Strachota go on the air and for over a day apologize for an offensive remark that Bob Collins made on the air. It was the talk of Milwaukee radio listeners and picked up by *Journal* columnist Mike Drew. One problem: it was not true, just another concocted promotion by George. A year later, George came back to WOKY.

George had a pronounced ear for music, totally unorthodox. Nobody I knew could pick records like him, although the jocks at WOKY at times disagreed. I mean, really? "God Didn't Make Little Green Apples, and It Don't Rain in Indianapolis in the Summertime"? He broke the records "Rose Garden" by Lynn Anderson, "For the Good Times" by Ray Price and *Sesame Street*'s "Rubber Ducky."

His career took him to over twenty cities. George did wild things on and off the air. He was always unpredictable, and we put up with it all because he was a great PD. One day, when he had been drinking, he was pulled over by a cop in Milwaukee. George had become buddies with some of the police detectives and the chief of police, so he called the chief from his car phone. When the cop came up to the car window, George handed him the phone and said, "It's for you."

George had little patience with record promoters. These guys would come in with their latest hits, and many times, he threw their records in the wastebasket before he'd heard them. He would tell these promoters that if they would bring their top artists into town pro bono, he would play the record. After they made the appearance, if the record was not a hit, he would drop it from the playlist. One record pusher asked George if he liked a certain record. He said yes. Finally, the guy said, "I asked you three weeks

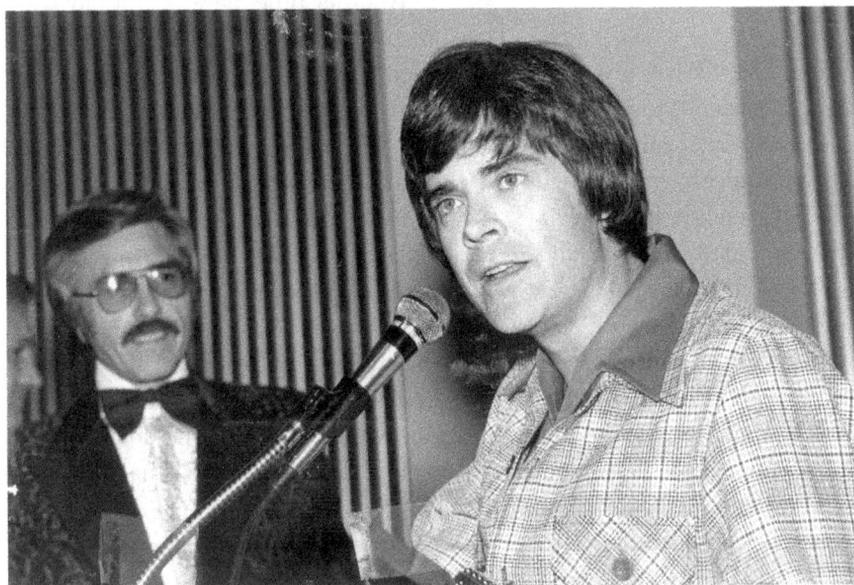

*Laugh-In* star Gary Owens presented me with the Air Personality of the Year Award at the 1975 Billboard Convention in San Francisco.

This is the award I received for being named *Billboard* magazine "Air Personality of the Year."

in a row if you liked the record and you said yes, but you're not playing it." George said, "You asked me if I liked the record. You never asked me to play it." He would laugh and then add the record to the playlist.

One West Coast promo guy had to learn the hard way. In 1976, when I received the Billboard Air Personality of the Year award in San Francisco, George took us to an expensive Frisco restaurant (actor James Garner and his wife were at the table behind us) and ordered a $600 bottle of wine. After dinner, he presented the entire bill to this record hawker he had invited to dinner. The guy said to George, "How am I going to explain this $1,200 tab to my boss?" George smiled and said, "That's your problem, Harold."

Another time, he was at a bar with record promoter Paul Gallis when he announced, "We're going to Vegas." George was a generous person, often taking his friends to Vegas and picking up the tab. He told Paul, "Follow me to the airport; I might need your help." When they got to Mitchell Field, George and his group got out of the car, and he gave Paul the keys and said he'd see him in a few days. Gallis was left standing alone at the airport departure area with two cars. Try to explain that to the cops.

Out of the blue, George would invite the jocks and their wives out to dinner at the Pfister or Alioto's and pay for everything. He knew all the maître d's and waitresses and tipped very well. One time, after the waitress said "WOKY" after being asked what radio station she listened to, George, Dick Casper, Bob Collins and David Moorehead each left nine dollars in the shape of a heart with twenty cents in the middle. 920…get it? That was a big tip in those days for a forty-dollar lunch.

Jack Lee recalled that George was a natural leader despite his demons:

*He knew talent and hired the best people and pretty much trusted them to do good things with minimum supervision. We all wanted to do well for*

*George because of that mystical natural leader thing. Minimum supervision worked most of the time. When he made a move, it was never personal. One time George said, "OK, that bit you did pissed a lot of people off and... you know...the license and all...so I am going to have to fire you. Wanna go get some eggs?"*

Wilson had hired Doug Herman, and in his first year, he did the *Waukee-Talky* talk show from eleven o'clock to midnight. Doug recalled one Sunday night, he came in about nine to do his show prep and George stepped out of his office, where all the lights were off, and said, "Hey, man, if anybody asks I'm not here." He then went back into his dark office. It turned out George had lost a lot of money on pro football that day, and there were some people he didn't want to talk to. George loved to gamble and, by his own admission, won and lost a lot of money over the years. Despite his success (he was making a good wage at that time, $84,000 a year), with excessive drinking, gambling and spending, George kept losing jobs. He also lost his house, his car, his paycheck and his second wife, Esther, while he was in Milwaukee.

In divorce court, George told the judge, "I get expenses, and I'll get some payola here and there." The judge said, "You can't do that. You need something to live off of." He became a member of Alcoholics Anonymous, and in his last years, he would not associate with those who drank to excess. He told me he realized how obnoxious he was when drunk and that he regretted many of his actions while inebriated.

After George got out of radio, he did a complete about-face, quit drinking and gambling, but it was too late to save his third marriage. Then, in February 2013, at age eighty-three, he married his long-time girlfriend Jackie (eighty-six) at a Las Vegas Chapel. His fourth wedding came about after George saw an Elvis impersonator on TV marrying a couple. He said to Jackie, "We should go to Vegas and do that." It was a sad day only two months later when I got the news from his daughter that George had passed away.

# RADIO PROMOTION HATH NO SHAME

Nothing was taboo as far as promoting a radio station went. We used billboards, bumper stickers, taxicab tops, TV commercials, key chains, magnets, pens and lighters. They even used a dining room table, white

tablecloth and candles with my head sticking out of the middle of the table and the announcer saying, "Have Bob Barry with your morning breakfast."

One of the first promotions I did was in Hartford at WTKM in 1959. Ray Kannass owned the butcher shop across Main Street from the station. He always teased me about getting a real job. I would try to sell him some advertising on my show, but he always refused, saying, "Nobody listens to your little radio station." One day, after we spent some time at the bar next to his meat market, he agreed to me telling my audience to come into his shop at 9:00 a.m. on Saturday morning for a free pound of hamburger. The lines were all the way down the block and around the corner. He went through one hundred pounds of meat before he closed the door. Are you ready for this? He still refused to advertise. Poor Ray was short a few fingers that got caught in the meat grinder over the years. With the tavern next to his shop, I'll let you guess how, or why, that happened.

In order to be a part of the big concerts that came to town, our marketing director, Lois Rice, came up with the WOKY Golden Mike Award. She called the promoters of some top acts at that time and told them we would present the award to them on stage. The station would end up with advertising dollars for promoting the show, and our DJs

One crazy promotion: "Enjoy Bob Barry for breakfast…on fun-lovin' WOKY."

would present the awards to the artist on stage. Bob White handed Nat King Cole the first "Mike" on November 11, 1963, at the Milwaukee Auditorium, for Nat's seventeen years of outstanding entertainment to Milwaukee's largest radio audience. We were all present to give the award to Cole: White, Bill James, Ray Spencer, Steve O'Shea, Bill Henry, Mitch Michael and me. We were up on stage with Bob and Nat, and when you see the picture of us it looks like I was dead serious about the presentation. We were all wearing our new station-issued sport coats with a big MB crest embroidered on the pocket and a WOKY ribbon on the lapel. The MB stood for Macfadden-Bartell Corporation, a publishing company subsidiary owned by the Bartells, who owned WOKY and a bunch of other stations.

On December 6, 1963, Raymond Spencer was scheduled to present the trophy to Tony Bennett. Ray had to work that evening, so I was asked to make the presentation shortly after the intermission. Photographer Clair Wilson was on hand to capture the moment. Talk about a thrill for a young jock.

I nearly got killed on a Saturday, May 17, 1964, at the downtown Boston Store. I emceed an appearance by TV stars Roger Smith and Kathy Nolan. They were starring in *Sunday in New York* at the Swan Theater. They signed autographs, and I gave away records, Beatle wigs and some radio station mementos. A screaming crowd of two thousand pushing and shoving teenagers, mostly girls, swarmed the celebrities in the middle of the store. Only two hundred were expected. One girl was kicked, her hair was pulled and the crowd messed up her blouse. One buyer for the store, Theodore Gillan, said he was surprised no one was seriously injured.

What would you think a ten-pound box of money would be worth? In February 1968, the station sponsored a Valentine's contest. The winner, a young lady from Wauwatosa, designed the best valentine and won the box of money, containing $126. I often wondered if that was in pennies.

Bruce Lehrke, president of the Wonago Rodeo, invited me to ride the bull Widowmaker in the fall of 1968. This was right before my marriage and honeymoon. The bull I feared turned out to be about three feet tall. My feet touched the ground when I rode him. Bruce sent me a letter saying, "We are pleased Widowmaker did not live up to his reputation in your special situation and hope your honeymoon will last forever."

Speaking of bull, one PR stunt brought Charlie the Charolais bull into the WTMJ studios. They told Gordon Hinkley that he had to take good care of him, feed him and so on. They kept him in Waukesha County and one time

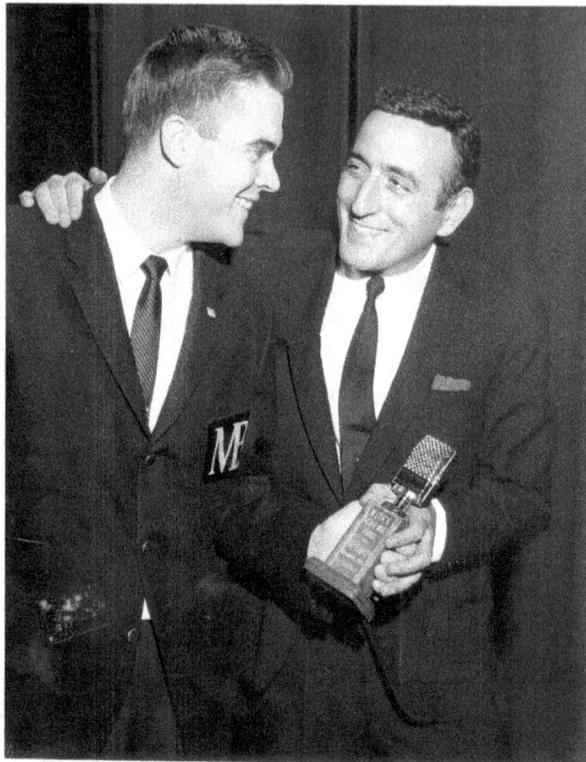

*Right*: I had the pleasure
of presenting the Golden
Microphone Award to
legendary crooner Tony
Bennett.

*Below*: This promotion
was full of bull. Show biz
sure is glamorous.

brought him into the city as part of the promotion. They thought he should have some grass from Hinkley's front yard in Whitefish Bay. They put him on the front lawn; he got away and went into Lake Michigan. They thought that was the end of Charlie, but they rescued him. It made the front page of the *Milwaukee Journal*. Gordie took good care of him. He brought him to market eventually and had a dinner for charity.

Another Gordie promotion on March 15 each year was "The buzzards come back to Hinkley, Ohio." The Milwaukee Zoo director, George Speidel, sent Gordie to the Cleveland Zoo in Hinkley, and he brought back a buzzard for the Milwaukee Zoo. They named it Gordo. Each year, they would celebrate this day on WTMJ. One day, Gordo got away. They had to rescue him, and once again, this made the front page of the *Journal*. You don't think they were letting these animals get away just for the publicity?

WTMJ also promoted "Gordon's Gorgeous Gourds" using Gordon Thomas and Gordon Hinkley. They would give out thousands of free gourd seeds every spring. Listeners would grow the seeds and bring in the gourds in September. The largest would win prizes in a competition between the two announcers to see whose listeners grew the largest gourd. Folks seemed to love these simple down-home promotions.

In the 1970s, when New York City was ready to file bankruptcy, I asked listeners to help raise $300,000 to save them. In one week, pledges for more than $100,000 came in, but you know how people are about pledges. I received $8.73, which I forwarded to the mayor of New York to help save the Big Apple. I guess it worked. They're still there.

Music guru Joel Whitburn has a collection of thousands of records and CDs, all the top hits from 1940 to the present, in a huge record vault in the basement of his home in Menomonee Falls. Joel owns every album and single ever to appear on Billboard's "Hot 100" and "Top Pop Albums" charts. In 1970, he had enough information to start a book. When Joel first started, he was on my program with trivia, including the record race (beginning in 1972). He was given a title and artist of a song that was on the Billboard Top 100 charts between 1955 and the present day. He had to find and play it on the air from his home within thirty seconds or the listener would win $920. We would knock off a second each time he would find the song. There was a setup at his house where his record player could be heard over the air. He only lost once, when someone accidentally unplugged the player. In today's digital age, doing this would be no problem, but at that time, finding the record among thousands and getting it on the turntable in a few seconds was quite a feat. Joel was included in some national TV programs,

Music expert and author Joel Whitburn (*second from the right*) joined me in a visit with Donny Osmond and his brothers.

newspapers and magazines as a result of his knowledge and speed in finding these records in record time (pun intentional).

In the '60s and '70s we aired nonstop contests and lots of fantastic hit music. In 1969, thirteen times daily, WOKY's Swingin' Seven Go-Guys made on-the-air callouts. Those listeners who were called and could correctly identify the amount in the jackpot won it all. The amount was broadcast immediately before the announcer called. The starting jackpot was always at least $920. At times it was doubled to $1,840 and increased in varying amounts after each unsuccessful call. It was the biggest cash contest ever undertaken by a Milwaukee radio station.

The station would go to any extreme to get listeners and make money. Miss Sugar Spoon would go around in the Sugar Spoon Van looking for houses displaying Nabisco Shredded Wheat boxes or signs in their windows. For doing that you would get a silver spoon, making you eligible for an 1847 Rogers Brothers Silver setting for eight. A better one was "You Play, We Pay, Let WOKY pay your bills." We asked advertisers to share the cost of paying

for someone's car, rent or house payment for a full month. If we had twenty sponsors, we had twenty winners a week. Listeners were asked to send in their largest and smallest bills, limit $80. We would draw a letter from the box of mail received. When you heard your name, you'd have three minutes to call the station. Total cost to the station was a budgeted $700 per week.

The Brewers moved from Seattle to Milwaukee and had a bad losing streak in the spring of 1970, so a witch in Los Angeles suggested I cast a spell on them. I hired Barbara from Milwaukee, who claimed to be an authentic witch, and invited listeners to take part in the spell. We had a soundtrack with eerie music, and I managed to get permission to use Milwaukee County Stadium for the ceremony. At sunrise on April 22, 2,500 people showed up for the spell casting. We lit candles, ate donuts, drank coffee—some people brought beer. Barbara led the crowd in a chant: "We offer the flame to the god of Venus as a gift to the cosmos, and so to the wind. The Brewers are the cosmos. The Brewers are the wind. The Brewers are all-powerful. The Brewers are all-powerful. The Brewers will win the pennant." The Brewers lost again later that day, 3–1, to the California Angels, and proceeded to lose fifteen of the next twenty games. They did not win the pennant that year.

In 1969, thousands of dollars were awarded to listeners for answering their phones "I listen to funlovin' WOKY." Twelve live calls were made daily. We would call people at random from the phone book, and if they answered their phone "I listen to funlovin' WOKY," they would win the amount in the jackpot, and if they knew the total they would win double the amount. A typical listener response when we called was "I answer my phone that way all the time, but I didn't this time because my kids [or friends] were laughing at me for doing that." A woman who would take her transistor radio wherever she would go won a jackpot of $1,989.45. When we called her, she was doing her washing in the basement and ran upstairs to answer the phone. We heard many listeners utter some expletives after they said "Hello" and we told them who we were. Our competition accused us of buying our audience.

The contest paid off because the WOKY morning show ratings in April-May 1971 showed a 26 share of the audience, WTMJ second with 22, WEMP 13 and WISN with an 11-point share. In 1979, "Double Cash," WOKY's longest-running on-air contest, was replaced by the "I'm on the WOKY Payroll." Monday through Friday, eleven phone calls were placed, at random, to homes selected from the Milwaukee Metro White Pages. If the person reached answered the phone "I'm on the WOKY

Payroll," they would go on the payroll at $9.20 per hour, based on a five-day Monday through Friday work week from 9:00 a.m. to 5:00 p.m., forty hours a week, until we got another winner.

Then there was "Car 92," created in 1969 by WOKY PD David Moorehead. Skip Taylor, Carl Como and all-around jock, newsman and gofer Gene Johnson would drive around in the Car 92 van. We would play the "Car 92 Where Are You?" jingle (a takeoff on *Car 54, Where Are You?* on TV in the early '60s) and announce that they were in front of the (name) residence, and if they came out to the car within ninety-two seconds they could pick a prize valued up to $920. Inside the van were 920 sealed envelopes, each bearing a gift ranging in value from $9.20 to prizes such as household appliances. He would announce the name and address of the home in front of which he had stopped, and any member of that family had ninety-two seconds to come out and claim one of the envelopes.

Very popular in the '70s was the WOKY "Bridal Fair" and "Woman's World" held at the Grand Ballroom of the Pfister Hotel. The women were shown bridal etiquette, fashions and finances and heard marriage counselors. During the Woman's World segment, they were shown facial treatments, hair care and weight control, and a psychologist would answer their questions while psychic-mystic Irene Hughes was telling the ladies what their future would look like. The women would form long lines to find out if their hopes and dreams would come true. The place was jammed with young women and their mothers. Honeymoons, Vegas vacations and furs were offered as prizes.

In September 1972, Joan Gehr of Allenton, Wisconsin, heard me mention on WOKY that I would like some live wolves to help with an experiment. She contacted Jim Rieder, a wolf breeder from Greenfield, and had him bring three-year-old 175-pound male wolf Brutus and one-year-old 70-pound female wolf Cleo to the studios at Sherman and Fond du Lac Avenues in Milwaukee. I interviewed Jim and then went into the studio to pet the wolves because I was told that they are basically kind to people. As I reached out to pet Cleo, there was a vicious growl, and Brutus charged to within two inches of my right hand. Luckily, Jim had a leash on him. Then I tried my experiment, playing a cut from the album *The Language and Music of the Wolf*. According to the album liner notes by Robert Redford, the live wolves are supposed to react to the recorded wolves. All the wolves did was pace around the studio and not utter one sound. No sound is not the greatest for a radio program, and I was not about to go into the den with them again to get some reaction.

If you think children are scene-stealers, try working with wolves on the radio.

The station sponsored many contests tied in to trips to Las Vegas, Miami and the like. In February 1973, we had a Wayne Newton Valentine contest, and of course, we played his latest record so his label would pick up the entire tab for air, hotel, show and meeting him after the show. WOKY provided some spending cash for meals. All the listeners had to do is make "the most original valentine" for Wayne. One schoolteacher came up with a clever idea to win. She had her class design valentines, and she brought the best one down to the station. It was a beauty, and she and her husband won the trip to Vegas.

A press release from April 22, 1973, read, "Magicomedian George Schindler will attempt to saw WOKY personality Bob Barry in half at least once at Gimbel's this Thursday, April 24. The first attempt will be at 12:30 p.m. in the downtown store's second floor coat department. If he succeeds, Schindler again will attempt the feat at four p.m. in the book department of Gimbel's Mayfair store." The upside for me was that I got to see how the trick was done.

We did a promotion to help a parasailing venture on Okauchee Lake. I went up first and nearly got killed, getting my foot caught in the rope and untangled right before I took off. After that near-serious situation I decided not to endorse this project. The way it's done today is a lot safer.

My wife, Nancy, and I were able to spend some time backstage with Wayne Newton at the Frontier Hotel in Las Vegas. Check out those crazy 1970s outfits.

It was a tough job, but somebody had to do it. Nancy and I took contest winners to Las Vegas in the middle of the winter in 1974. Out of seven thousand entries, Sylvia and Gil Sobanski won the WOKY weekend getaway with all expenses paid. They even got ninety-two dollars to spend, which they

quickly put in the slot machines. Sylvia said her arm was sore from pulling the handles. They got to see Wayne Newton at the Sands, and Wayne invited us all backstage after the show. They said the highlight was seeing Frank Sinatra, who was performing his "Ol' Blue Eyes Is Back" return to show business at Caesars Palace. The town was packed with fans and celebrities, including Dean Martin and Sammy Davis. The Milwaukee couple also saw Elvis, Rich Little, Liberace and Juliet Prowse.

I still don't understand how this happened, but I loved it. In December 1978 on a below-zero day, I was asked to handle the announcing and running commentary during the WCT $320,000 Challenge Cup tennis matches in Jamaica. On the court we saw Bjorn Borg, Dick Stockton, Roscoe Tanner and Ilie Nastase. There was also a skinny young newcomer by the name of John McEnroe in the tournament. He thought he was the greatest and later proved himself right. He lost to Borg in the final and refused an interview. In fact, he wouldn't even say hello. But I got interviews with the rest of the field and enjoyed the tropical weather, eighty-some degrees warmer than in Milwaukee. I did need to take a crash course in tennis and managed to bluff my way through it. As McEnroe would yell, "You can't be serious."

When I returned to WOKY in 1979, the station hired a plane that flew over Milwaukee County Stadium during a three-day weekend dragging a banner with "Barry's Back at WOKY." Then we did our show atop a building for three mornings while a huge billboard was being erected with the "Barry's back" theme. By the time we finished our show on the third day, the sign was completed. One morning, Bobby Vinton joined us on the billboard site at Green Bay Avenue and Capitol Drive, and he never let me live it down. Every time he appeared in Milwaukee, he'd tell the audience about what he had to do to get a record played on my show. But I did buy him a beer at the bar across the street from the station at Sherman and Fond du Lac Avenue. You should have seen the faces of the guys at the bar when Bobby walked into the corner tavern. On another occasion, Vinton co-hosted the program with me for ninety minutes, the longest for any celebrity on my show in thirty years. During that time, he taught me how to sing the Polish part of his hit "My Melody of Love" and made me an honorary Pole. He said, "If you ever get in trouble call me and I'll put the Polofia to work." Vinton, proud of his Polish ancestors, said, "The Polofia is the Polish Mafia."

In August 1979, Mike Ruppe, the publisher of the *Southside Spirit* newspaper, and I began an effort to send Pope John Paul the longest invitation ever assembled, inviting him to visit Milwaukee on his tour of the United States. The outcome over a three-week period brought 25,560

You should have seen the looks on the patrons' faces when Bobby Vinton and I walked into the bar across the street from WOKY. We had just finished my morning show on a hot and humid morning from the top of a billboard on the east side of Milwaukee.

signatures, making the invitation 649 feet long. The assembly took place in the St. Alexander's school gym on South Fifteenth Place and East Holt Avenue. The final invite was displayed in the Hall of Flags main lobby of Milwaukee's convention center. The lobby ran 600 feet, east to west. The goal was to make it as long/tall as the First Wisconsin Building, which is 610 feet. Even Milwaukee mayor Henry Maier signed the invitation. After all that, the Pope regretted he could not come to our city.

In the '70s I started using my children, Robby and Heidi, to read the Milwaukee public school lunch menu, recorded and on the air twice every day, Monday through Friday. They were so young I needed to prompt them for each line and then splice it together. They also would throw in a pun at the end. "The neighbors have a new baby. They taught him to sing." Really? What song? 'Silent Night.'" We would record a week's worth of menus at one sitting. It was a chore but worth the response we received. My son recently confessed that his classmates on the school bus teased him when the driver would turn on WOKY and he would be heard doing the menu. Later, I used young guest listeners who could read, and they would recite it over the phone.

In September 1979, we did our morning radio program remote from the USS *Oliver Hazard Perry*, the first active navy warship to tour the Great Lakes in twenty years. It was stationed at Jones Island Harbor in Milwaukee. I was stationed on the tripod mast, at a height of about seventy-five feet. I can thank Dick Randall, the president of Aquarius Productions in Pewaukee, for this promotion. After overcoming obstacles such as the Gas Company cutting electrical lines, the show went smoothly. Tours were offered to the public in the afternoon. One cold morning, I asked for a brave girl to show up in a bikini. To our surprise, five shivering young ladies were on deck, to the delight of a good number of sailors. We did the same on board the USS *Lawe* in July 1981. Sure was better bikini weather for that fun tour of duty!

In October 1979, Bernie Strachota, who had been the GM at WRIT back in the '60s, was in the promotion department at First Bank Milwaukee. He brought us a cash grab contest. WOKY listeners were offered a chance to walk into the First Bank Milwaukee bank vault and grab as much of $100,000 as possible. The winner of the contest had sixty seconds to grab the cash from the vault. The cash was in many singles, fives and a few tens and twenties, and therefore, we didn't need to feel sorry for the bank. They came out unscathed, as the disappointed winner learned. The amount he grabbed was under $1,000. Of course, with almost any contest involving the possibility of a big prize, the station carries insurance.

Another one of the wonderful perks in broadcasting was involving my family in promotions. Eight-year-old Rob and I were bused to Navy Pier in Chicago at 6:00 a.m. on July 19, 1980, where we boarded the navy destroyer

My daughter, Heidi, got her first taste of showbiz in the downtown Milwaukee Christmas parade, in good company here with TV meteorologist Joe Witte.

USS *Owens* for a cruise to Milwaukee. My daughter, Heidi, and my son rode in the Downtown Christmas Parade for several years. Also, Rob got to play in the McDonald's characters kids' game at Milwaukee County Stadium. The two of them also got to see a lot of entertainers up close and personal, including Rick Nelson's last appearance in Wisconsin.

"Have a Barry, Merry Christmas with Bob and WOKY" was a December 1979 promotion. Our show was broadcast live from a display window of Gimbels, located at Plankinton and Wisconsin Avenue. The window was decorated with holiday trees, snow and such. We urged listeners to send or drop off toys and/or a check to Milwaukee Children's Hospital. We also had guests join us, including the WOKY Chicken. I pointed at him holding a sign reading "Chicken," and he held a sign pointing at me reading "Turkey."

On December 19, 1981, at the Brook Club in Waukesha, tennis star Bobby Riggs (the one who lost a celebrity match to Billie Jean King) played a celebrity round of tennis with Bob Wolf from the *Milwaukee Journal*, Mike Hegan of baseball and WTMJ-TV fame and myself. The master of ceremonies was Larry the Legend of WZUU. This was the only time Bobby Riggs didn't care if he won or lost because he didn't have a bet on the match.

In 1982, listeners would do anything to win a Cabbage Patch doll. Adoptions of the kids exceeded 2.5 million. They were selling so fast that I couldn't even find one for my own daughter. In 1983, Bob Reitman and Gene Mueller told their WKTI listeners that they arranged for a B-29 to drop 2,000 Cabbage Patch kids over Milwaukee County Stadium. They told listeners to show up in the parking lot with a catcher's mitt on one hand and a credit card in the other. Twenty people showed up, and Reitman and Mueller ended up getting tons of publicity for the stunt that never happened.

WISN was involved in promotions with the Brewers, including October 1983 when Mike Murphy and I joined Brewers pitcher Don Sutton to sign autographs on Brewer placemats to raise money for the building of the Ronald McDonald House. In the same year, Charlie Hanson was giving away twenty-five-dollar tickets to see Frank Sinatra. You could win by answering questions about Ol' Blue Eyes's career. The winners qualified for "A Night Out with Frank," which included limo service, dinner, drinks and a pair of tickets. Wonder what those tickets would cost today. Charlie was hired in 1956 by WISN manager Carl Zimmermann. Hanson had been a popular fixture in Milwaukee radio with his cast of characters, including Shaky (who he said was based on the night-time janitor at the station), Sonny and Cher, Deadline Klieglight, Wilbur Frammes, Schlomowitz and Loser Lapidus. He worked from a handwritten college-ruled notebook and

would spend hours at home writing the routines for the next morning's show. He would go through facial expressions and hand motions when he did these bits in the studio.

At WISN on June 16, 1987, I did my entire show from 3:00 to 7:00 p.m. live from the Fuji Blimp high over Milwaukee and County Stadium, assisted by our promotion director Julie Stolper and newsman Bob Bach. One thing we didn't count on was the noise inside the blimp. Little was heard by the audience except engine noise. Good idea, bad outcome!

Many times I would end up doing some really stupid promotions just so the station could get the account. One afternoon I sat in a hot tub in the middle of the showroom floor. Another time, spring of 1989, at Kubiak Pool and Spas on Highway 100, they had me in a whirlpool out in the middle of the parking lot. If anything would clear out a room it was that sight. Thank God they let me get out of the pool to make my live broadcast. Holding a microphone while sitting in water is not a good idea.

Another successful promotion in 1989 was the "95-minute trip." It's seven o'clock on Friday morning and you're staring at your clothes closet through sleepy eyelids. "TGIF" keeps running through your mind. Suddenly, the insistent ring of the phone breaks your reverie. You're still trying to decide what to wear as you mumble hello. You hear "Hi, this is Bob Barry at WZTR." Our first call went out to Dan and Chris Dietrich from West Allis. A sleepy voice answered the phone. "Is this Dan Dietrich?" More alert now, I confirm that I have the correct name and say, "Congratulations! You just won an all-expense paid trip for two to Orlando, Florida. If you'll turn your radio on to STAR-95, you'll find out that this is not a joke, we're live on the air right now." Sure enough, as you flip the clock radio back on you hear me on the radio and on the phone. You forget you're standing there in your underwear as you hear "Included are round trip airfare, hotel, car rental and spending money." The listener says, "You must be kidding, is this a joke?" I tell them "It's no joke, but there is a catch. You have to get to the airport within 95 minutes from right now. Can you do it?"

Suddenly you're in high gear. What about getting off work? The kids? Ushering at church on Sunday morning? Oh, what the heck, let's go for it. The trips each week had destinations of Orlando, Tampa, Miami, Los Angeles, Seattle and New Orleans on Northwest Airlines. We would help them get off work, find a baby sitter, get someone to milk the cows, whatever, but they needed to be at the airport in ninety-five minutes. We would have someone waiting at Billy Mitchell Field to help them get on the plane. Dan and Chris did try to make arrangements to go, but unfortunately, things

couldn't be worked out. For the people who could go, we provided each winner with a survival kit, including toothbrush, toothpaste, mouthwash, hairbrush, shampoo and disposable camera. About 80 percent took us up on the offer. The station's promotion director, Cindy Schneider, made sure the winners got to the airport safely by keeping in touch with them as much as possible. She was there to see no danger was involved in the sprint to the airport. She did some research and found out you can safely get to the airport in thirty minutes from anywhere in Milwaukee.

We encountered many different situations with this contest. There was a minister who had to get out of doing a Sunday service. After he got a quick OK from the president of the congregation for the weekend trip, the pastor and his wife raced to the airport with plenty of time to spare and were met by our representative, who gave them their plane tickets and other prizes, and then they were off to Phoenix. Our third winner in four weeks was a couple of dairy farmers in Cedarburg, Joan and Dave Brandt. Joan was the one who answered the phone and was all excited, but she kept asking her husband if they could go until he finally said yes. Joan and Dave made it to the airport with only ten minutes to spare. They spent the weekend in Dallas. Those who took us up on the offer had a great time. We only had one mishap, and that happened in Miami. The lady's purse was stolen when they were filling up their rental car with gas. During this promotion our rating went from 11.0 to 19.3.

We also had a contest at STAR 95 promising Chicago concert tickets to Paul McCartney's 1990 World Tour and maybe a personal visit with Paul for the person who would do the most outrageous stunt. On July 28, 1990, Brian Kernatz of Brookfield sawed his garage in half with a handsaw. He and his wife got to see the concert, but Paul reneged on the chance to meet Brian. The couple also received a $950 shopping spree at Boston Store, dinner before the show and limo service the entire day with plenty of booze along the way. They slept all the way back to Milwaukee, and I wonder to this day if they remembered the concert. I do remember them being a fun couple.

Have you ever entered a radio station contest? Then it might interest you to know what goes on behind the scenes. When a radio announcer says be the ninth caller and you win, many times he has instructions on how to handle that. We were instructed by the program director to answer the phones "WOKY" when we got to the ninth caller, and if that person showed no enthusiasm, we would tell them they were caller number eight. We'd continue doing that until we got someone who sounded like they were

excited to win. The children of employees many times did judging of mail-in contests. All entries that looked like they were not in our demographic target audience were discarded. Yes, neatness does count…a lot! Also, if you want your requests played, make your call sound interesting or it will never get on the air unless the DJ is getting no calls and he needs yours. Most all calls are either screened or recorded and played back at the discretion of the on-air personality.

All of these promotions, giveaways and gimmicks were used to get ratings. Ratings were very important to radio stations. Your income was based mostly on the number of listeners your station commanded. When Nancy and I got married in 1968, we were told by GM Dick Casper that we would need to change our wedding date due to the Arbitron rating period that month. But he said the good news was that the station would pay for our honeymoon. We changed the date, and we went to Jamaica, but on our honeymoon I proceeded to get third-degree sunburn and ended up in bed, alone. I tried every remedy known to man and nothing worked until I remembered my mom's old fix. In a hotel room in NYC on the way back to Milwaukee, we soaked towels in vinegar and put them on the burns. That relieved the pain and took some of the redness out. Can you imagine what the housekeeper thought when she walked into that room? "Wow, this is one kinky couple."

# CHAPTER 3

## BOB BARRY CALLS THE WORLD AND OTHER INTERVIEWS

Management at WOKY always said I could say what I wanted to, within reason, but every time you open the microphone, you had better be saying something interesting, informative and fun. And that's how *Bob Barry Calls the World* developed. I had some stiff competition, and I knew I would have to do something different. One day I got a call from a listener asking if I thought it would be possible to talk to the president of the United States. So on a dare I tried, without success. But the reaction to being shoved from one White House rep to another was positive. And I loved the dependence on unpredictable telephone conversations. It charged my energy cells.

One thing led to another, and I found myself making lots of calls. When I moved to the morning show I was on the phone all the time, with a monthly bill of $1,000, according to GM Ralph Barnes. But Barnes was smiling the day I located thirteen-year-old Caroline Kennedy (JFK's daughter) in a tennis camp in Mayrhofen, Austria. The camp receptionist called her to the phone after I told her that I was calling long distance from the United States. I'll bet she got her ear in a ringer for that. Caroline told me she had never been on the radio before and proceeded to answer nine questions in one minute. She did add that she did not appreciate all the publicity generated from being a Kennedy. In other words—don't call again. But, she did end the conversation by saying, "Have a nice summer."

I published a newsletter each month with birthdays of the famous and not so famous, along with bios and important and unimportant events in history. I started doing that for radio stations in our chain, and it became so popular that I advertised the letter and got a lot of subscribers from all over the United States and Canada. In 1989, I published a book, *Bob Barry Celebrity Almanac*, with the same material that appeared in the newsletter, only it covered an entire year. As an added incentive to buy the book, I included a small book of telephone contacts. In this book would be phone numbers for each month of the year. For example, in July, the EAA airplane convention took place in Oshkosh. There you would find information on the event and the phone number for the convention chairman. Others would include the Miss America Pageant headquarters, a newspaper columnist who had a knack for predicting the winner of the Kentucky Derby and, on the lighter side, the World Cow Chip Throwing contest. Occasionally I would give them some numbers of celebrities who told me they didn't mind if I gave out their number to other radio stations.

I called all over the world, which is why in the late '60s and '70s they called the show *Bob Barry Calls the World*. This included the prime minister of Australia, whom I woke up at 3:00 a.m. local time. I asked him if he got many calls at all hours of the morning. He replied in his heavy Australian accent, "Yes I do, mate, from characters like you."

One time I ordered a pizza from Rome. "Do you deliver?" "Sure, we deliver." "How soon could we get the pizza?" He said, "We only deliver in the nighttime." I said, "That's good because it will take a while to get here."

Ron Howard and his wife, Cheryl, stopped by the studio in 1977 to promote his movie *Grand Theft Auto*. He told me that he started acting when he was four years old. He has acted in numerous movies and TV shows and produced many movies. Most remember Ron as Richie Cunningham on *Happy Days*. He told me that the executive producer, Tom Miller, was from Milwaukee and had some actual footage filmed in Milwaukee for the show. He said, "The only controversy on the show was a scene where my best friend Potsie is going to show me how to unhook a bra, by putting this giant bra on this radiator in the bathroom at Arnold's. That caused quite a stir, but it wasn't censored or anything. We got a lot of mail about that, and since then there hasn't been anything that has disturbed anybody."

Bill Dana told me that his favorite cut of all his comedy bits was "Jose the Astronaut." When you end up in the Smithsonian you feel pretty proud. If you saw *The Right Stuff* movie, you see references to that all the way through because Alan Shepard's code name became Jose. The first words from the

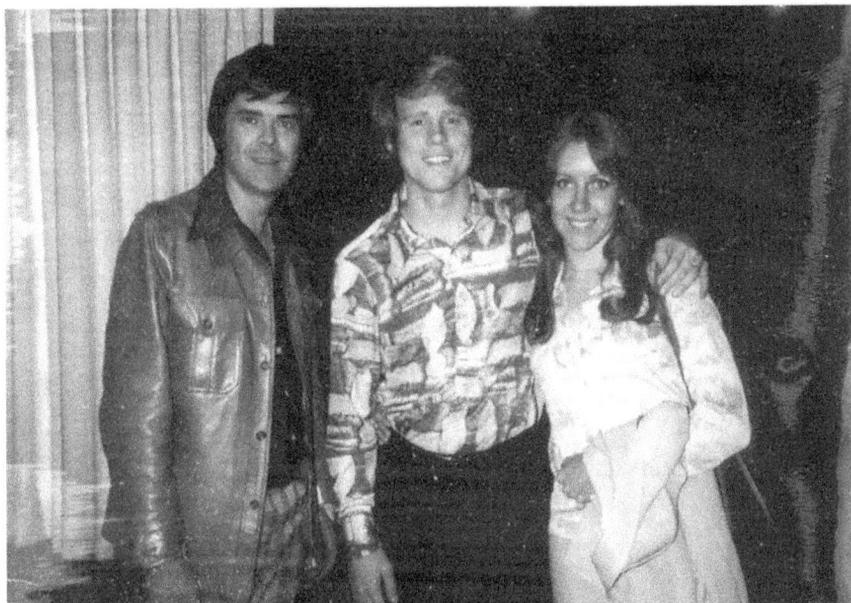

He's come a long way since Opie—charismatic film actor/producer/director Ron Howard and his lovely wife, Cheryl.

Al Molinaro from Kenosha, Wisconsin, and Anson Williams were stars on *Happy Days*.

Al Molinaro, who played Arnold on *Happy Days*, could always break me up.

ground when Alan Shepard went into space back in May 1961 were "OK Jose, you're on your way." And when they landed and they opened the capsule, the first words he said were "My name Jose Jimenez."

My most expensive call was over one hundred dollars for over thirty minutes with actor Orson Bean in Australia. And all that he remembered about Milwaukee was Father Groppi, a civil rights protester in the '60s who was born in the Bay View neighborhood and died in 1985.

Every week I would call a psychic, astrologist, graphologist or hypnotist. Listeners loved it. One day I talked to Flora Davis, an expert on body language. She said, "When your boyfriend or girlfriend looks deeply into your eyes, he or she is very attracted to you. And when a woman takes her fingertip and runs it around the rim of her glass, this means that she would like to be touching you, but because it's in public, she used the glass as a substitute." I said, "What does it mean when I'm out with a girl and I tear the labels off beer bottles?" She said, "You've had too many beers."

During a call in February 1975, I asked Zsa Zsa Gabor how her new marriage was going and what number husband he was. She said, "Dahl-ink, it's much too early in the morning to count that high." I asked if she was a good housekeeper. She said, "Of course I'm a good housekeeper; every time

My son Rob met the Lone Ranger, Clayton Moore.

I get divorced, I keep the house." I mentioned that on the marriage license it says she is forty-six years old, which would have made her only seven years old when she was Miss Hungary in Budapest in 1936. "You get me up at this ridiculous hour of the morning to ask such a stupid question?" she asked, very upset. So I quickly changed the subject and asked about her cosmetic business. "Vie, dah-link, now you are talking." She talked about her products for the next five minutes. Finally, any advice for our married

women listening in this morning? "Advice? Yes, tell zem they should all go back to bed." Zsa would never reveal her real age, but when she died in 2016, we all found out that she was ninety-nine.

Clayton Moore was the Lone Ranger on TV ('40s and '50s) and in the movies. On May 10, 1980, he told me he remembered when James Arness of TV's *Gunsmoke* filmed bit parts for *The Lone Ranger* in the early '50s. He was paid forty-five dollars a day. I asked Moore if he ever took the mask off. "Only when I shower."

Evel Knievel had a very interesting life. He got his name from an article in his hometown (Butte, Montana) newspaper. He was in jail for stealing hubcaps, and there was a murderer in the next cell. The city attorney thought it would be funny when he said the taxpayers would need to pay more because they had awful Knofel and evil Knievel in jail and could not trust them. He later became a hockey player on a local team, and they called him Evil Knievel and the name stuck. He changed it to Evel so it wouldn't make him sound like a bad person. His given name was Robert. He told me that he never practiced the very dangerous jump at Caesars Palace because there was no way he could test the motorcycle at the fountain so he would know if he had enough speed to make the jump. He missed it and suffered serious injuries. He said, "I survived my injuries because I'm tough." There were three things he wanted to do in life: parachute out of an airplane, drive a car in the Indy 500 and go to bed with Liz Taylor. He said, "I jumped out of a plane, the Indy I replaced with the canyon jump, and Liz Taylor is too old and too heavy now, so I don't think about her anymore."

Jamie Farr, Klinger on the hit TV show *M*A*S*H**, in an attempt to get a discharge from the army, would wear women's clothing. He told me that his first scene was in a dress that he couldn't unzip. A burly set electrician unzipped it for him. Jamie said the guy is probably still wondering what was going on. He mentioned that he was a good friend of singer Wayne Cochran and came to see him at the Attic in Milwaukee.

Another actor from the aforementioned show was Mike Farrell, who played B.J. Honeycutt. He mused, "If you were to believe all of the publicity written about you, you could get a sense of your own importance far beyond reality, and unfortunately that's what happens too often. I was sitting in an interview and asked all kinds of questions, and this reporter was telling me how great I was, and I was getting all swelled up about it when my daughter's voice, when she was very young, came from the bathroom saying 'Daddy, I'm finished pooping, come wipe me.' That brings you right down to ground zero."

Jamie Farr, best known as Klinger on TV's *M*A*S*H*, joined me for the Muscular Dystrophy Telethon.

In March 1972, I talked with actor Burt Reynolds. He told me that he was fed up with all the attention he was getting since he appeared in *Cosmopolitan* magazine in the nude. He said he was bored with talking about it and would rather discuss his acting career. He said it was a crazy, dumb thing to do. He did it for laughs, and it just got out of hand. "It wouldn't have made any difference if it was Yogi Bear, it was all about the first to do a nude layout in *Cosmo*." I asked him what his ex-wife Judy Carne said about the foldout. He said, "She liked it, and besides that she thinks that I have a terrific ass."

Johnny Weissmuller made nineteen Tarzan movies in twenty years, starting in 1931. He was one of seventy-five guys who tested on the back lot for the part. The producers didn't even know if he could swim. They wanted to see action, so they asked him to run, climb a tree and swim. Then they finally found out who he was, and that helped him get the part. He won five Olympic gold medals. He did his own Tarzan yell. "I was a yodeler when I was a kid and tried to find a shrill yell like they had listed in all the Tarzan books. So with my high voice as a kid I would yodel at the German picnics on Sunday, so I thought of that yell." Then he gave

me a sample and just about blew my headset out! "Tarzan and Jane were married in one of the movies by her dad." And all that time I thought they were living in debauchery. They had three cheetahs for each film they made because they were temperamental. "If you yelled at them or pulled them, they would bite like hell."

Yvonne Craig was the commissioner's daughter Barbara Gordon and Batgirl on the 1960s *Batman* TV show. She revealed to me how you could tell the good guys from the bad guys on TV in the '60s. "In westerns the bad guys have long sideburns and black hats and on *Batman* the good guys have no cleavage. Julie Newmar has a low-cut costume because she's a bad guy, but I have a turtleneck on 'cause I'm good. It seems unfair, but it's a children's show, so they won't allow it. No cleavage at 6:30 in the evening. The costume was very, very uncomfortable, made of girdle fabric with little pieces of metal in it that would stab you."

Arnold Schwarzenegger said a girl asked if he would take his shirt off, and he told her only if she would take hers off. He was surprised when she did and said it was an offer he couldn't refuse. Maybe this was a sign of things to come.

Buddy Ebsen (Jed Clampett on *The Beverly Hillbillies*) said it cost only $54,000 to make the first show. His mom lived in Milwaukee years ago and encouraged him to pursue an acting career. In 1939, he was offered the job as the Scarecrow in *The Wizard of Oz* but switched to the Tin Man. It almost killed him because they powdered his face with aluminum dust. He had to drop out, he got so sick. Jack Haley took over the part.

Barbi Benton was one of Hugh Hefner's girlfriends. She did her first cover for *Playboy* magazine in 1968 and first inside pictorial in 1969. She was not paid for her first layout in the magazine. She told me she did it for fun. Barbi started dating Hef in 1968 and kept it up for almost nine years. She was hired for the TV show *Playboy after Dark* to pretend she was Hugh Hefner's girlfriend. That's how that relationship started. She said it was not a basic relationship of boyfriend, girlfriend. She was eighteen, and Hefner was forty-two. He had a mansion in Chicago when they met, and he never left the inside of the house. The mansion had an indoor swimming pool (equipped with topless bathing beauties), a bowling alley, pool tables and a game room. She moved Hef out to California and found him a house. Barbi said she taught him the benefits of being an outdoor person. One thing she could never get him to do is go out of his world, out into the real world where people go to parties, people cry and you see the good, bad and ugly. He left the Playboy Mansion only on rare occasions.

*Right*: Barbie Benton, on loan for a day from Hugh Hefner, stopped by to promote her new album.

*Below*: At the Playboy Mansion in Chicago, I explained to founder Hugh Hefner that I only bought his magazine for the articles.

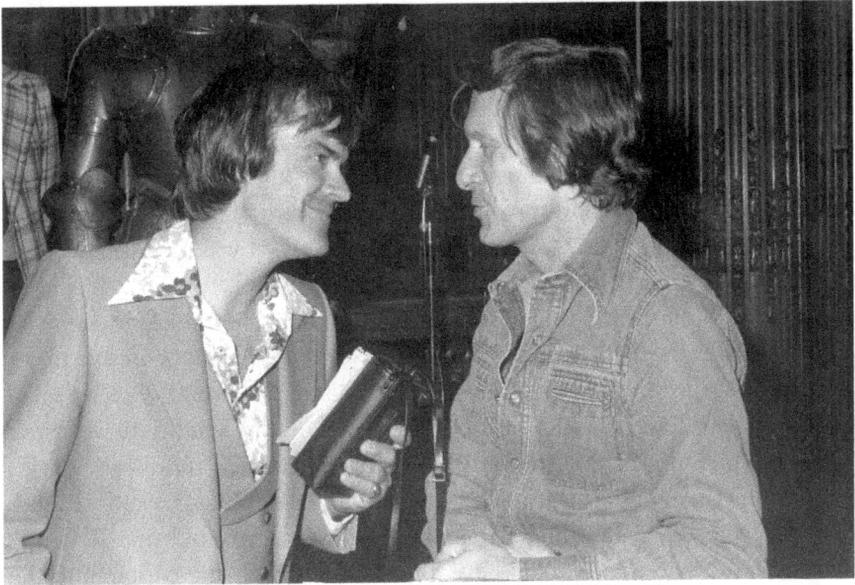

I talked with George Burns on December 10, 1979, a month before his eighty-fourth birthday. He said, "Smoking cigars hasn't hurt me. I smoked inexpensive El Producto cigars because they fit into my cigar holder better than others. I gave up on Hemp El Ropos because they burned too fast. Three doctors told me to quit smoking cigars years ago. Since then, two died and the other is coughing a lot." He said the secrets for long life include many hours of hard work and not allowing yourself to get old. Every day from 10:00 a.m. until noon he worked with his writers, then had lunch, played

some bridge and went home to take a nap. After waking up he had a few martinis and if he went out in the evening had a couple more. When he and Gracie Allen were married, mixed marriages were extremely controversial in the Catholic Church. Burns was Jewish and Gracie was a Catholic, and they were married by a justice of the peace. Burns said, "She was *very* Catholic; she ate fish on Wednesday, Thursday and Friday. I was the only Jew in the family. The children were raised Catholic." He advised, "Don't get old, don't walk slowly and take little steps. If you do, you won't get there."

One early morning I woke Bob Hope after he had made a late-night trip from California to Chicago. He told me that his body was doing a take but still insisted on talking with me. I asked him if he ever got in trouble with his material. "I used one joke about it being so cold in Florida, Anita Bryant's pansies froze. There were so many protests I dropped that line from future appearances."

Janet Leigh had to do so many takes of the shower scene in *Psycho* that the moleskin she used to cover her nude body fell off. She said, "The hell with it, just keep the camera rolling and let's get this over with." Alfred Hitchcock loved her adventurousness.

I asked Hitchcock if he had any nudity in his new film *Frenzy*. He said, "Once I was asked if nudity will last." I asked him what his answer was. Alfred quickly responded, "All breasts sag inevitably." I was so startled by his answer that I never noticed if he answered my question.

Speaking of nudity, I told Dyan Cannon that I remembered when she posed nude for one of her films. She said, "Never. Well, maybe in one film I did a nude scene and that was from a distance, and one time I did a scene in a bra. *Playboy* offered me a lot of money to pose nude. When I'm nude, it will be for my pleasure or my husband or friends' pleasure. I did a movie with Omar Sharif where they put my face on a dynamite body for a split second. Film producer Otto Preminger did that. He was a dirty old man." Lenny Bruce used to say, "Nude scenes are for box office, to bring people into the theaters. Tits and ass is all it is." Later when I saw her at the Playboy Club in Lake Geneva, I reminded her of the interview, and she said, "We weren't on the air, were we?"

I had a contact in Hollywood, a very wealthy Jewish man, who would sell phone numbers of celebrities or their agents. The cost varied depending on whom I would like to speak with. The price per celeb could vary from ten to twenty-five dollars for these numbers. I had to put out ten dollars to interview Dick Martin from *Rowan and Martin's Laugh-In*. Dick told me that they were only sued once. Jacqueline Susann filed the lawsuit because they

At the Playboy Club in Lake Geneva, the question was, which one swallowed the canary, Dyan Cannon or me?

gave her the "fickle finger of fate" award. He said it was great. "We could always use a good lawsuit to improve the ratings."

Jim Fixx, author of books on running, said beer could help runners. He told me he was in a race with a runner who was doing extremely well and Fixx was having trouble passing him. There was a mile to go in the race when all of a sudden, this lead runner stopped and rummaged around the area and came up with a can of beer in some bushes. Jim passed him and won the race with a forty-five-second lead. He said, "Beer can help a runner if it's the other guy who drinks it." Poor Jim died of a heart attack while running in 1984 at age fifty-two—way too young for a man who really took care of himself, although in his younger years he was a heavy smoker.

Jim Backus told me that Mr. Magoo developed when he did radio shows and was asked to do a double part. This was the only way he could make more money. "The AFTRA Union had you play yourself also, unless you were a big star. You had to do that extra voice or do a lot of shows. When I started out on 'Gang Busters,' I had to play an FBI man and a store clerk. I had to get as far away from my own voice as possible, so I came up with a guy who sounded like Magoo." They did a rough read with sound effects for

over an hour and then did the show live. Sometimes he did three or more shows a day. His family lived in Milwaukee when he was very young.

Adam West (Batman on TV) said he always felt like he was wearing his underwear on the outside. He said it cost $250,000 to produce an episode at that time and that's why they canceled the show—it cost too much. West's young sidekick, Burt Ward, a.k.a. Robin the Boy Wonder, talked to me from Malibu. After the show (120 episodes) was over, he was not allowed to wear the Robin costume for appearances. They would send out their own Batman and Robin and advertise that they were the real originals from the TV show. The shows were filmed in Los Angeles at the 20th Century Fox studios and at Desilu studios in Culver City. The chase scenes were done in Los Angeles and up in the hills in California. He said it was easy to get guest stars because the show was such a big camp hit. He was studying acting, going to UCLA and tried out for the part along with thousands of others and claimed he was very lucky he got it. It took five days to make each episode and was very expensive to make. He never got a penny in residuals. "Everybody thinks there is so much money in residuals, and there can be if you made your shows after 1969 when the screen actors' guild said the actor must be paid forever. Until then we only got paid up to the tenth rerun, and it's only five percent of your salary." He said the producers were losing a quarter of a million dollars a week. "We had a lot of fun. We put on our tights to put on the world."

On the anniversary of the death of Lee Harvey Oswald, I called his mother and asked her if she still thought he was innocent of killing President Kennedy. Mrs. Oswald bitterly responded that she didn't like the way I phrased that question. "You're not questioning me, Marguerite Oswald, correctly. I know my son is innocent. I'm the underdog, so go ahead and do as you damn please with me," she said… and hung up. When the president was assassinated on November 22, 1963, I was at home taking a nap, getting rested up for my shift on the all-night show (midnight to 6:00 a.m.) when I heard my mother scream, "They killed the president!" I shot out of bed, got dressed and went into the station. I was there all night and most of the next few days, helping with press updates and playing classical music. A Top 40 radio station playing classical music had to be a first.

I was hung up on by the best of them. When I called veteran actress Ingrid Bergman to ask about her book, *Ingrid Bergman: My Story*, she told me to buy the book and read it myself. "I'm not going to stand here and tell you what's in it. Do you think I'm going to tell you my story over the phone…500 pages? Goodbye and good morning!"

The FCC ruling that on-air personalities had to tell people they were going to be on the air and then tell them they are on the air took a lot out of the live surprise phone calls. I woke Peter Falk up one morning live on the air. We talked about his rumpled raincoat he wore in the *Columbo* TV series. Got your raincoat on Peter? "No, it's too fragile." Then I asked him if he would record a voice track for my show saying "Hi, this is Peter Falk, Columbo on TV, listening to Bob Barry on WOKY." He mumbled, "You didn't get me up this time of the morning to do that? Talk to you later, Bob." Click.

When we had the pollution scare in the 1970s, people were complaining about the air quality and all of the dirt on their cars. I would call the CEOs at the factories and ask what they were doing to combat the problem. They didn't appreciate the calls and turned me in to the FCC, and I was told to stop immediately. My biggest disappointment with making phone calls came in 1975. A Supreme Court ruling said that a radio or television station couldn't call a person and put him or her on the air live. The court ruled that a live call is an invasion of the individual's privacy. I didn't like to have to ask for permission. I thought if you tell a person they are on the radio, they could say, "I don't want to be on the air" or hang up. The actual rule said I had to call them ahead of time and ask if they could go on the air live. Then before the interview I had to tell them they are going on the air live.

Donald Duck—OK, the voice of the duck, Clarence Nash—divulged how to talk like Donald. "First you need to think like a duck. Then put your tongue up to the left side of your mouth and vibrate it, but make sure you don't have any food in your mouth when you try this." (I know you're going to attempt this!)

Roy Rogers, whose real name was Leonard Slye, surprised me when he called me on May 12, 1977. I think he was promoting some state fair appearances that were coming up. He told me that his sidekick, Gabby Hayes, was straight as an arrow off camera. He wore tweeds and spoke perfect English. One time, he shaved off his beard and was so upset at the way he looked that he took his wife to Palm Springs, California, and they stayed there for six weeks until it grew back.

On October 4, 1969, Art Linkletter's twenty-year-old daughter, Diane, jumped out of a window on the sixth floor at the Shoreham Towers in West Hollywood, thinking that she could fly. It was called a suicide, but Linkletter said her death was the result of the manufacturers and sellers of LSD. I talked with Art in June 1970. He set up the Diane Linkletter Fund to educate people on the dangers of drugs. In talking about marijuana, he said, "It could be

safe to use, but you never know when it will trigger something more serious. There are three types of users: the curious who wonder what it would be like and try it, the rebels who are against the establishment and their parents, and the personality deficient who become potheads, really heavy users." He told me that his daughter graduated from smoking pot to LSD.

Birdo Charles, promptly at 6:25 a.m., picked up the phone in a booth on Fourth and Wisconsin Avenue, which I would call on a regular basis, and for five minutes or so he was a celebrity. It began as a onetime lark and became a regular feature. Birdo, on his way to work at Marquette Cement Company loading trucks with cement bags (at six feet, three inches he could handle it), had become an Ed McMahon of the phone booth, becoming my sidekick on the show for a few minutes each day. He gave away records and interviewed people walking down the avenue. One day, a sanitation truck pulled up, and the driver, Bob from Butler, admitted to us that pumping one thousand gallons of sludge a day was not his favorite job but he was stuck with it. John the barber from Menomonee Falls would also add his comments about the day's events. Birdo's talent included beeping out a small repertoire of tunes on the push button phone. Before the phone rang for the first time, Birdo's claim to fame was a stint with the West Allis Spartans football team, but he said he quit because his size 14 shoes kept getting him off side. He later was paid to appear in parades representing the station, but when he asked for more money, his radio career and parading days were over.

Jerry Wolfgram, a Lisbon, Wisconsin farmer, also called WOKY almost every morning at 6:40 from the barn while he was milking cows. He said the cows loved the music we played and produced a lot of milk, so they must have been content. He would often talk with Birdo Charles. They would talk city versus country and even attempted to see how many people they could get into a manure spreader to set a world record. We also staged a foot race between them at Fairview Park. It was not much of a competition because Birdo was in shape, loading heavy cement bags into trucks every day, and Jerry admitted that he was not in that great of shape.

Another listener who would call regularly was Lydia. She would have a quick quip and then hang up. Examples: "There is a girdle made from old automobile parts. They're calling it the Ford Foundation." Or "I had my bra and other unmentionables in the dryer at the laundromat and the guy next to me said, 'Do you mind changing places with me? Your machine is showing a much more exciting picture than mine.'"

Milton Pitts was the White House barber. He worked for President Nixon, Henry Kissinger and most of the Nixon cabinet. He said Richard Nixon's

hair was natural silver gray. He charged $7.50 for the cut and added that these guys were not the best tippers.

William (Fishbait) Miller was the guardian to many Washington, D.C. confidences as the House Doorkeeper for twenty-four years. He was the one who announced presidents to Congress: "Mr. Speaker, the President of the United States."

One time he locked up the entire House of Representatives in their chamber all night while they were debating. He told me, "I locked all the doors and everybody had to get permission to go to the bathroom, or to go down and have supper. And you know, I had a Republican member of Congress from Pennsylvania who had weak kidneys and he wet his pants twice before he could get permission quick enough." He said he got the name "fishbait" because he was a little kid.

I had an interesting conversation with Kenny Baker, the inside man for R2D2 in the 1977 film *Star Wars*. Baker said they filmed for about six months, and sometimes he had to be inside the robot for three hours at a time. "I could take the head off for a little air and there was a seat inside for resting, but otherwise I had to stand and rock the robot from side to side to get it to move." He loved the record "Short People" because he was only three feet, eight inches tall. He said he was taking it back to England to use in his cabaret act. He got a salary and bonus for his part in *Star Wars* while Alec Guinness, who played Obi-Wan Kenobi in the film, got a percentage of the profits and made $4 million.

Many times when a celebrity was promoting something their agent would call my producer to set up a time to call me. I answered the hotline one morning and heard the woman on the other end singing "I'm Wishing, I'm Wishing for the One I Love." Turned out to be Adriana Caselotti, the voice of Snow White, singing a tune from the classic children's film. She started on the film in 1934 and worked with the animation crew until shortly before the movie opened in December 1937. Adriana was paid the grand sum of $20 per session and earned a total of $975 over the three-year period. Of course, the film made, and is still making, lots of money.

Other times the celebrity's number or their agent's number would be listed in a newsletter that I subscribed to. My producer would then call that number and set up an interview. Most of the time the star was promoting something, and it took some real hard work to get the person to talk about something other than their cause. One such phone conversation was with Carroll O'Connor, who was promoting Save the Whales or some such thing. He told me that he was not at all like Archie Bunker in *All in the Family*. He

My interview with Muhammad Ali was going great until I asked him about his alleged draft evasion. Then he walked out on me.

said he (Carroll) doesn't even drink beer. He added that he makes more money than Archie and is not a bigot. He was discovered for the part while filming the movie *What Did You Do in the War Daddy?*. The show *All in the Family* was taped on Fridays in front of a live audience. One time they had to stop the tape because O'Connor wasn't wearing Archie's white socks.

On September 13, 1971, former heavyweight champion Muhammad Ali was in Milwaukee to watch his brother Rahman Ali box at the Milwaukee Auditorium. I caught up with the champ in the lobby of the Coach House Inn after the fight. He said there would be no way he would fight his brother or any other Muslim, no matter what the circumstances. He also said he'd beat Joe Frazier in their next meeting because he's not going to clown around as he did before. (Ali won their second fight by a unanimous decision in 1974.) He told me he earned more than $50 million boxing but only got to keep a small part of it. Taxes and some bad investments got a lot of his lucrative purses. When I asked him about how he avoided the military draft, he got up and walked out of the room. That was the end of that conversation! (In the 1960s, Ali had been arrested and found guilty on draft evasion charges. The U.S. Supreme Court overturned his conviction.)

Then there was the morning when Jimmy Carter called, yes, President Carter. I said, "No really, who is this?" It took a minute before I believed him, and we had a pleasant interview about his Habitat for Humanity program. And we talked no politics.

When actress Pamela Mason was promoting her film *My Wicked, Wicked Ways*, she threw me a curve when I asked her what wicked thing she was guilty of. Without hesitation she said "Adultery. I could be accused of adultery at various times, including with my first husband and with actor James Mason. In fact, I was having an affair with Mason while married to my first husband. I was married when I was sixteen to a cameraman who was nineteen. His first job after we were married was to photograph James Mason's first film. He took me onto the set and introduced me to James, and that was the end of my marriage to the camera guy."

Do you have one of those Incredible Hulk dolls? The guy who starred in the TV show never got one penny for the sale of the dolls. Lou Ferrigno told me that it was very unfair. Lou was teased when he was a kid for his speech impediment, so he took body-enhancing drugs to bulk up. He wanted to be recognized and feel important. And so he ended up as the star of *The Incredible Hulk*.

Actress Marlo Thomas, head of St. Jude's Hospital research center, which her father, Danny Thomas, started, told me she got married late in life because "marriage isn't fair." And even though she never married until Phil Donahue came along, she vowed she would not live without love. She lived with a man when she was single, and when her father would come to visit, it was something of a trauma for him. "He was like a man going to his execution," she said. "He wouldn't go into the bathroom for fear of seeing two of something, like robes or pajamas." Even though she didn't follow her dad's strict list of values, he never gave up on her.

The popcorn king Orville Redenbacher told me that popcorn is the oldest food item that we have in America. It's been around for over 4,600 years. He was raised on a farm in southern Indiana and graduated from Purdue University in 1928. In 1941, he started breeding hybrid popcorn seed to sell to processors throughout the United States. In 1971, they decided to give up on the competition and went into Chicago to hire a top marketing firm to develop a brand name for the popcorn. They didn't know anything about popcorn, so Orville sat down and talked to them for three hours. He told me, "A week later they came back with the name Orville Redenbacher, which coincidentally, was the same name my mother came up with seventy-one years ago. But they charged me $13,000 for it."

I talked to a Japanese kamikaze pilot who lived in California. He said he felt terrible. He was flying his plane toward a U.S. ship during World War II, trying to hit it, and he missed, crashing into the ocean. That ship rescued him. Talk about a great country. I wonder what his boss had to say.

Actor Robert Stack came from New York and didn't know how to drive a stick shift. He backed up over a camera and the director while playing Eliot Ness in *The Untouchables*. The TV show was shot on the set of *Gone with the Wind*, a California studio location. They made the back lot look like Chicago and blew it up on a regular basis. They couldn't shoot outside because of the TV antennas and new cars that were not of that era. Stack never thought the show would make it. He had some advice about acting. "If you have any question about being an actor, don't do it. It's got to be in your blood, and you'll know if it is."

Red Skelton was very proud to announce that he was among the first six inductees into the International Clown Hall of Fame in Delavan, Wisconsin. He told me that he was the only person inducted who was not a professional clown.

Baseball great Hank Aaron told me that every day every black person is always reminded that he's black. He received a lot of hate mail. It made him feel sad because there were so many sick people in the world. No matter what they said, his bat spoke for him. After he broke Babe Ruth's record, he was surprised that the Babe's wife avoided him. Hank admitted he does not work out, no exercise at all, but I noticed that he does watch his diet. I've had the opportunity to be with him at several baseball banquets I emceed in Milwaukee and fundraisers for his Chasing the Dream Foundation.

Gavin MacLeod said that he got his start in show biz on Mother's Day when he was four years old. He had the lead in the kindergarten play and had to kiss the leading lady. He put his arms around her and gave her a hug and her first kiss and then he felt a warm feeling that started in his shoes. Annette had wet her pants in his socks. He called it his baptism into show business.

Vaughn Meader had the number one album, *The First Family*, on the charts for forty-nine weeks in 1962. He did a political act on stage in the early '60s. One night he thought to himself, President Kennedy is a New Englander, and I'm from Maine, so that shouldn't be too difficult for me to do. He had other material that he did after the assassination, but he got a bad reaction because people still remembered the impressions of the president. He ended up telling stories and drinking way too much. Of course, all radio personalities, myself included, asked him to do President Kennedy on their show. He sounded exactly like him. Kennedy once said at a speech, "Vaughn Meader was busy tonight, so I came myself."

Freddie Prinze was a prince of a man. Too bad he left us way too early. He told me that the TV sitcom *Chico and the Man* started a whole new career

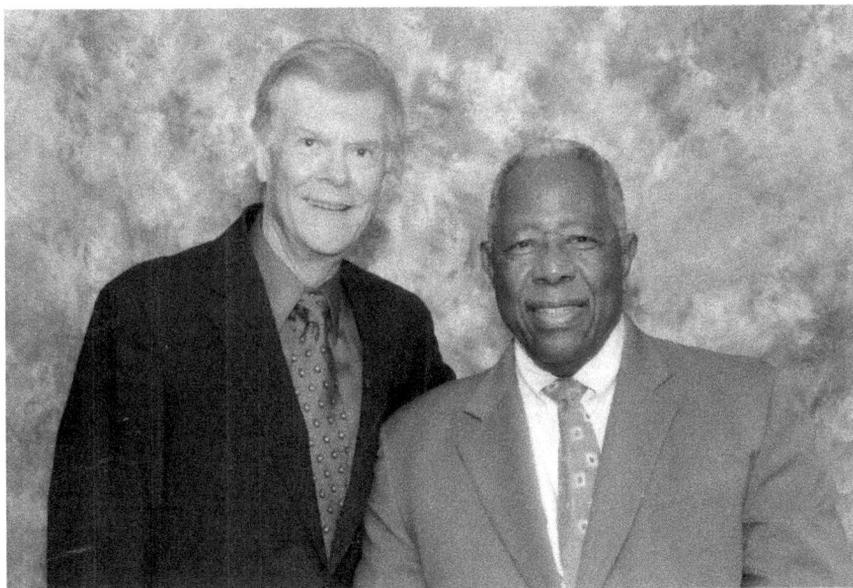

I will always believe that Hank Aaron is the true home run king.

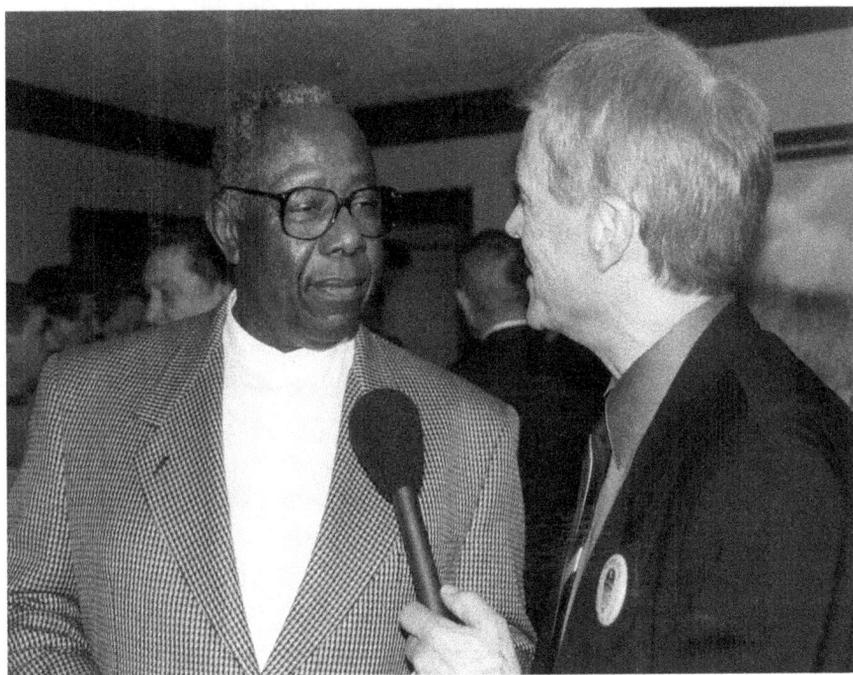

I was honored to interview the great Milwaukee Braves outfielder and slugger Hank Aaron.

for him. "Yeah," he said, "the last career I had the police weren't too happy about. But I ran well." Before that show, he did comedy in nightclubs, he danced off-Broadway and he wrote material for Johnny Carson, Jack Paar and Merv Griffin. He wrote all of his own material. He liked to play off real stuff. "At the zoo, the sign says 'Do not annoy the monkeys.' Why, are they busy? And why can't we feed them? Is there something in the bananas that's not good for them and would maybe ruin their lives?'" He said he studied ballet for four years. "In the ghetto, where I lived, it was not good to walk around with tights in your bag." When he did *West Side Story*, he was on Johnny Carson's show, and the producer of *Chico* saw him. That's how he got the job. Jack Albertson was his mentor. He taught Freddie dancing and how to deliver comedy lines, like, "Who was that blonde I saw you with last night?" "That was no blonde. That was my agent. He always walks that way." He didn't like being compared to Lenny Bruce, but he did like making $35,000 a week in Las Vegas. He suffered from depression, and a couple of years after I talked with him, he committed suicide by gunshot in 1977. He was only twenty-two years old.

I sat down for lunch with actor George C. Scott at the Vince Lombardi golf outing in Menomonee Falls. He was under the influence of a few cocktails when he told me he would not talk about the Oscar he turned down for Best Actor in the 1970 film *Patton*. He was the first actor to turn down the award.

Sophia Loren stopped by the WISN studio one day to promote her new perfume. I told her that my mother would not believe that I was sitting right next to her. She said, "That's what they all say." She wouldn't tell me why, but she always carries a small bag of salt with her. Her secret to beauty is being content with life. She goes to bed at 8:30 p.m. and gets up at 5:00 a.m. She told me, "I exercise fifteen minutes every day." One thing that impressed me was her size. She is nearly six feet tall.

Yakov Smirnoff decided to make his last name Smirnoff because Americans liked that vodka. He started as a stand-up comic in Russia when he was fifteen years old. It took him a long time to get out of Russia. His humor is a bit on the controversial side: "The Russians shot down that Korean plane in 1983 to impress Jodie Foster....It was a spy plane. They saw a lot of Oriental people pointing cameras out the window." He told me that a popular Russian perfume is "Evening in Prison."

It's a bird, it's a plane, it's Lois Lane. Noel Neill played Lane on TV's *Superman*. She said that she and George Reeves, who played the part of Clark Kent (Superman), did most of their own stunts. Only one time did they

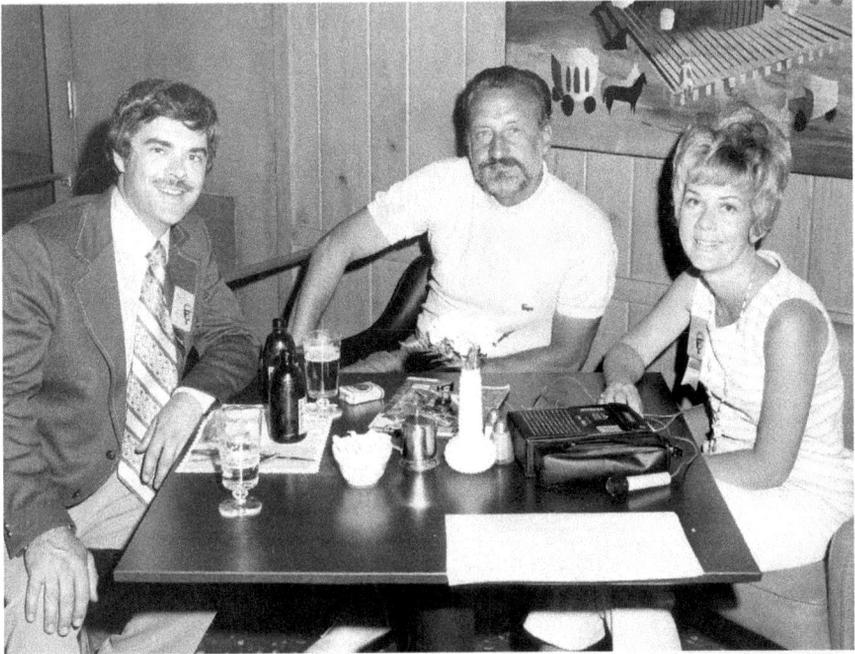

Here I am in my facial hair days with actor George C. Scott ("Patton") and my wife, Nancy.

have a problem. The wall that he was to crash through started to harden, so when he hit it, he got his hand and feet stuck and they had to shoot the scene over. They made $200 a show until they got a $25 raise. She said there was more money in westerns in those days. She doesn't understand why George Reeves committed suicide. They had just signed a contract for twenty-six more shows and a movie before he shot himself June 16, 1959, at age forty-five. He left no note.

Michael Caine told me he had to gain thirty-five pounds to do the film *Educating Rita*. He said it was easy to gain but oh so hard to take off. He didn't learn to drive a car until he was fifty. He said in England there is no place to park and they have a lot of public transportation, so he never found the need to drive over there. In the United States he needed to get around, so he took five lessons and passed the test. He told me that he loves to play alcoholics. He hated the critics who said actors are paid too much. When a film does well, the producers get $35 million and the actors responsible for its success get $5 or $10 million. I told him that was a nice paycheck. He said, "You're entitled to your opinion."

Is there a more beautiful woman in the world than Sophia Loren?

Leonard Nimoy, Mr. Spock on *Star Trek*, told me the makeup for his part took between two to five hours. They had scientific people working on the show, and they developed scripts that they felt could actually happen someday. They were ahead of their time!

Michael Reagan, President Reagan and Jane Wyman's adopted son, revealed what he remembered most about his dad was "the ranching and constantly building things at the ranch in Malibu for the twenty years he owned the land. What I remember most about my mother is that at one time she said to me, 'I build men; I don't build little boys.' And that's because I wanted a 10-speed bike. All my friends had 10-speed bikes. We lived in Beverly Hills, and why couldn't I have one. She said if I give you everything you want, and I have the money to do that with Mike, you're going to be forty years old and be a little boy. If you go out and you earn it and pay for it yourself, then you're going to be a forty-year-old *man*. That's what I remember most about her, and I haven't liked her since. I'd rather be a child." Michael became a successful syndicated talk-show host.

"Hey kids, what time is it?" Howdy Doody, Buffalo Bob Smith, came to TV on December 27, 1947, and ran for thirteen years and 2,543 shows through September 30, 1960. Bob told me that he was doing the morning show on NBC from 6:00 to 9:00 a.m. and also did a kid's radio show on Saturday mornings where he used a character called Howdy. NBC was looking for somebody to do a kids' show on TV and had a puppet show in mind, so they listened to his radio show and said, "This is good, let's make a puppet called Howdy Doody and let Smith host the whole thing." He and Howdy were co-emcees of the show, and Bob brought in his own puppets: Mr. Bluster, Dilly Dally, the Inspector and Flub-a-Dub. Bob prerecorded the voice of Howdy so he could interact with him.

Paul Tibbets was the pilot of the *Enola Gay* aircraft that dropped the atomic bomb on Hiroshima on August 6, 1945. He divulged that it was a routine flight and he was the only one who knew exactly what their mission was. During the flight, he told the crew members what they were going to do and that this mission would end the war. "We could see the city of Hiroshima as far as seventy miles away, so that gave us a lot of time to close in on it. We were quite busy with last-minute preparations of checking the weapon to make sure the batteries were charged and all the systems were go. The visibility was perfect. The bomb was a long tube thirty-six inches in diameter with a rounded nose and tail on it to give it guidance. It was sixteen feet long and weighed over nine thousand pounds. We wore welder-type glasses, and even though the sun was shining, we saw the brilliance of the flash. It looked like a boiling barrel of tar. We were not prepared for what we saw."

Ned Day, whose dad was the famous bowler, asked if I would do an interview with his wife, who was Miss Nude America at the time. I called her on the air, and she told me that she wanted to do the interview in person at the station and that she would appear in the nude. The *Journal* reported it, and there was an outrage from a lot of women. On the morning she was to appear, there was a snowstorm, and the interview was canceled. It was funny because she could have done the interview fully clothed, insinuating that she was nude, and who would have known. I mean, really? We're talking radio, folks!

When celebrities would come to town, they would stop at the station or I would go to them. Henny Youngman was here for an appearance at the Milwaukee Athletic Club in October 1969. He was doing that show for his friend Bob at Robert Block Advertising and his buddy Sid Stone, longtime Milwaukee cartoonist. I'll never forget it because my wife, Nancy, was at

St. Mary's Hospital with our newborn son, Rob, and I was at the La Joy Chinese restaurant on Lisbon and North Avenues with Youngman, Jane Morgan and record promoter Johnny Heidner. I expected Henny to be very funny, but he was not. He was very serious. Years later, when I talked with him on the phone, it was a different story. He told me that he started "dial a joke" in New York City. It brought in $80,000 in one month. I asked him to play his violin and give me a sample of the service. He said he only played his violin for revenge and didn't have time, and then he proceeded to rattle off what seemed like his entire joke list. He said, "Bob Barry wanted a facelift, but they couldn't do it for $75, so they lowered his body. Bob's been complaining about headaches. I told him, when you get out of bed, it's feet first. I solved the parking problem. I bought a parked car. Barry's got a great doctor. He gave him six months to live. He couldn't pay his bill, so he gave him another six months. Someone wanted to know what the latest dope on Wall Street was. I told them, Bob Barry."

There always seemed to be a Gregory Peck, Marie Osmond, Jonathan Winters or Hugh O'Brian in town, and I was given the opportunity to talk with them. They, of course, were promoting something. They wanted to be on the air to promote a book, movie, concert and many other things. I met many but never really knew any of them, with the exception of a handful.

Sharing a rare serious moment with comic genius Jonathan Winters.

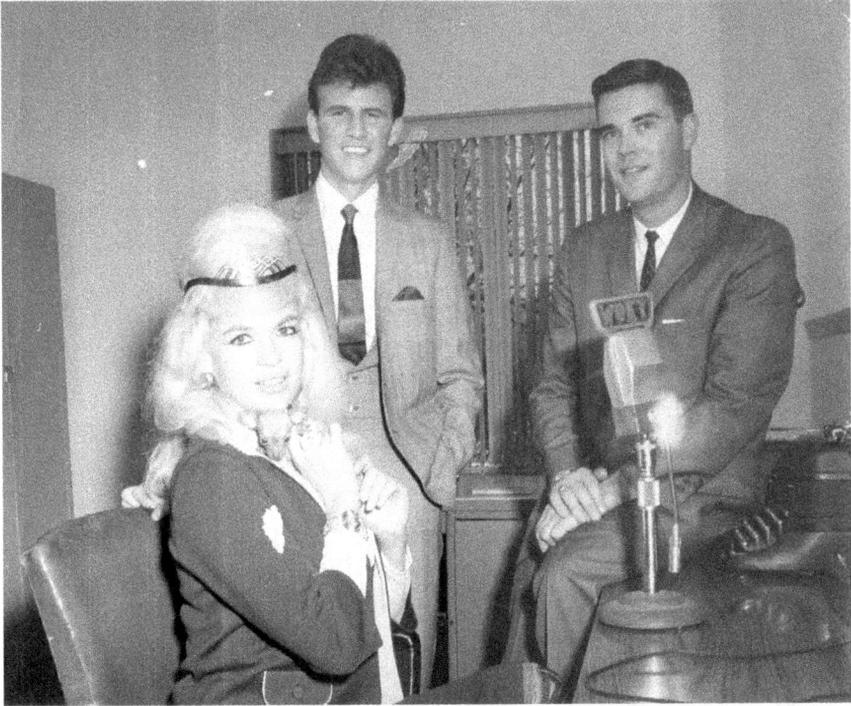

Glamorous film star Jayne Mansfield with her new puppy, and teen crush Bobby Rydell joined me in the WOKY studio.

Some who under no circumstances would do an on-air interview were Louise Lasser of the TV show *Mary Hartman, Mary Hartman*; Lee Majors, "The Bionic Man"; Johnny Carson; Carl Bernstein, coauthor of *All the President's Men*; and Robert Redford. They were very paranoid.

A prized possession was an interview with Jayne Mansfield in the studio at WOKY. Most people thought of her as a dumb blonde, but in the interview she came off as a very intelligent person, a sharp businesswoman. She died in a car accident in 1967. To my dismay, the tape of that interview was lost in a basement flood at our house in Sussex during the ice storm of 1976. I will always remember the little new puppy dog she brought with her. Cute but not yet house broken. The maître d' at the Pfister Hotel told me that the dog messed up the carpet in her room, and she refused to pay for the damages.

# THE GOOD, THE BAD AND THE UGLY MUSIC ARTISTS

Some celebrity musical artists are a pleasure to work with. They understand that you have a job to do and respond accordingly. They know that they are always in the public eye, but they come across as normal, down-to-earth people. Others, not so much.

My first live music celebrity interview was with Frankie Avalon at the Riverside Theatre in downtown Milwaukee. The audience, made up of mostly young girls, loved him, and he knew it. They were screaming like in the early days of Frank Sinatra's fame. I was invited to the show and to go backstage to meet him. The record promoter, and later a close friend of mine, Johnny Heidner, told me to bring a recorder along. I stayed up half the night thinking of what I was going to ask him. I even jotted down a few questions. I was really confident that this was going to be a great interview. When I got backstage, Frankie hurriedly shook my hand. I got the microphone out and told him I knew that he was in a hurry but I'd like to ask a couple of questions. I proceeded to ask about three questions, and I could tell in his face that he didn't want to be there. He finally said, "I don't have time for this now, kid," and walked out. I'm thinking that maybe this is not the business for the faint of heart. Years later, in a more cordial interview, Avalon told me that early in his career he was in New York for a recording session. The record company was looking for a different type of sound, so he came up with the gimmick of holding his nose while he sang. This is how "De De Dinah" became his first hit.

It might have been a foreshadowing of things to come when Karen Carpenter told me that she got very little sleep, ate the wrong foods and was under a lot of pressure from being on the road so much. Her brother Richard said that their squeaky-clean image was not what the press made it out to be. Karen added, "We like to do normal things, have a good time, and we enjoy what we do." Richard said, "President Carter said that he committed adultery in his mind, he's human, and I'm sure that many others have done the same but haven't admitted it." Karen surprised me when she said her favorite TV program was *The Gong Show*.

Sonny and Cher came into Milwaukee on the Big Bunny, Hugh Hefner's plane. I met them at the airport when they got off the plane. Cher immediately got into the limo, while Sonny graciously gave me an interview. After a few minutes, I told him I was going to talk with Cher.

He said, "I'm not too sure that's a good idea." I got into the back seat of the limo with Cher, but she was very aloof and refused to talk. I could see she was angry about something. A few days later I read in the *Enquirer* that they were splitting up. I never believed anything that tabloid reported, but it turned out to be true. They soon divorced. Months later, Cher got a bit testy with me on the phone when I asked her if it was true that she was breaking up with her husband, Gregg Allman, whom she had recently married. "I don't know," Cher said. I asked her why she didn't know. She said, "It's not that I don't know, it's just that it's none of your damn business." It was all downhill after that!

Sonny Bono told me that he never read music. He said, "I always wrote what I felt, and somehow the melody would come along. I can play seven chords on the piano, and I stay within the limit of seven chords. I had an elaborate system where I would code different chords with numbers, very primitive."

Chubby Checker remembered in 1955 when he went to see Frankie Lymon, the Platters and a group called Hank Ballard and the Midnighters. Hank wrote the song "The Twist." It wasn't until 1960 that Chubby and his brother made up a dance to that song, and it turned out to be the biggest record for Chubby. He also told me that he jogs ten miles whenever possible, even when he is on tour. He would rent a cab and tell the driver to take him ten miles out of town, and then he would jog back to his hotel.

Nancy Sinatra said her producer, Lee Hazelwood, wrote the song "These Boots Were Made for Walking." He said he didn't want her to record it because it was a man's song. She said, "No way, it's cruel if a man sings it, and it's funny if a girl sings it." It took months to convince him. She said that just the instrumental with that unusual bass would have been a hit. The song "Something Stupid" was brought to her dad's attention. The head of the record company told Frank Sinatra not to record it. Frank said, "I bet you two bucks it will be a top 10 hit." Nancy still has the bill framed from the headman of Reprise Records. The DJs called it the incest song because a father and daughter recorded it. Frank and Nancy thought that was hysterical.

In the early '60s, Andy Williams was appearing at the Holiday House in downtown Milwaukee when in the middle of singing one of his many gold records, the microphone went out. He threw the microphone down on the floor and continued to do a very short performance without the sound system. His anger could have fired up an average-size home. He was a very unhappy camper and left a lasting impression on this audience member.

Not a good way to impress the press. You can be sure all of the media in attendance talked about it on the air the next day.

Johnny Mathis told me that most of his big hits, like "Chances Are," "Misty" and "It's Not for Me to Say," were written for him, and many were channeled to him through Mitch Miller, who was a very important artist and repertoire man in the days when he was growing up. "He had a lot of say so as to who got what songs." He was not one for publicity: "When the music stops, that's all that interests me. I don't like the social aspect of the business and it's been a constant source of irritation for me throughout my career. I do have a very social life, but it's all very private, which I think is as it should be." I wonder how many couples fell in love to his music.

In 1966, when the Hollies, from Manchester, England, came to Wisconsin, I emceed their appearance at Carthage College in Kenosha. The following night, they were scheduled to appear at Devine's Ballroom at the Eagles Club in Milwaukee, but the show was canceled. Graham Nash told me that their booking agents didn't clear the concert with U.S. Immigration. They didn't give the authorities enough notice. "We could have done the show, but it would have violated our status in America and we could have been deported." They went through the next day and were cleared for future appearances in the USA. When I talked with them at the Immigration Office, Graham Nash, Tony Hicks, Allen Clarke and Eric Haydock were there. Allen told me that Eric got the group started in 1962. It was during the Christmas holidays, and that's how they came up with the name the Hollies. Tony said that their unique sound just came to them; they didn't work on it at all. You can view the outtakes from my TV interview with them online by searching "Hollies Milwaukee Interview."

All of the British groups came through Milwaukee, including Freddie and the Dreamers. Freddie said his lady friend thought they were a bunch of dreamers, so that's how they arrived at the name. They started cracking jokes and jumping around in the dressing room before shows and decided to do it onstage. I asked if there were any squabbles within the group. Freddie said, "Squaws? No, there are no Indians in the group." They told me to do their "Freddie Dance" and maybe I could get my weight down a bit. I made the mistake of asking for some British humor. I got "My uncle has no nose. How does he smell? Terrible." Outtakes from that TV interview are on a DVD.

Dave Clark of the DC5 told me they started out by writing all of their own songs. They had been performing and recording others' material as they were directed to do. Dave decided it was time they do their own stuff,

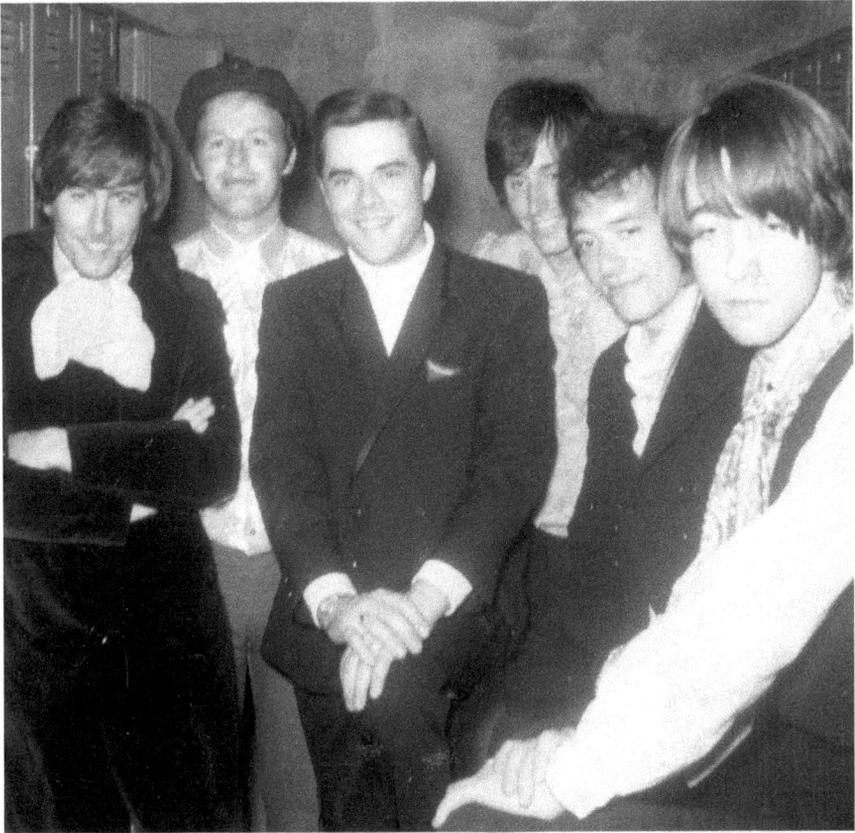

I spent some time relaxing backstage with Graham Nash (*far left*) and the Hollies.

and that's when they recorded "Glad All Over." When performing live, a part in the song called for stomping on the floor. He would have someone turn the lights off and on to that boom-boom beat. This added excitement to the live shows. Dave insisted on doing only a couple of takes when recording. If that didn't work, they would take time out for a couple of pints of ale and then continue recording. A Milwaukee producer, Jon Hall, did the same thing with his groups, and some of his best productions came after some shots of whiskey and a couple beers. I also have outtakes from that DC5 television interview and other British acts on DVD. Some of my celebrity interviews are housed in the Wisconsin Broadcasters Hall of Fame and at the Wisconsin Historical Society.

I had the pleasure of interviewing Bobby Vinton many times on the phone from his home in Los Angeles and in person when he would come

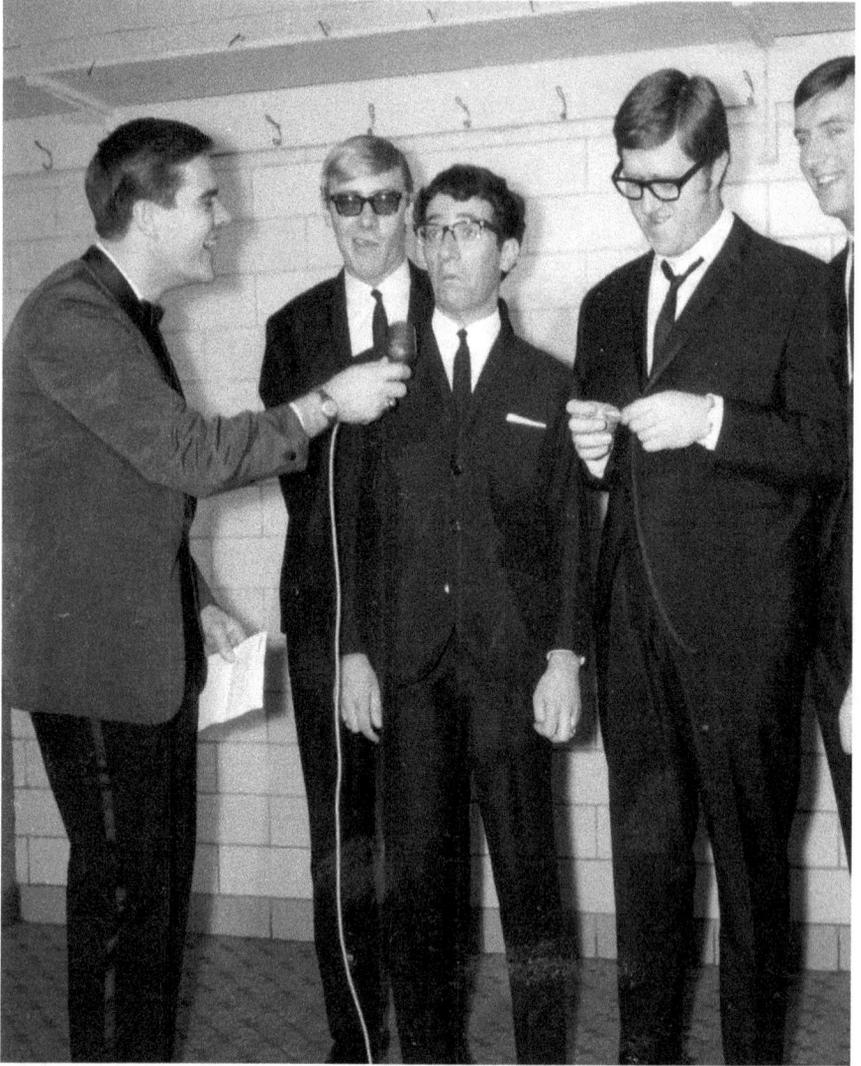

Freddie and the Dreamers, part of the British Invasion, shared one of their corny English jokes with me.

to Milwaukee and stop at the WOKY studios. He gave our station credit for breaking his record "There I've Said It Again" in the Midwest. He had tried everything, and nothing was happening in his recording career. "What I need is a gimmick....Maybe if I recorded an old love song that would be a bigger gimmick than the gimmick records that are out today." His hunch was right, and he had the second-biggest hit of his very successful career.

Al Martino told me that he made more money for the TV showing of *The Godfather* than he did for the making of the movie. "They need to go according to the Screen Actors Guild code. You were paid for the part that you had. If you have a feature part, then you're paid for the featured participation, but if you have a bit part, you're paid less. If you're the star, you're really paid well!" He told me that some of the Italian Mafiosi were not pleased with him playing the part of singer Johnny Fontane, who was viewed as a representation of singer Frank Sinatra. He said he never got any big gigs after that. He ended up singing on cruise ships and at Indian casinos.

I had to call singer/actor Robert Goulet back because he was watching, before DVRs, his favorite TV show, *Family Feud*. "People don't dare call me when it's on the air, long distance, whatever," he said. "I just say, call me back." I got a call one morning that said, 'Robert, Richard is on the phone.' I said, "Richard who?" He said 'Richard Dawson.' I said, 'Dickey, you're insane, you call me when I'm watching my favorite show.' He said, 'What show is that?' I said, 'Yours.'" In 1965, he was invited to sing the National Anthem ringside at the Ali-Liston fight. They told him he would need to sing it if he wanted tickets for the fight. He did, but he messed up the words, singing "dawn's early night" instead of "dawn's early light." He said, "I was so nervous with an audience full of celebrities, including Joe Louis, Rocky Marciano, Sugar Ray Robinson and the governor of Maine. The only other time I was that nervous was when I was a guest on my favorite show, *Family Feud*."

I happily cornered Dolly Parton backstage at the Grand Ole Opry in Nashville in 1977. I was invited by Channel 18 to preview a new country TV show. She admitted that she is a natural blond but wears the big wigs to cut down on the time she would need to do her hair. Her husband is not her biggest fan. He likes some other female singers better. He also likes rock 'n 'roll and bluegrass better than country music. She quipped, "He loves me but would not buy a Dolly Parton record if they didn't come to the house for free." Their house is in Nashville, which she loves, and she also has homes in New York and Los Angeles.

Carol Bushman, of the singing group the Chordettes, was from Sheboygan, Wisconsin. The record "Mr. Sandman" sold over two million copies. She told me that the male voice on the song was Archie Bleyer. They were on Arthur Godfrey's *Talent Scout* show on radio and TV and were the first entertainers on Dick Clark's *American Bandstand*.

Johnny Marks wrote "Rudolph the Red-Nosed Reindeer." He said the first time he took the song to RCA records, they told him he had to be

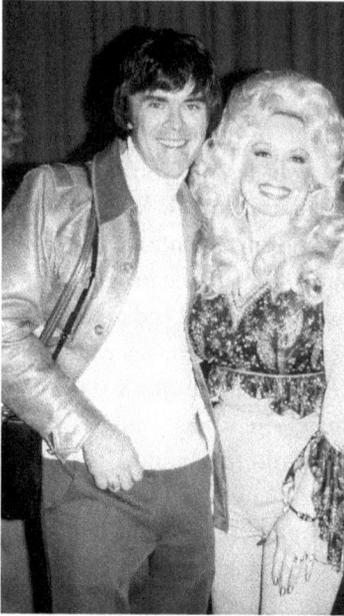

Dolly Parton talked with me about her greatest hits. You can fill in your own caption on this one.

kidding. "A reindeer making history? Do you think you're talking about Winston Churchill?" The man who recorded the famous holiday hit was Gene Autry. Gene told me that he didn't like the song either. His wife talked him into recording it.

Tom Jones had a group in London called Tom Scott and the Senators. His full name was Thomas Jones Woodward. The hit movie *Tom Jones* was out at that time, so he decided to drop Woodward. He started singing in school and pubs. He went to London to record "It's Not Unusual." He mentioned on a TV show that he would love a Paul Anka song, so Paul wrote "She's a Lady" and sent it to him. Burt Bacharach liked Tom's singing voice and asked if he would record "What's New Pussycat?" for a movie. Jones responded, "That's not the type of song that I should do." It was a crazy song for a crazy movie. Burt wrote the song for Lonnie Donegan, but he said he wouldn't do it justice. That's when Burt asked Tom to cut it. Tom said it was great to be in London when all the big groups were hanging out there—the Beatles, the Stones, the Who. His most embarrassing moment was when a woman walked into the men's room to get his autograph. Yes, he was at the urinal.

I told Liberace that I tried to claim some dress clothes that I wore for personal appearances on my income tax and they told me that only Liberace could do that. Liberace told me that the IRS challenged him, so he wore one of his outlandish costumes to a hearing. They quickly allowed the deduction.

Donny Osmond graciously talked with a thirteen-year-old WOKY listener, Wendy Quant, on the air by telephone. Wendy took over the interview and said that Donny's voice was starting to change. Donny admitted that it sounded very squeaky. In reply to how they got started, he said his brothers sang on the streets of Disneyland and were discovered. But this was before he was born. He said his favorite groups were the Carpenters and Bread. This was in 1972, and his record "Puppy Love" was a hit. Donny and his brother Jimmy also called Stephanie Haas, who was in a Milwaukee hospital. They talked with her for over half an hour, making her day. Another time,

I recorded an interview with Donny and Marie from my home, and they talked with my two children for a few minutes. Talk about excited kids! After that they were imitating them, singing, "I'm a little bit country, I'm a little bit rock and roll."

I interviewed Les Paul, congratulating him on his induction into the Rock and Roll Hall of Fame. He was inducted for his invention of the electric guitar and the eight-track tape recorder. Les was born Lester Polsfuss in Waukesha, Wisconsin. He and his wife, Mary Ford, born Colleen Summers, also in Waukesha, produced two hits in the '50s, "How High the Moon" and "Vaya con Dios." Paul told me that he worked for WGN radio in Chicago for a short time. He was fired after he told the audience that he was going to take a break for the news. Then he put the microphone down next to the Teletype machine and said, "And now let's have fifteen minutes of news." Management was not amused at the tick of the Teletype for a quarter of an hour. One night, when Les was in Milwaukee, Jim Patterson, the owner of Solid Gold McDonald's, invited Nancy and me to have dinner with him. He told some wild stories about how the mafia would dictate where and when he and his wife would appear in Las Vegas. He said most of the time he didn't argue with them. He told me that when he was a kid, his mother would wake him up early in the morning. He would get dressed and go down to the corner bar, get a bucket of beer and bring it home for her breakfast. When his mom was in the nursing home, she whispered in his ear what she wouldn't give for a beer. He had to write out a prescription, and his mom got two cans of beer a day. One day she heard him on the radio and told him he sounded like all the other guitar players. That comment motivated him to be different. He loved to tell corny jokes: "Do you know what they call nuns who walk in their sleep? Roman [roaming] Catholics." One morning I was talking about Les Paul and mentioned that he was seventy-six years old. The phone rang seconds later, and it was Mrs. Polsfuss, Les's mother, in Waukesha. She said, "Les isn't seventy-six, he's sixty-eight, and he would really be upset if he knew you added years to his age." (A permanent exhibit to honor Les Paul is housed at the Waukesha County Museum.)

Rosemary Clooney divulged that Mitch Miller found a song called "Come on-a My House," and he asked her to record it. She didn't want to do it. She thought she could sing ballads a lot better, so she declined, but Mitch said, "You had better show up tomorrow morning at nine or maybe you won't be recording for Columbia Records anymore." It turned out to be her first hit record.

My mom was excited to meet Les Paul. He had her in stitches.

Joe Terranova, aka Terry (from Danny and the Juniors), told me that in high school the group was originally called the Juvenaires, but they were juniors in school and changed the name to Juniors. He said, "Kids in the '50s wanted to get a hit record to impress their friends. It was an ego trip." Their first single in 1957 was called "Do the Bop," after a hit dance at the time. Dick Clark suggested they change the title to "At the Hop." Joe said, "That record and a lot of other hits of the time would never have made it without *American Bandstand*."

George Shearing said he learned to live with blindness and would turn down any chance to see because he was able to live with blindness and the reeducation would be traumatic. He would never consent to an operation. Some people never noticed that he was blind. In a restaurant, a waitress

trying to pass him knocked her tray against him. She said, "What are you, blind or something?" He said, "Yes, as a matter of fact, I am." She was most embarrassed. A listener called in and asked Shearing if he had been blind all his life. George said, "Not yet."

Singer, actress and songwriter Peggy Lee was a most gracious interview. She played an alcoholic blues singer in *Pete Kelly's Blues*. She found it to be a very depressing role: "Along the way I've seen singers like that who didn't know how to handle fame and had alcohol problems. I sort of patterned my role after them. I always felt very sad for them because they probably started to drink because they were looking for something more to life and didn't know how to get it." She said singing while drunk was a very difficult thing to do. They had to prerecord it, and she had to put it all in sync. "Trying to sing out of tune and staggering around was hard to do." They offered her something to drink, but she turned it down because she said, "How would I know if I was acting or not?" Peggy's biggest hit was "Fever." Writers Jerry Leiber and Mike Stoller brought the song "Is That All There Is?" to her, and she liked it because "it was like a riddle and it could be a comedy or a tragedy." It became her first Top 40 hit since "Fever" eleven years earlier and earned Peggy a Grammy.

Elton John said he was an errand boy who answered a newspaper ad looking for young, exciting songwriters. Lyricist Bernie Taupin answered the same ad. Elton collaborated with Bernie Taupin to write "Your Song" for Bernie's girlfriend. He looks for a hook before he writes a song, and it usually takes about a half hour. Elton told me that he got his early influence from Jerry Lee Lewis. His elaborate rose-colored glasses and costumes cost thousands of dollars. Elton asked me, "When you first heard 'Crocodile Rock' [his first number-one hit], could you tell I was having a good time?"

Paul Anka told me that he wrote "My Way" for Frank Sinatra because it fit his age at the time and would not have sounded right if he recorded it himself. He wrote "She's a Lady" for Tom Jones because the rhythm and the lyrics were Tom's style. Of all his songs, the most performed was the "Tonight Show Theme." Paul said "Diana" was his biggest hit, and "Put Your Head on My Shoulder" was "my most important record." He felt the song was the turning point in his career. He had been writing teenage songs up until this time, and with this hit, he was acknowledged by an older audience.

Bobby Vee's producer was Snuff Garret. Snuff was nineteen and Bobby fifteen when they began their collaboration. Garret would go to New York City to find songs, and they would decide which ones Bobby would record.

Elton John was one of the many top-notch performers invited to the Playboy Mansion in Chicago.

He said without today's technology they were hard-pressed to do the string lines on "Rubber Ball" and "Take Good Care of My Baby." Bobby filled in for Buddy Holly (and the Crickets) the night Buddy, Richie Valens and the Big Bopper were killed in a plane crash. Vee continued to work with the Crickets in the early '60s. Bobby's biggest hit, selling 2.5 million records, was "Come Back When You Grow Up." He felt confident that a song written by Carole King, "Take Good Care of My Baby," would be a number-one record. It was not only number one but also a gold record, having sold over a million copies.

I caught up with Rick Zehringer of the McCoys at the Office of the National Academy of Recording Artists and Sciences. He was a New York governor and U.S. Trustee for the organization. They were going over last-

The McCoys scored a number-one record with "Hang On Sloopy" in 1965.

minute details before the Grammy nominations were announced. He told me that he did the soundtracks for the films *Where the Boys Are* and *Bachelor Party*. The group was not originally called the McCoys when there were just two of them, and then they went through several names, including Rick and the Raiders. There were a lot of Raiders in the United States, so they were going through a bunch of old pictures and one had McCoys on the bass drum head. They thought it sounded American and original. He said working with the McCoys was like a hobby that became his job. Rick told me right after the record "Hang on Sloopy" came out, it was made the state rock song of Ohio. The song was a hit the year before by a group called the Vibrations. It was number one on the R&B charts. The record company president was the writer of the song, and he said if he got a bunch of guys who look like the Beatles to do this song, it's probably going to be number one. The McCoys looked to him like that group. Rick said that Randy Hobbs and brother Randy Zehringer were still in high school, and their manager had to work hard to keep them in line so they would get their schoolwork done.

I talked to Jim Pike after the Lettermen broke up, and he told me I could say Jim Pike of the Lettermen, not with the Lettermen, or he could be sued. The Lettermen had their first hit, "The Way You Look Tonight," in 1961. The Four Freshmen influenced them. They took the Freshmen style and put it into a contemporary sound of that time. Their second hit was "When I Fall in Love," which sounded a lot like their first record, and that idea resulted in an automatic hit. They wanted to try something different in their concert shows, so they put a medley together of "Going Out of My Head" and "Can't Take My Eyes off of You." Then they put the live show on an album, and those songs were so often requested that the medley became a hit single. Jim lost his voice for over ten years. He couldn't talk or sing and had to write notes to his wife. The doctor said he would never talk or sing again. He kept fighting and finally got his voice back.

Gary Puckett told me that the group disbanded in 1971. They came up with the name Union Gap, and the record company put his name in front because the records sounded more like a singer with a band behind him. It was fortunate for him because he said it gave him some personal recognition. I asked if Puckett was his real name. He asked, "Really? Would I change it to Puckett?" He was fascinated with the Civil War, and he grew up near Union Gap, Washington, so his band all dressed in Union army–style uniforms. After his first hit, "Woman, Woman," Gary and their producer decided that ladies would be the direction they would go in, so they came up with "Young Girl," "Lady Willpower" and "This Girl Is a Woman Now." Those ladies were good to him. They helped him sell millions of records.

Paul Revere (and the Raiders) had a '60s club in Reno, Nevada, that he owned with Bill Medley of the Righteous Brothers. It came about that they were playing at the Frontier Hotel in Las Vegas with the Righteous Brothers when Bill recorded "I've Had the Time of My Life" for a movie. Bill told him it was a stupid movie called *Dirty Dancing* that would never amount to anything. The movie, of course, became a monster and the song a big hit, to Bill's complete surprise. The club in Reno was named for one of the Raiders' hits, "Kicks." He said, "That song was probably one of the first where the lyrics were saying something other than 'the moon is blue and I love you' or 'you don't love me and I'm gonna kill myself.' It was not related to a love story of any kind. It was a message song about E, an anti-drug song and the first song of its kind to come out with any kind of a statement. It ended up getting an award for being an anti-drug song." He said that their biggest hit was "Indian Reservation" in 1971. When they released it, nobody would play it, Paul said, so "I went clear across the country on a motorcycle

Paul Revere (*second from right*) and the Raiders were just having fun at a sold-out concert in Milwaukee.

with a friend of mine. Two bikes. We went easy riding, stopping at every radio station along the way. It took three months, and I finally got enough friends to play the record on the radio and eventually it took off and became the number-one record in July of 1971, selling three million copies." John D. Loudermilk wrote the song and recorded it on an album about ten years before the Raiders recorded it.

Gene Pitney wrote "He's a Rebel," which was made a hit by the Crystals and was a copywriter's nightmare because so many artists have recorded it. He also wrote "Hello Mary Lou" by Rick Nelson and "Red Rubber Ball" by Bobby Vee. He had a free ride with Roy Orbison with a song called "Today's Teardrops," which was the B-side of "Blue Angel." That's when he found out that you get paid the same money for the backside of a record as you do for the front. "You don't get performance money like on the A side, but as far as records sold, it's the same thing." He told me,

> *I still get calls from people who watch the movie* The Man Who Shot Liberty Valance *and they stay up and watch the whole thing to the end, waiting for the song and it never comes on. They call and say what happened? They took the song out of the movie. The song was never put in the movie. It was a bureaucratic mistake. After having success with "A Town without Pity," all kinds of offers came in to do motion picture themes.*

*Burt Bacharach and Hal David wrote the song, which was terrific, and the film had John Wayne, Jimmy Stewart and Lee Marvin for a cast. It was directed by John Ford and had all the ingredients. Paramount Pictures paid me a whole lot of money to do it. While we were in the studio recording the song, we found out that they had already released the picture. Bacharach couldn't believe it. And then I found out that the score they used was from a Henry Fonda film called* Young Mister Lincoln.... *Why they did that I have no idea.*

Gene was sixty-six when he died unexpectedly on April 5, 2006, in a Cardiff, Wales hotel room. He was on tour. The final song of his concert, "Town without Pity," got a standing ovation

When I was doing the *Early Show* on WITI-TV in the '60s, Brenda Lee stopped by for a few minutes. She told me that she had been recording cute songs until she wrote her big hit, "I'm Sorry." "The record company was hesitant to let me do a love song at my age, but I finally talked them into it at the end of a recording session. We had only five minutes left in the session, so they came up with a quick arrangement and I recorded it." The song turned out to be her biggest hit.

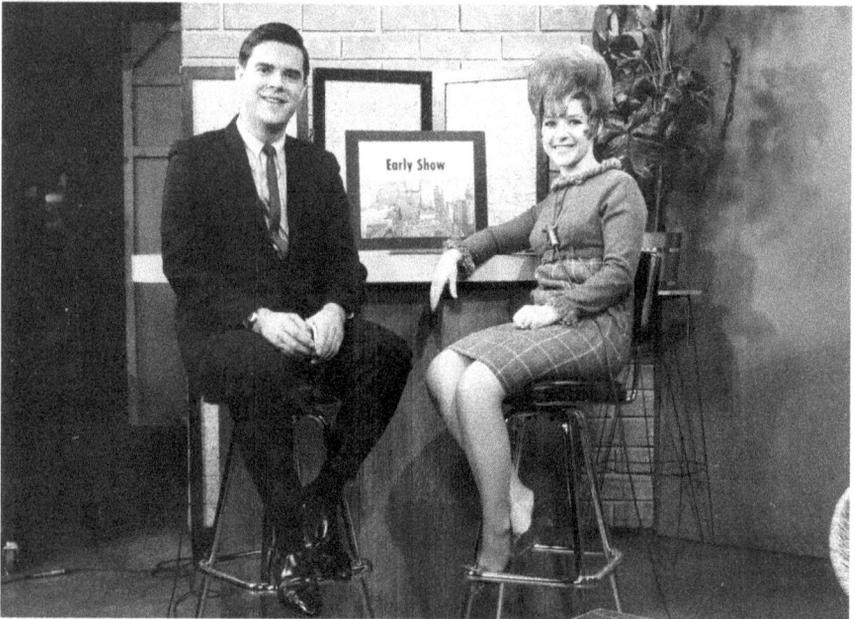

Brenda Lee gave my TV audience some "Sweet Nothings."

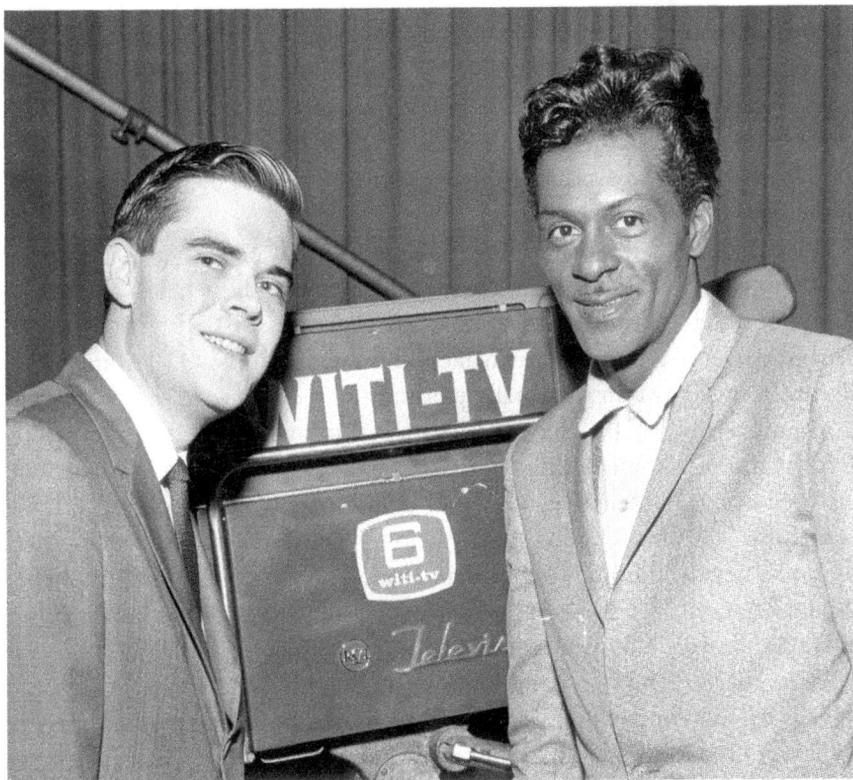

Music legend Chuck Berry appeared as a guest on my *Early Show* on WITI-TV6.

Del Shannon, real name Charles Westover, said he got his stage name from the Deville Cadillac, and Shannon came from a wrestler who used to come into the HILO Club in Battle Creek, Michigan, when he was working there. His name was Mark Shannon, and Del thought that would be a great name. His song "Runaway" was not only a big hit for him but was used in the *Crime Story* TV series and a Tom Cruise movie as well. He came up with the music for the song one night on stage in Battle Creek, and the next day he wrote the words. Then Max Cook came up with the great synthesizer solo, so he gave him half the song. Del suffered from depression and took his own life on February 8, 1990.

Neil Sedaka corrected me when I mentioned that "Oh Carol" was written for Carole King and was his first hit. "I hate to differ, but the first one was 'The Diary' in 1958. It went to number 18 and I consider that a hit." He said he was a real nerd in school who loved classical music. He finally turned

to pop songs, and then and only then did he become a class favorite. He was one of the first to use overdubbing, singing along with himself on another track. Neil came up with the title first for his hit "Breaking Up Is Hard to Do." When he wrote the song, he knew it would be a hit even though a few top DJs thought it was a dud. It hit the charts at no. 62, then 26, 10 and up to the no. 1 spot within a month.

Brian Wilson of the Beach Boys confessed that it took about six months of studio work, with endless overdubs, to come up with their big hit "Good Vibrations." He said that they started the group in 1961 with his brothers Carl and Dennis, their cousin Mike Love and neighbor Al Jardine. The album *Pet Sounds* was his personal favorite work.

Maurice Gibb of the Bee Gees surprised me when he said they wrote "How Can You Mend a Broken Heart" with Andy Williams in mind, but they recorded it themselves and had a huge hit. They wrote "To Love Somebody" for Otis Redding shortly before he died in a plane crash in Lake Monona, near Madison, Wisconsin, in 1967. The song also became a big hit for the Bee Gees. They would do the song on stage with Otis in mind. Barry did an impersonation of him doing the song.

Johnny Rivers was in a band in junior high school and had a lot of local success. He had no big popularity until he moved to California and opened Whisky a Go Go in 1964. He told me that in the late '50s, Alan Freed got him his first recording deal and thought his name (Ramistella) was too long to remember. He was just a kid then, so Freed talked him into changing it. He heard Johnny talk about where he grew up in Baton Rouge, Louisiana, on the Mississippi River, and that's how his last name came about. I asked him for an interesting story about one of his songs, and he told me "Poor Side of Town"

> *was a real departure from what I had been doing prior to that, with the live audience participation thing, like "Secret Agent Man," "Memphis," and "Midnight Special." Those were recorded at the Whisky a Go Go. So this song was really different, with strings and background vocals. It was a ballad and a real gamble. The record company said you've got a good thing going, why change it? It could ruin your career. But Lou Adler and I thought it was time to try something new, and it was a success overnight and I was happy it worked.*

Guitarist Dick Peterson from the group the Kingsmen told me they recorded "Louie Louie" after the song had been around for a few years.

They pooled all of their money, went into a studio and recorded the hit in one hour. It took about six months for the record to start climbing on the charts. It became number one on the *Billboard* Top 100 on December 14, 1963. Some radio stations in the United States banned the record, saying it had obscenities in the lyrics. This was never proven. My former producer, Skip Taylor, has a translation that would be banned in Boston.

The Everly Brothers started as the Everly Family with their mom and dad. They did religious and country music duets. Then they started recording. They recorded "Bye Bye Love" in 1957, their first hit. Someone brought it to them, they tried it and it sounded good, so they decided to cut it. Elvis Presley and twenty-five other artists turned the song down. It was a country tune, but the record company sent it to rock stations by mistake and that started their string of hits. They described their music "like a quilt, a mixture of pop, R&B, country, and folk." Don told me that the secret of getting along with brother Phil was that they never roomed together. I saw the guys twice in my career, once at the WOKY studios and another time Bill Taylor and I emceed their concert at Marty Zivko's Ballroom in Hartford, Wisconsin.

I asked Dean Torrence from Jan and Dean which record was their biggest hit. He said, "You mean the one we got paid for? The record

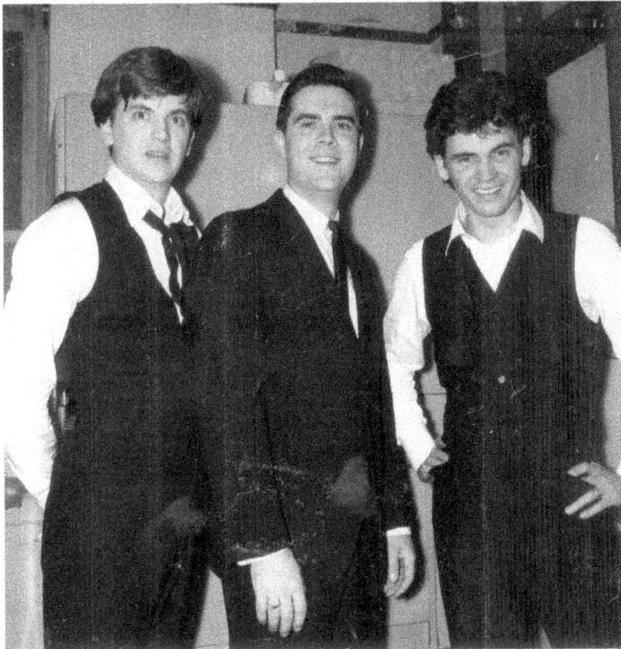

Don and Phil Everly, the Everly Brothers, had a long string of hits in the 1950s and '60s.

companies paid you whatever they felt like paying in those days, and who knows how they came up with the accounting? If you're talking about chart records, the one that seemed to be highest on everybody's chart was 'Surf City'." Their hit "Deadman's Curve" was ironic because Jan had an accident very close to where the song mentions, within two miles, at Whittier Drive and Sunset Boulevard. He said it was eerie. Another one of their hits came about one day when they saw an elderly lady on a local Southern California Dodge dealer TV commercial. This little old person was pictured in a super-stock race car. She would race all the kids, even cops, and ditch them. At the end of the commercial, she would come screeching up to the camera, roll down the window, look the camera right in the eye and say, "Put a Dodge in your garage, honey." So they decided to write a song with a senior citizen in a souped-up car that would be funny. The song "Little Old Lady from Pasadena" became a hit for them. They hooked up with that little old lady for a couple of years, and she came to concerts and even posed for their album cover.

In a conversation with Louie Armstrong backstage at the Milwaukee Auditorium, Louie told me that he had several tunes on a list that were possibilities for an album. One of the songs was "Hello Dolly." He had never heard of the Broadway show. They decided to try it with a beat to make it sound like his type of tune. It ended up on the LP and turned out to be a hit single. He said, "It was a very unexpected hit."

Peter Noone of Herman's Hermits, whom I interviewed in his Pfister Hotel room, said the group's name came from a British TV show character called Sherman on *The Bullwinkle Show*. They changed the Sherman to Herman and added Hermits. He said, "The reason for our popularity at the time was our new ideas, new sound, and we looked sharp on stage." Their records got played a lot more in the United States than they did in England. The only complaint he had about our country was that Americans didn't understand the British humor. One of their first hits, "Henry the Eighth," written in the early 1900s, was popular in the States, so they thought if it's that cute sound they like, we'll do more. That song took three minutes to record, but the tag on the end took a couple hours. Their first LP took three hours to record. The producer told them that they needed one more tune to complete the album. They told him about a Tom Courtenay song called "Mrs. Brown, You've Got a Lovely Daughter." He said, "Let's hear it." They sang it for him and he told them, "OK, we're done." He had been recording the song as they played it for him, and that's the way it ended up on the album.

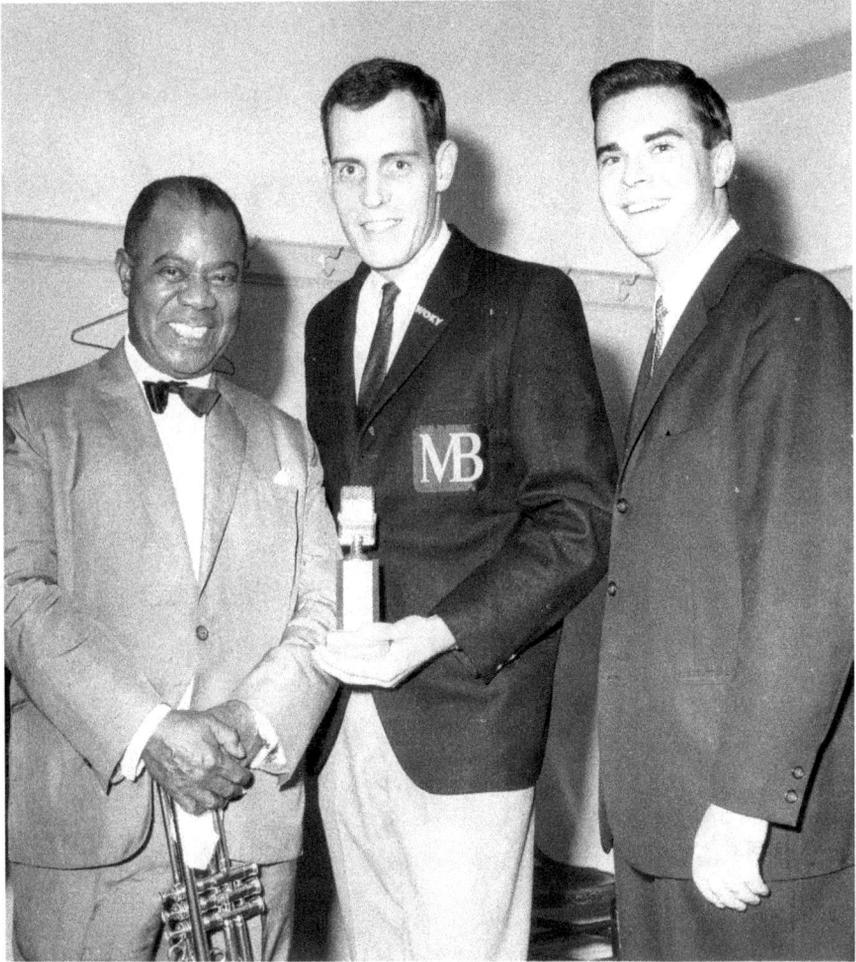

Steve O'Shea and I had the privilege of presenting the WOKY Golden Microphone to gravel-voiced trumpeter Louie Armstrong.

On November 9, 1964, I sat down with Mick Jagger of the Rolling Stones at the Coach House Inn, the same place the Beatles had stayed just two months earlier. He told me that they started in 1962 and met at a jazz concert in London. They needed a name quickly for the group. Rolling Stones came from a blues song called "Rolling Stone Blues." "We thought that's a good name for the group, so we called it that." Mick said they always preferred rhythm and blues music to all others. He said that long hair is no big deal in England, that's the way they wear it—just like the crew cut was popular in the United States. He said he learned to play

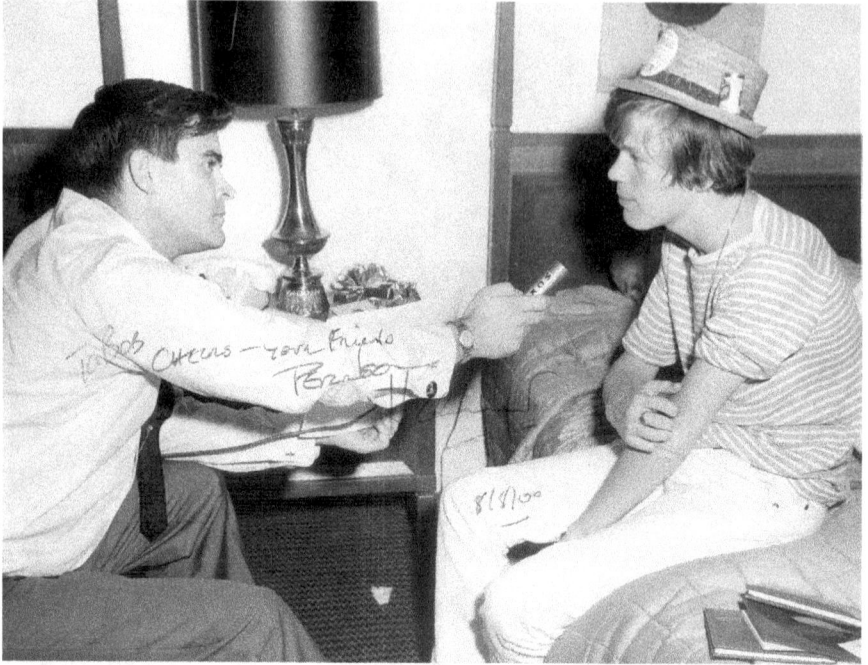

Peter Noone (Herman) and the rest of the Hermits.

*Left*: Bill Wyman, the Rolling Stones' bass player, was unhappy when I showed him the WOKY survey with no Stones songs on the chart.

*Right*: Autographs of the Rolling Stones on a WOKY music survey.

the maracas from his Mexican grandmother. He gave me an interesting reason why the groups were so popular at the time. "You've got four or five in the group. If the girls don't like one, you've got another four to like. There's much more variety. Teenagers seem to feel closer to groups for some reason." When I talked to the Stones and other groups from England during the 1960s, I never dreamed they would still be entertaining when they were in their seventies.

Tina Turner said that in Las Vegas and nightclubs, she and Ike would play to the older people in the audience by starting their set with slow, older songs to let them know that "we know what they like to hear and then as the show progresses we do the show we usually do." That's how they came up with the opening for their hit "Proud Mary": "You know every now and then, we think you'd like to hear something from us, nice and easy...we're gonna take the beginning of this song and do it...easy...and then we're gonna do the finish...rough."

Jimmy Dean admitted, "If it took more than an hour to write a song, I would throw it away." It took him less than an hour to write "Big Bad John." He said, "I thought the song would make one hell of a movie, and I wanted

to play a part in it." He did have a part in the film when it came out in 1990. He played Cletus Morgan and performed the song in the movie.

Bobby Sherman was one of the most ambitious celebrities I ever met. He came into town in October 1965 by himself. The local record distributor, Kenny Windl, drove him first to WITI-TV to do my *Early Show* program, then to WOKY for additional interviews. Later, he went to WRIT for King Zbornik and Eddie Doucette. Then, the personal manager for Dee Robb and the Robbs, Con Merton, picked him up in a limo and drove him to a store at Capitol Court for autographs. There were 250 girls crowded around the record counter trying to get near him. They finally had to whisk him out of the store for fear he or some of his female admirers would be injured. Then it was off to a quick dinner, followed by an appearance at the Scene and the Penthouse, where he had a chance to meet up with his friend Johnny Tillotson, who was performing there. Finally, he joined Tex Meyer of WRIT for his nightly live broadcast. Then, at 11:00 p.m. he flew to Cleveland to do more appearances. He was also filming *Shindig* and *Ben Casey* in between promotional gigs. Bobby's biggest hit was "Little Woman" in 1970.

Fats Domino said he got the name from his first single record, "The Fat Man" in 1949. He made a lot of hits after that. Pat Boone covered some of them, and he ended up with the hit version because many stations would not play black artists at that time.

Bobby Goldsboro told me that his career started when he was a guitar player in Roy Orbison's band in 1962. Then he began writing his own material and in 1968 recorded his biggest hit, "Honey." He had no idea the song would be as big as it was. It sold almost five million copies and was one of the biggest-selling records worldwide that year.

James Brown called himself "The Godfather of Soul" or "Soul Brother Number One" because "I tell it like it is." He told me that he was so successful that he owned several airplanes, a radio station and some music publishers. He told me that he loved his hit "It's A Man's, Man's, Man's World" because even in a man's world, there's nothing without the love of a woman. Amen!

Corey Wells told me that they came up with the name of their group after trying names like "Six Foot Three" and "Tricycle." They got the name from a book about Australian aborigines sleeping with dogs to keep warm, and a really cold night was a Three Dog Night. He said that they were lucky to come up with songs by Randy Newman, "Mama Told Me Not to Come"; Harry Nilsson, "One"; and Laura Nero's "Eli's Coming." They also came up with a song from the Broadway musical *Hair* called "Easy to Be Hard."

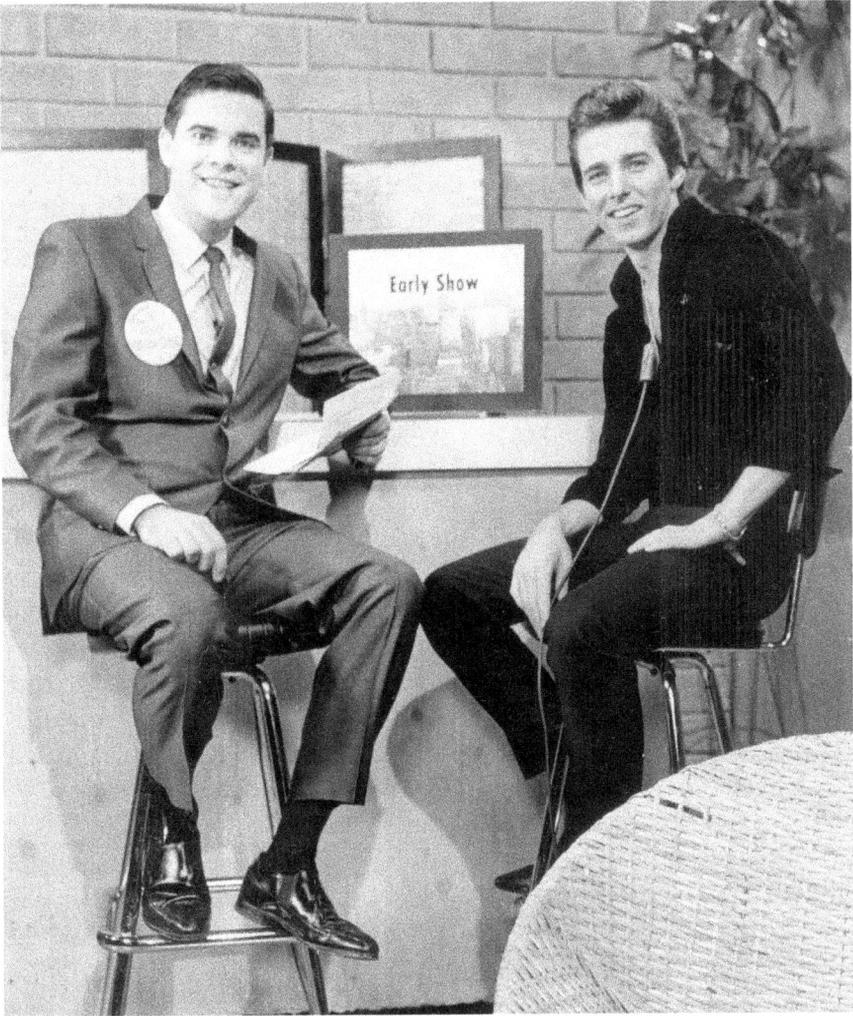

Bobby Sherman joined me on the set of *The Early Show* on TV6.

Their biggest hit, "Joy to the World," sold almost four million records and was the number one recording in 1971.

Rick Nelson said that the worst appearances he ever made were at service clubs in Europe. "It was like being in prison. We would play every night for a month at a time." He told me that he and his brother were born into show business but were never forced to entertain. It was their decision to go into radio and TV. When they were in public high school, they had friends outside of the industry just like normal people. They were on TV

Bobby Goldsboro was in town promoting his only no. 1 recording, "Honey."

for fourteen years and on radio for eight, one of the longest-lasting family shows. He was about eight years old when their parents, Ozzie and Harriet, had a Christmas show planned. Bing Crosby's kids were going to be on the show, so he and his brother David said, "Wait a minute, if they're going to be on, why can't we be on the show?" That's how they started on radio and their eventual long entertaining career.

Mark Volman told me that he credits Milwaukee Summerfest with playing a major role in the Turtles coming back on the touring circuit in the early '80s. There were some people there from the William Morris Agency who saw the show and were impressed by the great response they got.

Mark said, "The early '70s were very traumatic for us. It was tough to get the Turtles name back. It went under water in 1970 in litigation and was tied up for nearly four years." That was the reason they took the name Flo and Eddie when they went to work with Frank Zappa's Mothers of Invention. It was finally settled in court in 1974.

He pointed out that by calling themselves the Turtles in 1965 they would probably create an illusion that they were from England. The truth of the matter was that if you were from England in the '60s you were almost guaranteed immediate airplay on the radio.

He told the story of their hit single "Eleanor."

*We were making an album in 1969 called* The Turtles Present the Battle of the Bands, *which was basically a satire on how we got our start. We had won many band battles and one was at the DJ's nightclub where we were the house band backing up the Coasters, Drifters, Sonny and Cher, and Gerry and the Pacemakers. On the album we portrayed musically and visually ten styles of music that represented what was going on in the year 1969…bluegrass, country, protest music, and folk. We called the group Howie, Mark, Johnny, Jim and Al, just like John, Paul, George and Ringo. The record company wanted us to do another "Happy Together" hit. So we came up with "Eleanor," which was a parody of the band the*

*Turtles. When you take lyrics like "Eleanor, gee I think you're swell, you're my pride and joy etc., even though your folks hate me," it had every cliché we could think of. We wanted to use "you're fab and gear etc." but the record company made us change it to pride and joy, etc. We never thought it would be a hit. It made top five.*

Ray Charles had a great attitude. I told him he was an inspiration to many when he overcame his blindness and became a superstar. He told me,

*It was not the same as someone who lost a finger or a leg or your hand. You're not supposed to become a vegetable. Even a vegetable turns out to be good for something. The first thing you want to do is not let anybody make you feel sorry for yourself. Whatever you want to do, you should pursue it. Give it all you got. My mother told me when I was a youngster that there are two ways to do everything, so you might not do something exactly the same as another person, but there is a way to do it to get the job done. It might take you more time, but whatever you want to do you should really get into it.*

Ray said his biggest hit in a short span of time was "I Can't Stop Loving You." It sold two million records in six months. But overall, he said, "'What'd I Say' is one that we have to play in concert, no matter where, doesn't matter if it's a royal audience or someone's garage." He told me that the song originated at a gig they were playing; they had used all of their material and still had a few minutes to go until the dance would be over. He started to play a bass line on the piano and told the rhythm section to fall in line. He told his backup singers to do whatever they heard him say. "Just repeat after me." The people started to dance and wanted to know where they could buy the record. Ray quickly recorded their newfound song, and "It became our anthem." As Flip Wilson's Geraldine always said: "What You Say, Ray Charles."

Mary Wilson of the Supremes said they started out as four members of the Primettes in 1959: Florence Ballard, Diana Ross, Mary Wilson and Betty Travis. Betty left to get married, so they hired Barbara Martin. Barbara was on some of their earlier records with the Motown label just prior to them becoming the Supremes. Then Barbara wanted to get married, so that left them with three members again. They decided it was too hard to keep a fourth member because she would always get married. That's how they ended up with the famous trio. They got along like sisters in the early days. Just prior to Florence leaving the group, they encountered a lot of problems

with Diana, including the name change from the Supremes to Diana Ross and the Supremes. Mary said that at concerts, "Baby Love" got the most response. I told her when we have lip sync contests at the record hops, the girls and guys, with pants legs rolled up, love to do that song. She laughed and said she was delighted to hear that.

In July 1982, Frankie Laine told me that "I Believe" was his biggest record, followed by "Jezebel" and "Mule Train." "Desire" was his favorite because "it started the whole thing and brought me what my success has been. I had quit five times before and I went back for what I felt was the last time. And mentally I was saying if it doesn't happen now then that's it." Mitch Miller brought a lot of hits to him, including "High Noon." "Yeah, Mitch brought that to me. We didn't get picked to do the sound track, but we wound up with the hit record, and Tex Ritter was the one who benefitted from the sound track. He did a great job. I don't know whether I would have done the soundtrack as good as he did. His voice, I think, was ideally suited for that feeling, that haunting feeling." He also admitted that he held a dance marathon record of 3,501 hours...that's 145 days. It was held in Atlantic City on Young's Million Dollar Pier in 1932.

Some of my calls were spur of the moment, but most were carefully planned. Many bits took three to ten calls to set up. My producer, Rick Shannon, made over twenty calls to Bing Crosby's publicist before he finally said yes. Rick bugged Bing's agent until the agent begged Bing to do it to get him off his back. Some very cooperative interviewees were Johnny Cash, Joey Bishop, Jonathan Winters, Pat Paulsen, Miss America Phyllis George, George Burns and Bob Hope. Those playing hard to get included Paul Newman, Bob Woodward and Clint Eastwood. Many would never do interviews: Johnny Carson, Frank Sinatra and, of course, Elvis, no matter how hard you tried. We saw Elvis a couple of times in Vegas and once in Milwaukee but never got to meet him. The last time we saw him in Vegas at the Hilton we were told we would meet him after the show, and then we got word that he was not feeling well. This was shortly before the drug-use stories appeared. We were also told we would be taken backstage to greet Sinatra at Caesars in Vegas, but at the last minute that was called off. We must have made him sick, too. We did get front row seats for Elvis after the RCA record promoter gave the maître d' a hefty reward. Obviously, the Sinatra record guy wasn't as generous, as we were in the very back of the showroom next to the door. Nancy came so close to getting a scarf from Elvis, losing out to a screaming sweet young thing at the next table.

I got the whole story behind the famous Supremes from Cindy Birdsong, who joined the group in 1967, replacing Florence Ballard.

With hit songs like "Mule Train" and "Rawhide," Frankie Laine was one of the leading recording artists of the 1950s. He also recorded the *Blazing Saddles* theme song.

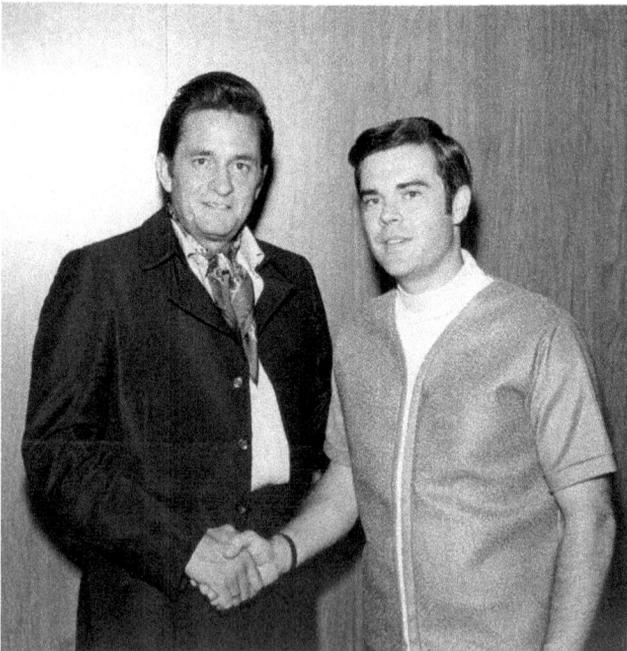

*Above*: My producer, Rick Shannon, putting me on the phone with another celebrity.

*Left*: Johnny Cash told me that his wife, June, was pregnant and if the baby was a boy, it wouldn't be named Sue. He said that "I Still Miss Someone" was his favorite song that he recorded.

As a young disc jockey, I confronted Jimmy Durante with the probing question "Who is Mrs. Calabash?" If you are under sixty, you have no idea what that means.

Henry Mancini, one of the greatest film composers of all time, was also one of the nicest celebrities I interviewed on the radio.

What can I say about Diana Ross, who literally pushed me aside when I asked to get a few words with her backstage after her show at the Wisconsin State Fair? Real class acts were Bobby Vinton, Neil Diamond, Elton John, Henry Mancini, Jimmy Durante, Danny Thomas, the Monkees and singer-actress Ann-Margret, who was standing in the showroom with her agent at the Leilani Supper Club on Blue Mound Road. She was there with her husband-to-be, Roger Smith, who was singing at the club. The agent said no interviews, but AM whispered to me to meet her in the next room, where we did a quick interview. (A quickie with Ann-Margret.) She was cute. I said, "You're not married to Roger, are you?" She said, "Ah, no, living in sin!" For one of Roger's shows in Milwaukee in 1964, the Ricochettes appeared with him. The ad read "Milwaukee's Beattles." I guess not everyone had been following the Beatles. Talking about nice celebrities, Paul Anka gave Harvey and Linda Moy a shock when he walked into their Chinese restaurant in Menomonee Falls with his entourage. He was appearing in town and decided he wanted some good Cantonese food. Harvey has proof of that day, with a picture that hangs among many celebrities who have enjoyed his excellent cuisine.

The Captain and Tennille met in the summer of 1971 in San Francisco. Tennille wrote the music for an ecology play called *Mother Earth*. They needed a new keyboard player for the show, and "The Captain" Daryl was recommended. He was just coming off a Beach Boys tour and had time to play in the show. Daryl got his nickname from Mike Love. Daryl went into a war surplus store in the Midwest and bought a captain's hat, and he wore it on stage. Mike started teasing him about being the Captain of the Keyboards, and the name stuck. Captain dropped the keyboard and added Tennille. Toni Tennille was born and raised in Alabama. Her dad sang with Bob Crosby's Band, so her musical influence came from Ella Fitzgerald, Frank Sinatra and Carmen McRae. Daryl's dad was symphony conductor Carmen Dragon, but Daryl was more a fan of Fats Domino and the boogie sound. Toni wrote "The Way I Want to Touch You" for Daryl, and because they were still happily married after six years, she penned, "Baby You Still Got It." Toni told me, "I didn't write all of the songs for him. I wrote 'How Can You Be So Cold, When I'm So Hot,' and that doesn't apply to Daryl." I guess things change. In 2016, Toni wrote in her book *Toni Tennille: A Memoir* that their marriage was rocky from the beginning and that she did write that song for him. She tells about how Daryl was quirky, controlling and distant and unable to return her affections. They were married for thirty-nine years before their split in 2014.

# CHAPTER 4

# THE CONCERTS:
# FROM ANIMALS TO ZOMBIES

The Dave Clark Five, the first of the British Invasion acts to appear in Milwaukee, drew a crowd estimated at ten thousand to George Devine's Million Dollar Ballroom at the Eagles Club on June 7, 1964. The only problem was the ballroom had a capacity of three thousand. This was the largest crowd to ever attend an event at the ballroom. Devine's was where the Winter Dance Party Tour started on January 23, 1959, eleven days before three of the stars—Buddy Holly, Ritchie Valens and the Big Bopper—were killed in a plane crash near Clear Lake, Iowa. This was the first big tour by an English group—sixteen concerts and *The Ed Sullivan Show*, and the authorities were not expecting this kind of reaction. Tickets for the DC5 show were two dollars in advance and three dollars at the door. They claimed that seven thousand tickets were sold in advance for the show. Whoops! Needless to say, the fire department was not too happy about that. The temperature in the building had to be near one hundred, with no air conditioning. The DC5 was the first of the British groups to use a saxophone in their act. They were the tightest, hardest-rocking group I had ever seen. After their rousing theme "Peter Gunn" was played, about 4:00 p.m., the DC5 opened with "Do you Love Me," and that's when the crowd pushing really got going.

Dave Clark (*far right*) and the DC5 backstage at George Devine's Million Dollar Ballroom. In the back row, Rick Huxley and Mike Smith are standing on a narrow bench in an old dilapidated dressing room.

The teenagers were packed in so tight that when someone passed out, they passed them forward to the stage and we took them to a room backstage for medical assistance. The police tried to hold the crowd back but were overwhelmed and sweating profusely. Over thirty zealous girls and boys (mostly girls between the ages of thirteen and sixteen) were carried backstage, and then the paramedics transported some of

them to the hospital in ambulances. One of the girls, while being taken backstage, reached out to touch Dave Clark and, in the process of kicking and swinging, knocked over Dave's drum set. He was not pleased. While the group was playing "Bits and Pieces," so many fans rushed the stage that the DC5 finally had to stop playing. Dave Clark and the fire chief talked it over and decided that it was in the best interest of all to cancel the remainder of the show. They had been on stage for a total of fifteen minutes. Luckily, there were no serious injuries. The promoter, Joe Liptak, made a lot of money because the group came in to promote their record. He was ticketed and fined for overselling the concert and endangering lives. Emcees Bill Taylor and I were paid $25 each to introduce the bands. The promoter told us that the low fee was due to a high overhead and a small venue. Dave Clark said he had no idea the show was oversold and felt the group should not be held responsible for the problems. The DC5 came back to Milwaukee December 15, 1964, and December 11, 1965, to much smaller crowds. Promoter Frank Fried from Chicago, the same guy who did the Beatles promotion, said he lost money. I thought it was a good, enthusiastic turnout, and this time I was paid $250.

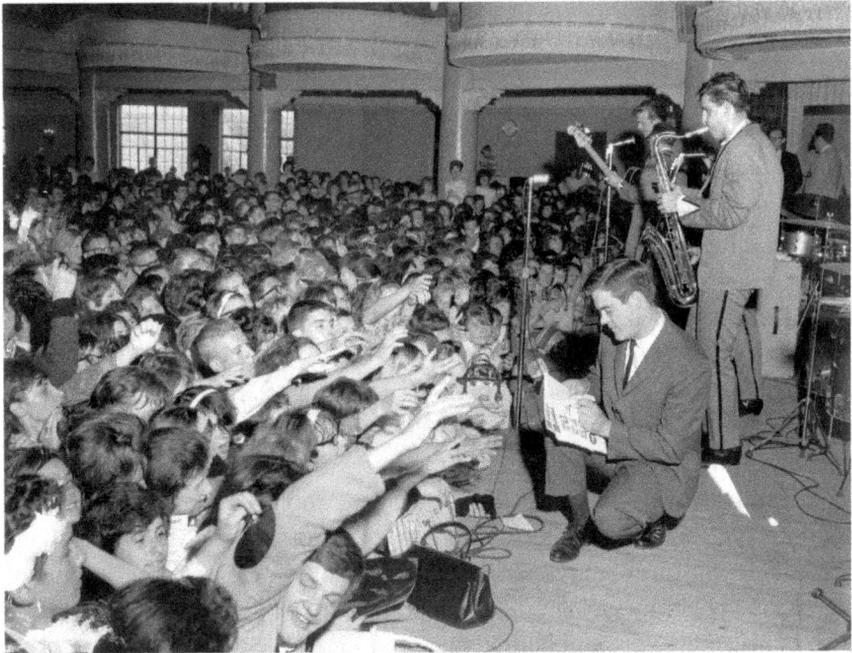

I'm signing autographs for fans at the Dave Clark Five concert. Easier to get mine than theirs, I guess.

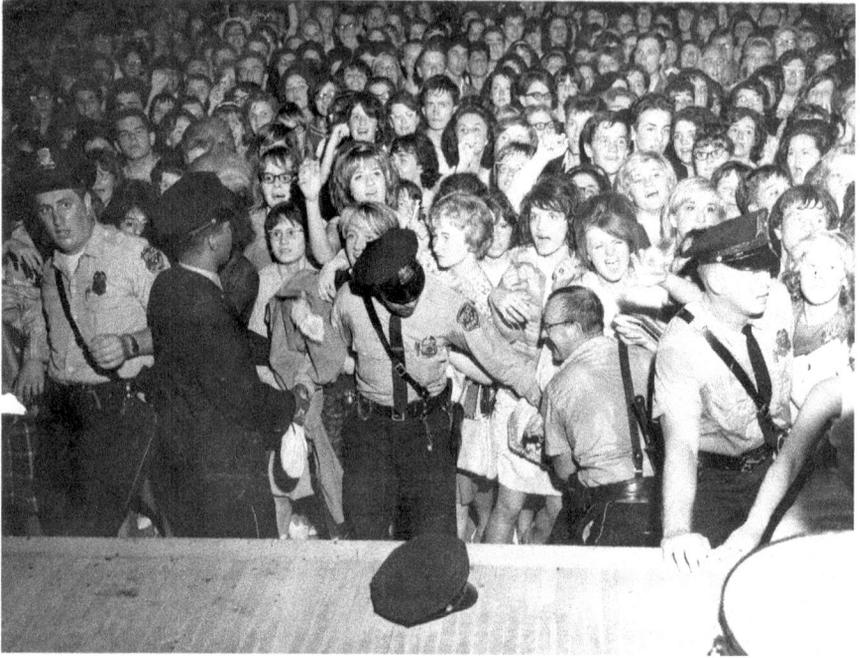

Police had their hands full trying to restrain thousands of young fans in the overflow crowd at the Dave Clark Five concert in George Devine's Ballroom in downtown Milwaukee.

The promoters of shows that came to Milwaukee in the '60s and '70s only stiffed me three times. O.C. White hired me to emcee the James Brown concert at Milwaukee County Stadium and never paid me. A West Coast promoter hired me to introduce Bill Withers ("Lean on Me") and ran out before I was paid. And then there was the 1997 Maritime Festival at the lakefront. It was Labor Day weekend, and they had some great talent there, including the Tygers, Skunks, Destinations, Esquires, Freddie and the Freeloaders, Harvey Scales and the Seven Sounds, Sam McCue, the Wrest and the Robbs. I was given a check before the concert, so I was safe, right? I don't know about the others, but my check bounced. The promoter left town and is still being chased by many angry people, including some of the vendors. One of the only smart ones was Sigmund Snopek, who got cash up front. This was one of the few times this happened, but it cost me a Sunday afternoon. The only saving grace was seeing a lot of the talent I had worked with in previous years and hadn't seen for a long time.

The Rolling Stones appeared at the Milwaukee Auditorium on November 11, 1964, and November 25, 1965. At the '64 concert I was paid $250 to

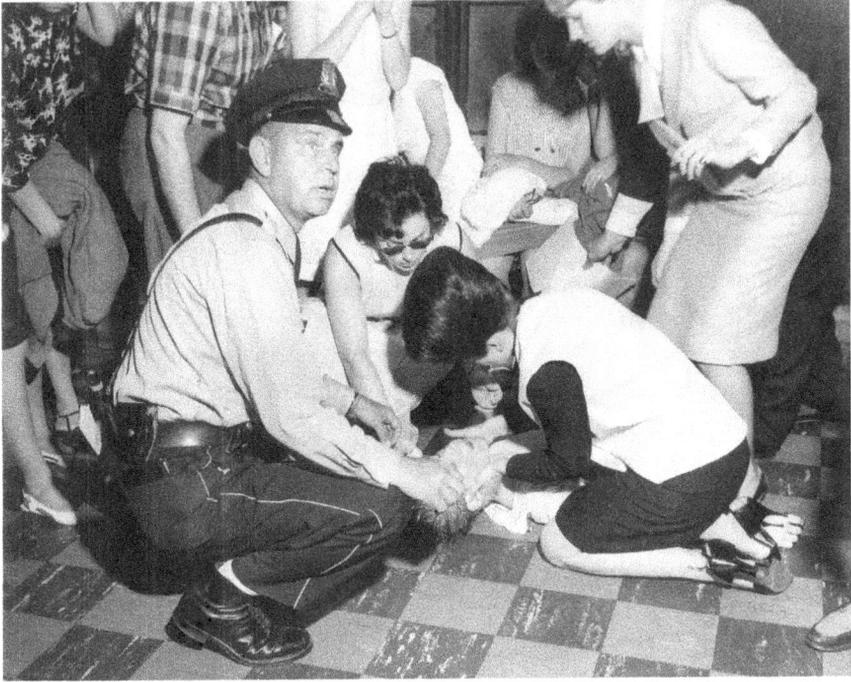

They were dropping like flies at the Dave Clark Five concert. Ten thousand people somehow shoehorned into a hall with a capacity of three thousand.

warm up the crowd, introduce the early acts, including the Road Runners, and then the Stones. In 1964, Brian Jones did not appear with the group. He was at the press conference the day before but not for the concert. He also missed Fort Wayne, Dayton and Louisville. They said he was ill, but it turns out he had a drug problem and was later released by the Stones. Jones died at age twenty-seven in 1969. He drowned in his swimming pool in England. The coroner reported that his liver and heart were enlarged by drug and alcohol abuse. Brian was not alone. Charlie Watts became a heroin addict in the mid-1980s.

Before the 1964 show, the mayor of Milwaukee, Henry Maier, went on the radio before they arrived in town, saying it would be a sign of immorality for teenagers to attend a Stones concert. Only 1,274 seats were sold for that 1964 concert, and 4,992 remained empty. The promoter lost about $2,500 on the show. The Stones survived the onslaught of flashbulbs and lipstick thrown at them throughout their performance.

They had a better turnout in '65. Lee Rothman of WRIT was the emcee. There was a feeling this show would not be sold out when the group was

driven up from Chicago the day before for a press conference at the Coach House Motor Inn. They showed steady boredom throughout the gathering, chain-smoking cigarettes, and all seemed to be suffering from colds. They were sarcastic. Brian Jones was asked how he got that biting sound on the harmonica. He said, "I bite it." When Charlie Watts was asked what he wanted to be, he growled, "Happy." Mick Jagger complained about the mayor of Cleveland banning teen concerts because they are "not culture." "Baseball isn't culture, but you wouldn't ban baseball games," he said.

After the concert, Mike Drew of the *Milwaukee Journal* wrote, "Unless someone teaches guitar chords to chimpanzees, the visual ultimate has been reached with the Rolling Stones. Screams from a thousand throats drowned out all but the most insistent electronic cacophony and the two-fisted smashes of drummer Charlie. With shoulder-length hair and high-heeled boots, they seemed more feminine than their fans."

The last time the Stones appeared in Milwaukee was June 23, 2015. They thrilled twenty-five thousand fans, the largest crowd ever at a Summerfest concert.

The year 1964 was a good one for concerts. I introduced Jay and the Americans at Pius High School on December 21, for which I was paid $150. Junior and the Classics (Bob Brantley, Brand Schank, Jerry Sworske), with somewhat of a local hit called "The Dog," was the warm-up act. The gym was packed, which was good for two local businessmen, Jim Haig and Paul Schinker, who sponsored the show.

I did over fifty appearances that year, including Washington High School fashion shows. Can you imagine a deejay coming to a school assembly in a tux, promoting wearing tuxedos for the prom? For the most part, the audience of young people was well behaved except for a few of the usual suspects who needed to be heard.

On Saturday, July 24, 1965, Herman's Hermits with Wayne Fontana and the Mindbenders appeared in concert at the Milwaukee Auditorium. For this two-hour show, Ed Pazdur Productions out of Chicago paid me $150. Herman's Hermits came back to Milwaukee, along with the Animals, one year later. Hermits fan extraordinaire Doris Kray was there and remembers every detail:

> *Keith wore dark pants, striped suit coat, and a dark mod hat. Karl wore a blue with white dot shirt and white with blue dot tie and he had very blonde hair. Lek had a brown shirt on and his hair was long. Barry looked cuter than his pictures and had a blue suit on. Herman was hit in the head by a*

Jay (*second from right*) and the Americans recorded a number of huge hits, including "Come a Little Bit Closer" and "Cara Mia."

*light bulb. He put his hands to his face, stopped singing and walked behind Lek, who gave him a handkerchief. Herman held it on his forehead. He's right handed but held the microphone in his left hand. My girlfriend and I went downtown a couple days later, went to the Arena, and took some of the curtain that Herman must have touched and went into a room where they must have taken showers. I have the ticket stub, the curtain piece, and some toilet paper in my scrapbook with the comments: toilet paper I got from the Herman Concert. A fan threw a roll of it on stage. Herman picked it up and threw it in front of our section.*

The Scene, near Wisconsin Avenue in downtown Milwaukee, formerly the Swan Theater, had a showroom with a six-hundred-person capacity. On

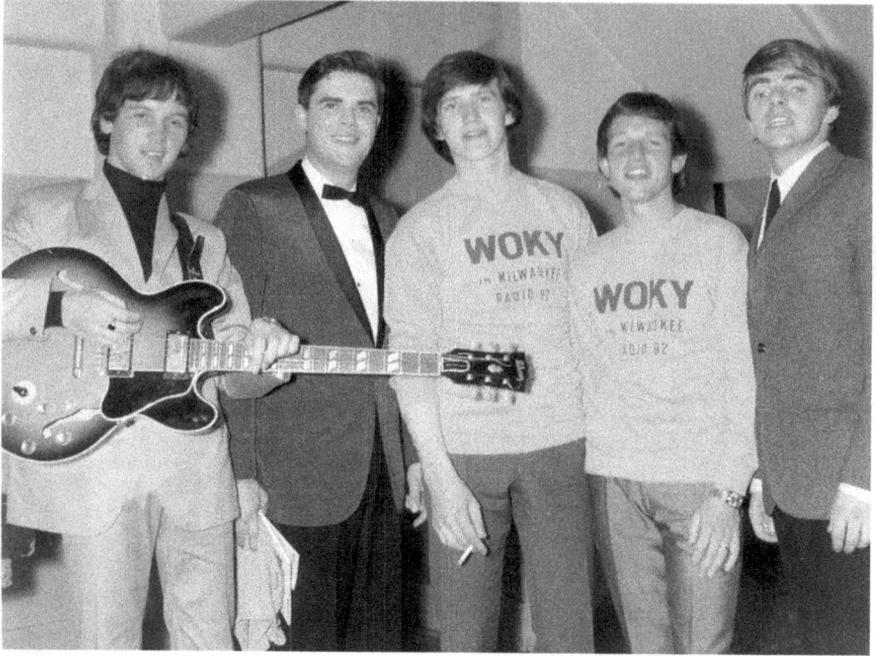

Wayne Fontana and the Mindbenders, a popular group in the British Invasion, hailed from Manchester, England.

September 19, 1965, Chuck Berry played two shows there with a $2.00 price of admission. Club owner Frank Balistrieri paid me $50.00 to introduce Berry. Other name acts Balistreri brought into the club included Little Richard, Jerry Vale, Paul Butterfield Blues Band, Smokey Robinson and the Miracles (admission $2.50), the Esquires, Vic Damone, the Allman Brothers, Mothers of Invention, Steppenwolf, Miles Davis, Cream, Rod Stewart with the Small Faces, Tommy James and the Shondells, Wayne Cochran, Frank Zappa and, on September 12, 1966, Ray Charles. The club also had a go-go room with go-go girls dancing nightly. They even had noon luncheons. Club landlord Frankie Bal became head of the Milwaukee crime family in 1962. He asked me to book some acts for him, but after careful consideration, I decided that would not be a good idea.

Another downtown Milwaukee nightspot was the Attic on Second Street. Neil Sedaka was one of the great acts appearing there in the summer of 1965. Other big-name performers featured at the Attic included the Everly Brothers, Count Basie, Dave Brubeck, Stan Getz, Jerry Lee Lewis, the Platters and Johnny Rivers—the list goes on.

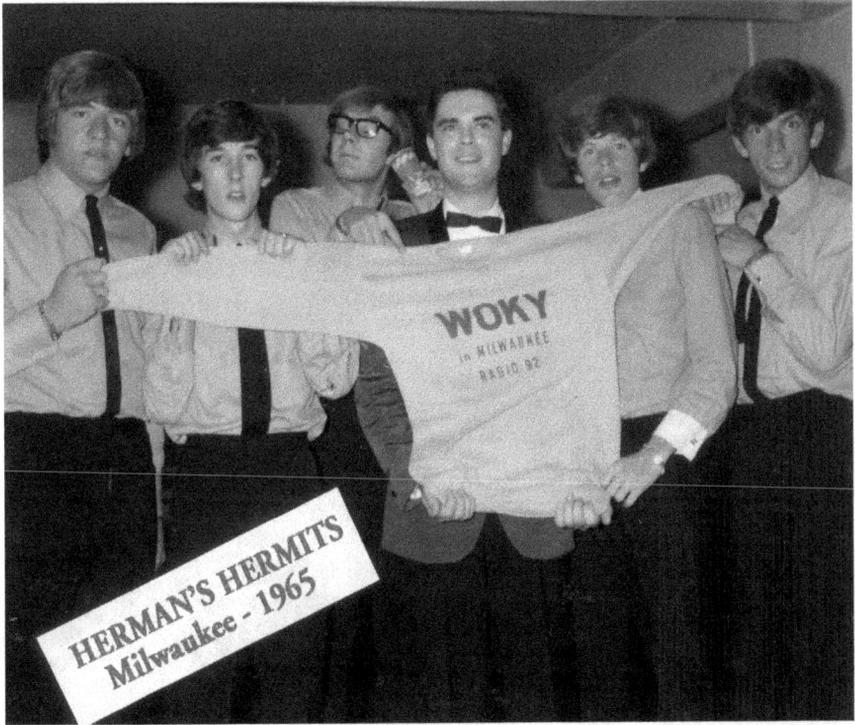

Herman's Hermits (Herman, real name Peter Noone, is second from the right) helped promote our station with a WOKY T-shirt.

Local acts were more likely to appear at some of the far-flung venues around the state. One of the popular acts appearing at the Cow Palace in Fond du Lac was the Ricochettes, who would go to their gigs using a hearse to carry their equipment. I got a tape of a song not yet released by the Beatles and played it for them, and they cut it. The song, "I'll Be Back Again," became a regional hit. One of the group's members later backed up the Everly Brothers and Bobby Vee.

There was a lot of good talent in Milwaukee in the '60s. In 1961, the Nomads with Sam McCue, Larry Foster, Larry Schils and Jim Sesody were a house band at Muskego Beach, later known as Dandelion Park. Thousands of kids would jam the hall to see them. The band went to Dave Kennedy Studio on North Avenue and recorded "Lariat" and "Gail" and released them on the Key label. Then they changed their name to the Legends and soon were the backup band for the Everly Brothers, Peggy March, Brook Benton and others at the Beach. They ended up going to Chicago to record at Sheldon

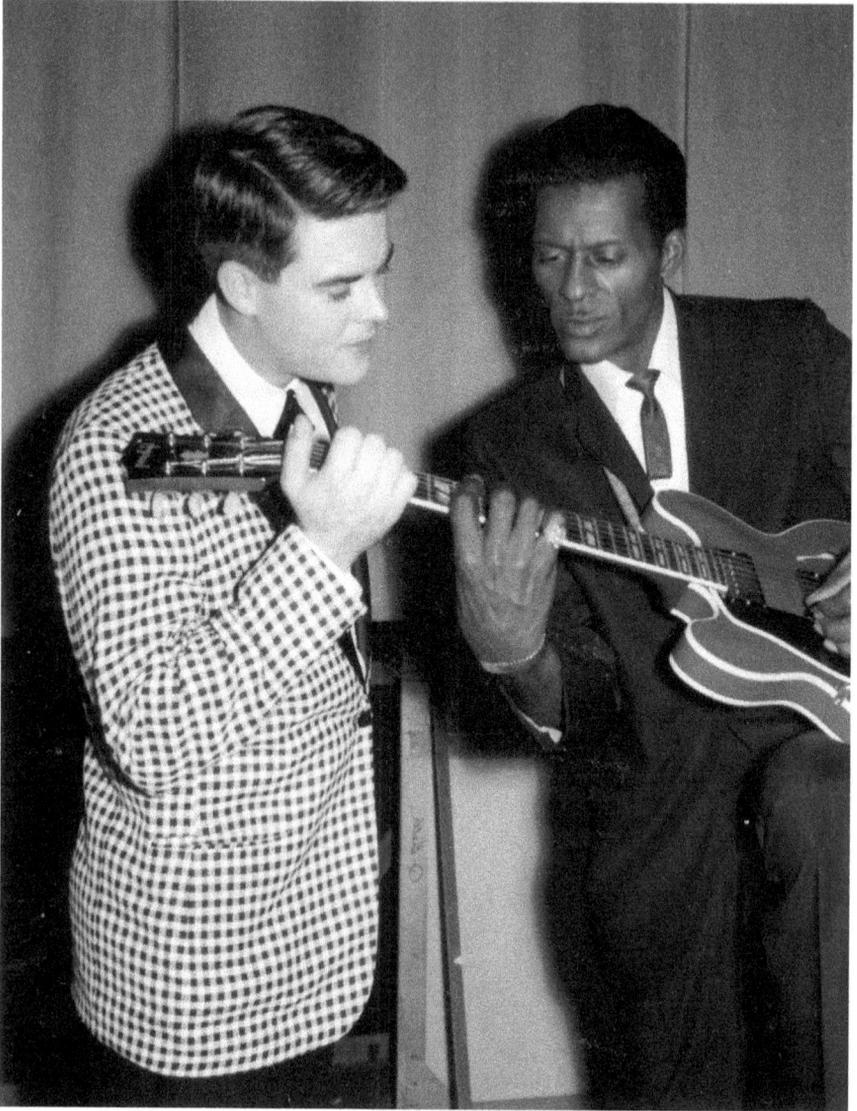

Rock 'n' roll pioneer Chuck Berry gave me an impromptu guitar lesson at the Scene, a downtown Milwaukee club owned by local Mafia boss Frank Balistrieri. I often emceed shows there.

Studios. This is where they cut a song that got a lot of airplay in Milwaukee, "Say Mama." The Legends just about owned the air-conditioned Muskego Beach Ballroom on Highway 24, four miles west of Hales Corners. The group appeared there often in the '60s. Price of admission was only $1.25.

At that time, most of the local groups only made about $50 to $70 for a sock hop, maybe $10 a man. I was paid $50 per hop, usually doing three on a Friday night. I regret not being able to work with some of these groups because the promoter who was paying me hired only acts he wanted to work with or would work for him. WOKY would allow us to make a thirty-second commercial naming all of our appearances for the week. With so many of us doing numerous hops, we had to speed up the commercial to the point where it was hard to understand. But we could still tell the people hiring us that we were promoting their dance. We were not allowed to mention the gigs on our shows. In contrast, Larry "The Legend" Johnson at WZUU and WISN would make mention of where he was appearing many times during his daily broadcasts. And it paid off for him. One contract for Mitchell Carpet showed Larry getting $500 for two short appearances at the carpet stores.

In the 1960s, most of the local DJs were doing the CYO dances every Friday night all over the Milwaukee area. These dances were held from 8:00 to 11:00 p.m. Sometimes they were scattered all over, one in Milwaukee, then Cudahy and maybe Port Washington or Hartland. Usually when I did three a night, I would have a driver who would drop me off at the door and wait. At one church dance hall, I jumped up on the stage, promoted my show, gave away a few albums and prizes, then introduced the band and hurried out to the car to go to the next dance. A priest at one appearance had stopped in to the boy's room for a couple minutes, checking for smokers. He came out and asked when Bob Barry was going to be there. A girl told him I had just left.

In the early '60s, teens gathered at the South Side Armory on South Sixth Street to see a battle of the bands between the Noblemen, the Bonnevilles and the Comic Books. For the entrance fee of seventy-five cents, everyone received a free record at the door. Other groups appearing at the armory on Friday and Saturday included the Legends and Continentals. These bands, plus the Darnells, also appeared at the Nightingale Ballroom on Friday and Saturday nights. The popular Noblemen began with a chance meeting of Brand Shank and Bob Strange in the halls of Washington High School in Milwaukee. The band was started after Brand and Bob met with drummer Jerry Sworske and Chuck LaLicata, with singer Toni Magestro being added later. They appeared many times at the Nightingale, SS Armory and Machinist Victory Hall in Cudahy. Once you appeared at those venues, you would never forget the smell of stale beer, smoke and grease. At times, the odor would nearly knock you out.

"And the British kept a coming!" On a Sunday afternoon, November 14, 1965, a rare treat was in store for audiences at the Milwaukee Arena. Not only did they get to see and hear the nationally famous Beau Brummels and McCoys, but also they got to see the internationally famous Freddie and the Dreamers perform. The McCoys did "Hang on Sloopy," the Beau Brummels sang "Laugh Laugh" and Freddie and the Dreamers sang their hit "I'm Telling You Now." Many thought the Brummels were from England, but they hailed from San Francisco. The Dreamers were from England and were just one of the many British groups to come through our city in the '60s. They were a very comical group and even got me to do the "Freddie" dance. That was a first and a last. They were in town promoting their film *Seaside Swingers*.

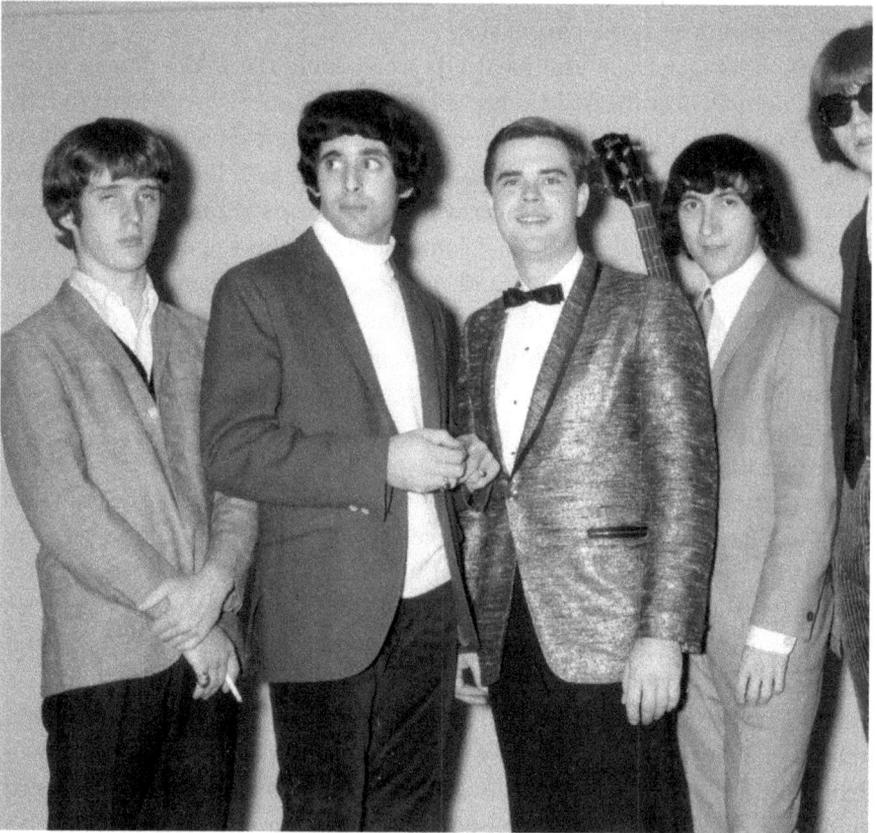

Sal Valentino (*second from the left*) told me that everyone thought the Beau Brummels were from England, which didn't hurt in the '60s when the British groups were the rage. They were actually from San Francisco.

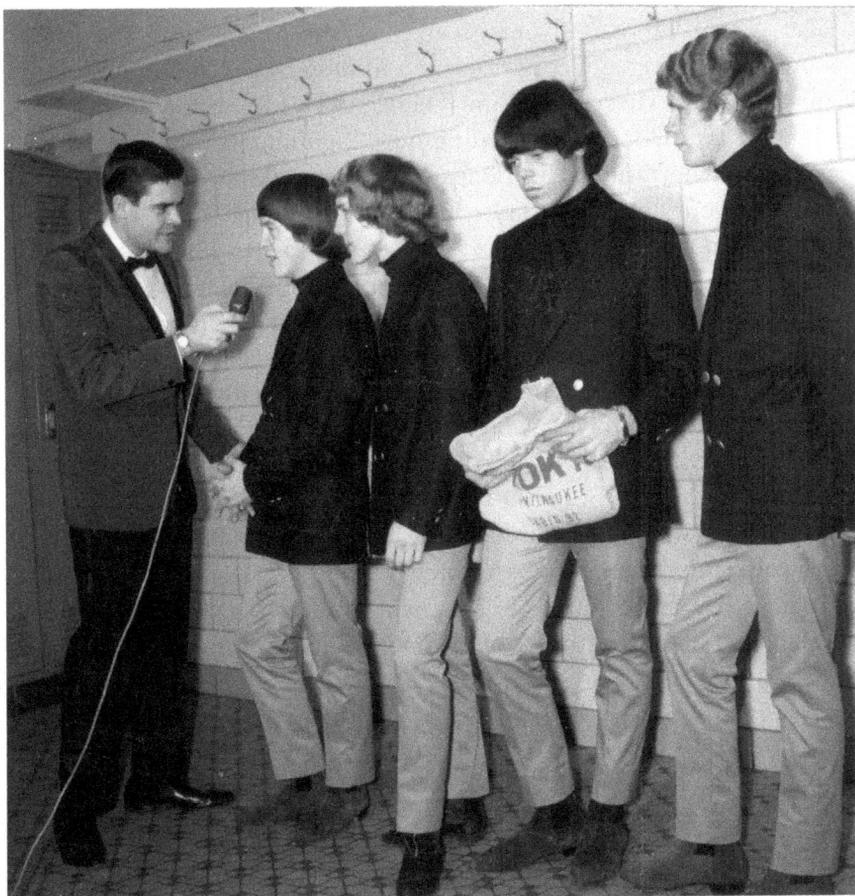

Here I am interviewing the McCoys after the success of their big hit "Hang On Sloopy."

In 1965, Jon Hall opened Teensville in Thiensville, a club for Ozaukee County teens that was open seven days a week and served only soft drinks and lots of music. Hall managed many of the local bands, including the Skunks, Tony's Tygers, Unchained Mynds from LaCrosse and others. Occasionally, he would bring in some name acts from outside the city, including the Buckinghams ("Kind of a Drag"), Shadows of Knight ("Gloria"), Ides of March ("Vehicle"), New Colony Six and Question Mark and the Mysterians. They told me that it cost thirty-five dollars to make their hit "96 Tears." They recorded it in their garage and then melted down the gold record they won for that hit so they could make a car payment. All of the local rock 'n' roll jocks would work at Teensville emceeing the shows.

The year 1966 started out great, with the Vogues and the Lovin' Spoonful appearing at George Devine's Million Dollar Ballroom. Joining them were locals Mickey They and Them and Dee Robb and the Robbins. In March, Lou Christie was belting out "Lightning Strikes Again" at a very popular northside spot, Beneath the Street, Milwaukee's A-Go-Go Night Club on Thirty-Fifth and Burleigh Street. Part of the attraction was no cover, no minimum charge. It was later called the Athena. Junior and the Classics was the house band. Every Tuesday night I would host a Gorilla dance contest. First prize was an evening at Fazio's on Fifth. One day, the owner of Beneath the Street called me and said I was to stay away from his wife and never return to the club. He threatened to take me to court. I called my attorney, who eventually found out that I was not the Bob that his wife was involved with. That was a scary situation. I never did return to the club or even go near it.

Summerfest was first held from July 20 to July 28, 1968. It was conceived by Mayor Henry Maier. He was inspired by a visit to Oktoberfest in Munich, Germany. The first Summerfest was held at thirty-five different locations throughout Milwaukee. Many of us had a hand in the first Summerfest

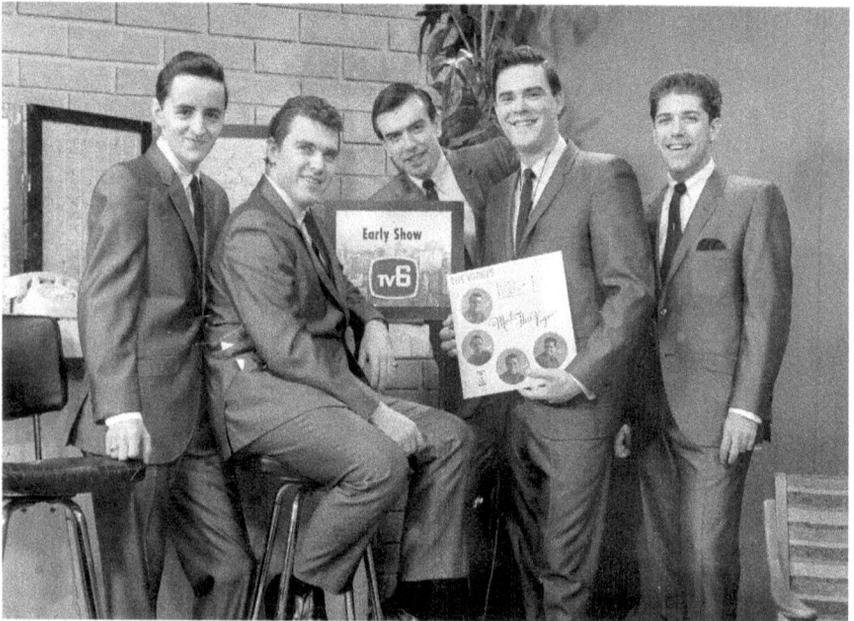

The Vogues appeared on my TV show to promote their new album, *Meet the Vogues*, which included their first hit, "You're the One."

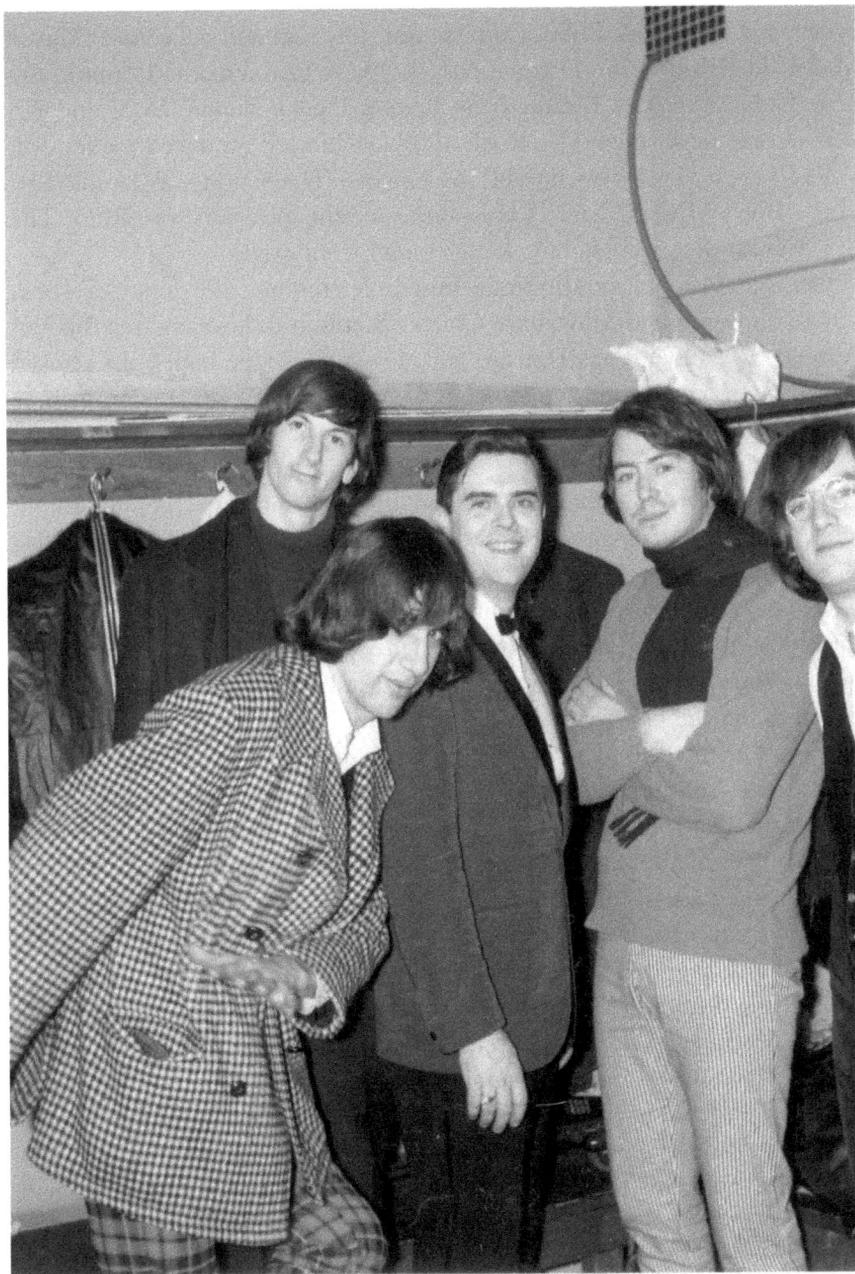

The Lovin' Spoonful enjoyed, as their song said, "Summer in the City."

events, including Dee Robb, Con Merten, Jon Hall and, of course, Mayor Maier. The Robbs, the Destinations, the Next Five, Freddie Cannon, the New Colony Six, the Esquires, the Lemon Pipers, Ronnie Dove and Up with People performed. Dee Robb and Con Merten produced the festival. WRIT's Tex Meyer was one of the emcees. The sound was handled by Uncle Bob's Music Center. Admission to see the local acts was $1.25. The first Summerfest was a failure. It's a wonder it survived.

On a foggy, cold, pouring-rain miserable summer day, June 22, 1969, 29,041 fans jammed Milwaukee County Stadium to hear and see the first Annual M'WOKY Pops Festival. For almost six soggy hours, the packed crowd sang, danced and screamed in response to the sound of fourteen of America's most popular recording artists. Such acts as the Monkees, Gary Lewis and the Playboys, the Guess Who, Tommy James, Royal Guardsmen, Cryan Shames, New Colony Six and the Buckinghams brought round after round of rocking applause and cheers. Most remember the five Buckinghams from Chicago for their hit, "Kind of a Drag." The Bar-Kays sang "Aquarius," belting out "let the sun shine in" over and over as a torrent of rain came down. Program Director George Wilson, promising to play their latest record, was able to get all of the acts for free or just expenses, so the charity made thousands of dollars from the event. The first fest benefited the Children's Outing Association and the Drug Abuse Lab at the Milwaukee Mental Health Center. Ticket prices were $1.50, $2.50 and $3.50, available exclusively at Boston Store. Some of the groups appearing went above and beyond our requests. I remember the Rip Chords accompanied me to the Children's Hospital and sang their hit "Hey Little Cobra" a cappella. Some of the young teenagers had been in the hospital for a long time and really appreciated the show.

The first Summerfest at the lakefront took place at the abandoned Nike missile site on July 17–26, 1970. The lineup of acts included Chicago, James Brown Revue, Sly and the Family Stone, Doc Severinsen, Cannonball Adderley, Procol Harum, Sarah Vaughan, the Cowsills, Andy Kim, Bobby Sherman, Ramsey Lewis, Pat Paulsen, Jose Feliciano and a whole bunch of local acts, including Thee Prophets, the Sidewalk Skippers, the Messengers, University Blues Band, the Esquires and Short Stuff. The estimated Summerfest crowd for the Sly & the Family Stone concert was 100,000. This was before the main stage was built. The opening acts were a Milwaukee group, Yesterday's Children, with Warren Wiegratz on the sax, and the Wrest. In those days the local groups commanded $250 for a night's work, but there wasn't much to go around after splitting with band members, road crew and

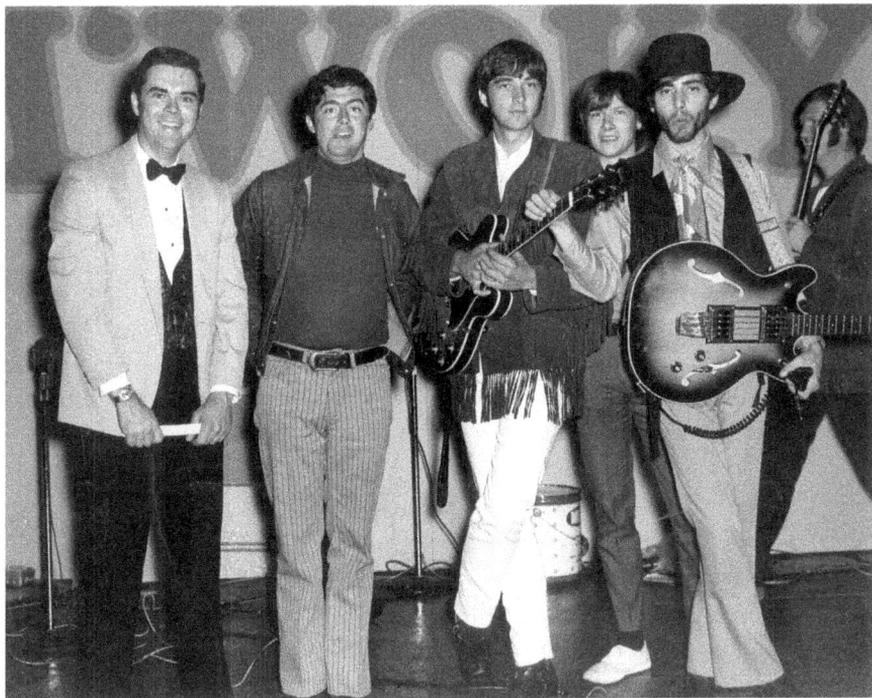

On stage at the WOKY Pops Festival, in Milwaukee County Stadium, with the Cryan Shames, a garage band from Hinsdale, Illinois.

hotels when on the road. Warren was on stage for almost every Summerfest. He appeared with Sweetbottom, Oceans, the Peter Safir Group, Streetlife and others. He was also with the warm-up bands for Sammy Davis Jr. and Gladys Knight and the Pips. Many connect him to the house band for the Bucks basketball games.

On May 1, 1970, you could have seen the Jimi Hendrix Experience at the Milwaukee Auditorium for only four dollars. Four months later, Jimi died at the age of twenty-seven.

Our 1971 third annual Pops Festival lineup began with WOKY GM Ralph Barnes introducing DJ Gary Price, who introduced the Classics IV. Then I brought on Hamilton, Joe Frank and Reynolds, who had a big hit that year, "Don't Pull Your Love," followed by Sugarloaf. Later on, I introduced Jerry Reed and Lobo. At some point, the police tactical squad was called in, apparently fearing a teen riot. The only outbreak that came close to that description occurred when Andy Kim left the stage and approached the stands and the crowd of young females responded. Jack

Lee and Jack McCoy got on the mike and calmed the crowd, telling the police that no force was needed to calm the enthusiastic young girls. Not one person crossed the police line.

Elvis Presley made his first Milwaukee concert appearance on June 14, 1972; he appeared here again the next night, then on June 28, 1974, and for the final time on April 27, 1977. He died four months later on August 16 at the age of forty-two. He did appear in Madison in June 1977 and made the newspapers for breaking up an attack on a gas station attendant. The paper said that Elvis exited his limo but never threw a punch because the fight stopped the minute the assailants recognized the singer.

George Carlin was the opening act for Arlo Guthrie at Summerfest on July 21, 1972. He belted out his "Seven Words" that you could never say on radio or TV—and apparently on stage. He was arrested for violating the obscenity laws. Before being handcuffed, Carlin discarded a bag of cocaine to avoid further charges.

In June 1975, the Rolling Stones appeared at County Stadium with warm-up acts Rufus and the Eagles. The Brewers management was unhappy because they said the fans destroyed the playing field. Alan Dulberger and Randy McElrath of Daydream Productions sponsored the show. Pink Floyd also appeared that year at the stadium.

I emceed the Italian Festival stage show on July 21, 1982, in more than two hours of pouring rain. All you could see was a sea of umbrellas and people wearing plastic trash bags handed out by the Festa folks. But who could complain at $5.50 to $9.20 a ticket. Our WOKY 920 Music of Your Life station welcomed the stars of Festa Italiana. Frankie Laine sang his hit "I Believe," with the lyrics that fit the occasion: "for every drop of rain that falls." Not one person walked out on the entertaining Jimmy Dorsey orchestra, the Four Lads, Dick Contino and Patti Page. Patti asked me to bring her dog out on stage when she sang "Doggie in the Window." I guess the dog didn't like DJs because she peed all over my tuxedo. Patti didn't seem to notice, so I never mentioned it to her.

The oldies were not goodies, as reported by Tina Maples of the *Milwaukee Journal* on August 9, 1989. In a concert at the State Fair Grandstand, Fabian, Tommy Roe, Bobby Vee and the Shirelles asked us to take a trip back in time. Tina wrote, "Bob Barry told the crowd that these songs sound great in stereo on WZTR and the small but enthusiastic crowd of 2,690 agreed." Only, she said, "They sound better on the radio than they did that night in concert." The acts were in fair voice, she reported, and "the sour harmonies of a local '60s band didn't help." She added, "Fabian's skills as a singer

Teen idol Fabian and I took in some of the Wisconsin State Fair. Apparently, the police officer wanted to be photographed with Fabian.

were limited even in his heyday as a fifteen-year-old teen idol, and those days are long gone. In a business that thrives on slickness, his appeal is an awkward but endearing earnestness, kind of like someone's dad helping the neighborhood kids play rock concert in the back yard."

In 1993, after almost thirty years, Paul McCartney finally came back to Milwaukee. He played for over two hours to a crowd of forty-eight thousand at County Stadium. Tickets were a bit higher then those in 1964, at $32.50.

157

It rained but did not dampen the spirits of the enthusiastic crowd. Paul returned again in 2002 at the Bradley Center, where I paid $252 apiece for tickets. The show grossed over $2 million. He came back in 2005 at the Bradley Center, 2013 at Miller Park and 2016 at Summerfest. He still put on a great show for the Amphitheater crowd at seventy-four years of age. The biggest difference between his show in 2016 and that memorable Beatles concert of 1964 was obvious—this time you could hear him, and he sounded pretty good.

# LADIES AND GENTLEMEN...THE BEATLES

Imagine no Beatles. What would the world have been like? The music they gave us, the humor, the escapism at a time we needed all we could get. Their impact was huge and still is felt today. No one in music will ever be as big as the Beatles.

In the United States it all started December 29, 1963, with the release of "I Want to Hold Your Hand." A few American stations got the record, but the Beatles didn't have any records on the U.S. charts until January 1964. They were very popular in other countries and had been recording as early as 1961. A few weeks later, hundreds of reporters, one hundred policemen and thousands of fans crowded into New York's Kennedy Airport. The Beatles had arrived to do their first American press conference. Shortly after, they sold out two shows at Carnegie Hall and appeared on *The Ed Sullivan Show* for what was, at the time, the most watched television event in history. The show drew seventy-three million viewers. Fifty thousand people applied for 728 available seats in the Ed Sullivan Theater. The girls swooned, and the boys began to emulate the group by letting their hair grow out and learning to play the guitar. A few months later, the Beatles were paid $2,000 a minute to perform at the Hollywood Bowl. On April 4, 1964, they had the top five hits on the *Billboard* charts: 1. "Can't Buy Me Love" 2. "Twist and Shout" 3. "She Loves You" 4. "I Want to Hold Your Hand" 5. "Please Please Me." This was the first and only time this had ever happened.

The Beatles' big year was 1964, and it was a year for a lot of great music—Motown, the surf sound, R&B and country. We played them all, including the standard pop hits. It was in the spring of 1964 when our music director, Arline Quier, was called into the boss's office and asked why she

was programming so many foreign artists. There were three Beatles songs on the Top 10 of the WOKY survey. That almost got her fired. In fact, our playlist at that time was rock, country and easy listening, what would have been called weird by any standard. When this whole British Invasion started, I didn't believe these songs were that great, compared to what we had been playing, and wondered why I should play "I Want to Hold Your Hand." Boy, did I need a quick music lesson. The phones went off the hook with screaming girls begging for more of the Fab Four, a term coined by the Beatles publicist Tony Barrow. After that I played every record, both sides, that the Beatles released. An army serviceman, stationed in Germany, sent me a copy of Germany's top-selling records, "Komm Gib Mir Deine Hand" and "Sie Liebt Dich," the German version of "I Want to Hold Your Hand" and "She Loves You." I was told that I was the first disc jockey to play the record in the United States. If they had recorded in a language no one had ever heard of, it still would have been a hit.

I was in the music director's office one day in early 1964 when I got a phone call from a man who said he was promoting the Beatles concert scheduled for Milwaukee on September 4, 1964, a Friday night on Labor Day weekend, at 8:00 p.m. He had done a survey of the area and found out that I was the favorite of Beatle fans in Milwaukee and wanted me to emcee the concert. (His name was Frank Fried, from Triangle Theatrical Productions.) At that time, I was making about $150 a week. I asked him how much it paid. When told there was no budget for the emcee, I declined the offer. Up until the day he called I was paid for every concert I had emceed. I explained the Fried call to the music director, and she told me I was crazy and to call him back immediately. I did, but by that time he had called a jock from the rival rock 'n' roll station. Fried explained that it was not final and he would get back to me. He did call back and told me the other jock would introduce the warm-up acts, and I would introduce the Beatles.

Topping and Company International House, 736 North Second Street, supplied the Beatles tickets. Proprietor Nick Topping was an experienced concert promoter and had booked shows featuring Miriam Makeba and Pete Seeger and others. In February 1964, just after the Beatles were featured three Sundays in a row on *The Ed Sullivan Show*, Topping was contacted by Chicago-based Triangle Productions and offered an opportunity to promote a Milwaukee appearance by the group. Topping accepted the offer. Triangle Theatrical Productions printed the program for the Beatles' September 4 Milwaukee concert and a concert in Chicago the following night. Inside there were individual headshots of the Fab Four with John and George

incorrectly captioned, plus a list of the supporting acts. There were also ads for upcoming attractions like "The Dave Clark Five, December 15 at the Milwaukee Auditorium, with tickets priced from $1.75 to $4.75," plus an ad for a local music store, Coca-Cola and McDonald's. There was a full-page ad purchased by Ludwig Drums: "Congratulations to Ringo Starr and the Beatles on your triumphal U.S. tour" with a photo of him behind his trademark "marine pearl" kit drums. The Milwaukee program was completely different from the generic Beatles Ltd. program sold throughout the August 19 to September 20 tour.

Topping said that within a week of signing the Beatles to a contract on April 17, 1964, he had sold all 11,838 seats at $3.50, $4.50 and $5.50. The Beatles were to get a percentage of the box office receipts, with a minimum of $30,000 guaranteed. It was estimated that they received $50,000. That's around $500,000 in today's dollars. The sales started on a school day, so many parents ended up buying the tickets for their children. Topping wasn't sure he would sell enough tickets, so buyers were given a receipt and tickets mailed out later. This was way before Ticketmaster.

After the announcement was made that our station would be the official Beatles radio station for their Milwaukee show, we received ten thousand (estimated by the *Milwaukee Journal* after they took a picture that was published in the paper) letters and gifts of jewelry, watches, homemade clothes, stuffed animals and cakes. One cake was shaped like a record player, and another, brought to the WOKY studios on Sherman Boulevard by Beatle "super fan" Jackie, was shaped like a guitar. She paid a confectioner to bake the cake. It was actual size with lots of detail, but the Beatles never saw it. Paul McCartney told me to give the mail to their road manager and donate the gifts and cakes to the Children's Hospital. Ringo chimed in, "Wait a minute, I'll eat the cakes." He also volunteered to drink the champagne. I did what McCartney asked, and when I gave a young girl with leukemia a watch and told her it was from her favorite Beatle, Paul, she had a big smile on her face and her mother told me that was the first time she smiled in months. Paul also called her. She only lived for a few more days.

The Beatles landed at Mitchell Field at noon on September 4. The Milwaukee Police Department deployed 140 officers for crowd control and security. The sheriff had 40 deputies at Mitchell Field with a bill for 260 hours of overtime. The county spent $1,200 to fence off an area to keep thousands of teens, some waiting for more than twenty hours, under control at the terminal. As it turned out, they didn't need that. The Beatles landed at the 440th National Guard site, a mile away from the main terminal. They had

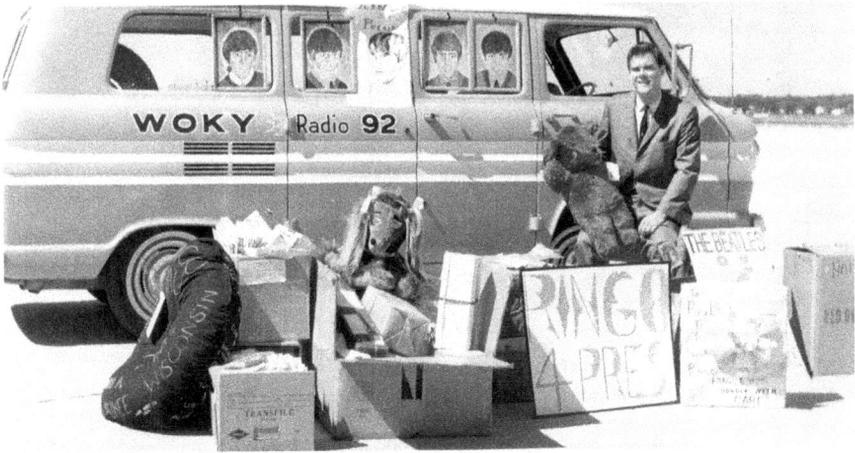

The WOKY van was filled with gifts for the Beatles, none of which they received. They only accepted the mail.

Well, bless your heart. Some thoughtful person made a cake especially for the fifth Beatle.

Two of the specialty cakes given to the Beatles by their adoring fans.

police cars escorting their limousine to the hotel. The entire seventh floor of the seven-story Coach House Motor Inn on Nineteenth and Wisconsin (now Marquette University's Mashuda Hall) was reserved for them. To give you an idea of how long ago that was, their phone number was Division 4-7600.

Not much has changed since the Beatles stayed there. There is the room, now a cafeteria, on the first floor where the Beatles and their entourage had a meeting and signed some autographs. They signed a few on the back of a tour schedule, which they gave to me to give away on the air. The conference room for the press meeting is still on the second floor. All of the rooms are the same on the seventh floor where they stayed and where our picture was taken. Even the elevator where the three got off to go to the press conference is there, although not working anymore. Their own press corps was on the sixth floor. The reason they stayed at the Coach House instead of the Pfister Hotel was that they wanted to be inconspicuous and not cause a riot. Many of the fans still found out where they were.

I am often asked why this unbelievable phenomenon happened. I think it was the youth of the day escaping from the aftermath of the Kennedy assassination, and besides that, Capitol Records launched the largest single promotional campaign in the history of the record industry. We started to hear the promotional commercials on the radio just before Christmas 1963. There were five-second ads every few minutes: "The Beatles Are Coming, The Beatles Are Coming…on Capitol Records." They spent a ton of money in advance publicity. Also, young people at the time seemed to have money to spend, most of it on leisure activities. The timing of their arrival could not have been better. Many people were asking, "Who the heck are the Beatles?"

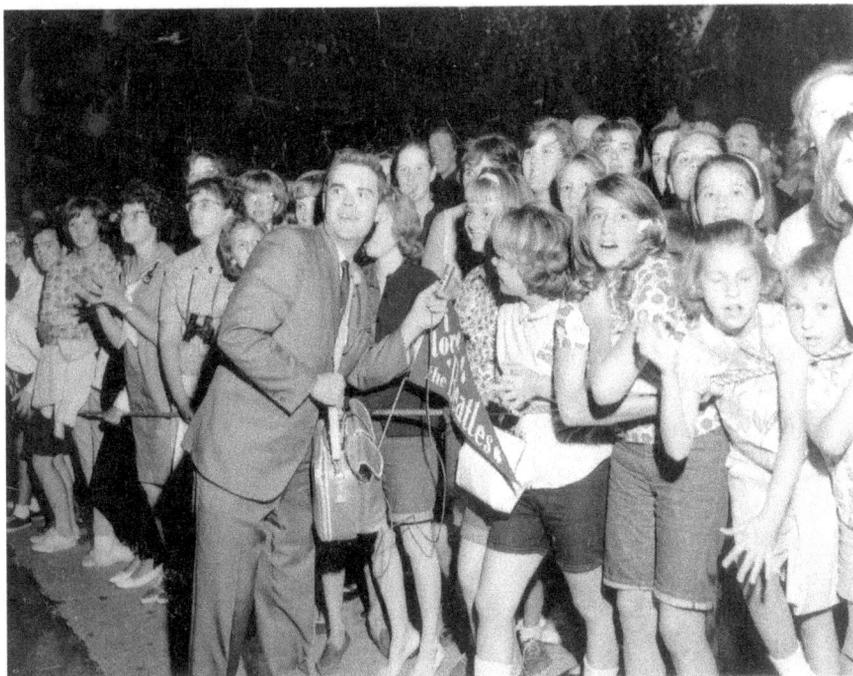

A swarm of young people, mostly twelve- and thirteen-year-old girls, tried desperately to catch a glimpse of their beloved Beatles at their hotel across the street at Nineteenth and Wisconsin.

They soon found out. Within six months, every record the group had ever made had been reissued here, and our radio station was flooded with Beatles discs. Seven different labels (Capitol, Vee Jay, Tollie, UA, Swan, MGM and Atco) churned out every single they could lay their hands on. It got out of hand, and companies were suing for everything they had while the Beatles racked up the top five records in the United States simultaneously.

On August 18, the Beatles departed England for their first American tour, performing in twenty-three cities, giving twenty-six concerts before the tour ended on September 21. The tour was chronicled in taped radio reports and syndicated throughout the country. These reports, along with my updates, kept ardent fans in touch and added to the momentum of the excitement that built in each city where they performed. Milwaukee was no exception. On the day of the Beatles appearance in Milwaukee, I was invited, along with other radio and TV reporters, to a press conference. In a conference room at the Coach House Inn, the Beatles' press secretary introduced members of their entourage, along with George, Ringo and

Paul. Their manager, Brian Epstein, was not with them in Milwaukee. John Lennon had laryngitis and did not appear. He stayed in his hotel room. Milwaukee doctor M.M. Bortin gave him, as John Lennon said, "the old penicillin in the rear shot" for his throat infection.

The conference lasted about thirty minutes and ran the gamut of usual questions about long hair and their preference in girls.

> *Q: What do you do with the mail you receive?*
> *Paul: I soak it overnight in lemonade, fry for two minutes in deep fat, garnish with a cucumber and serve it piping hot to Ringo for breakfast.*
> *Q: George, what would you do if you weren't popular anymore?*
> *George: Sit home and count my money.*

When asked if they had heard of Milwaukee, Ringo replied in his Liverpool accent, "I've 'eard of the beer that made it famous."

> *Q: What will you do after the bubble bursts?*
> *George: Ice hockey.*
> *Paul: Ringo originally wanted to own a string of hair-dressing salons.... John and I will continue writing songs, and John will continue writing books.*
> *Q: What is it that you've captured in the fans?*
> *Paul: Nothing really, we haven't brought anything new. They like our records, first of all. It's difficult, but I don't think we've captured anything really.*
> *Q: Is your work your vocation?*
> *Paul: We don't really have a vocation. We're not trying to be anything more than we really are. We're just trying to be normal, normal people.*
> *Q: What is your impression of the average American teenager?*
> *George: Just like the British teenagers, with a different accent you know.*
> *Q: Do you date mainly non-celebrities?*
> *Ringo: Yes, celebrities don't even want to bother with us.*

Paul asked the female reporter who posed the question, "What are you doing tonight?"

> *Q: When do you write songs?*
> *George: At night in the hotels, when we have a couple of days off, or on a coach traveling somewhere.*
> *Q: Does it take long to write songs?*

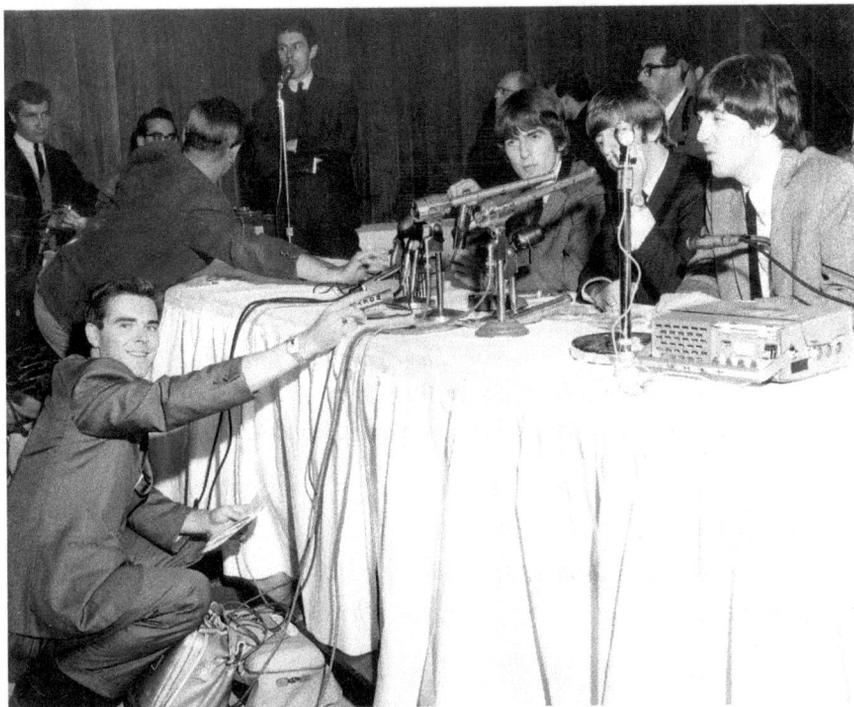

This was the Beatles press conference at the Coach House Inn on September 4, 1964. I'm holding the microphone because WOKY did not have a mic stand.

*Paul: Sometimes it does and sometimes it doesn't. Sometimes we stop and then pick it up a couple of days later and other times it could take thirty minutes.*

*Q: You didn't get a chance to see your fans today at Mitchell Field, what is your reaction to this?*

*Paul: The worst thing is, when we came in, people had been waiting at the airport for a long time and we were told as soon as we got in we weren't going to be allowed to wave or touch them. The police told us we couldn't even go past them and wave. We had to go out a back way, which was terrible. I think it was mean not to at least let us go have a wave. The police said, no this is the best way. There was no need to take us out the back way. Tomorrow in Chicago we've been told we can't see anyone. We're going to land on a small strip and we'll be out the back way again. It's a dirty trick.*

We were told that the decision to land at the 440th landing strip was made by the Beatles' manager in the air. Paul retorted, "The decision is never made in the air by our management. We were told as soon as we got on the ground, we were told by a member of the agency, the police had said this and we sent him back to ask the police chief again if we could drive past the fans in a car and again they told us no. He's a dirty lyin' policeman who told you that."

*Q: Parents criticize you, is there anything wrong with parents?*

*Ringo: Yes, there could be. We've got the majority of the parents liking us, and we have some who like us that are ninety years old.*

*Q: George, do you like to dance?*

*George: No, I dislike dancing. It's a stupid thing. You just wear your shoes out.*

*Interviewer: You dance in the film.*

*George: Yeah, but I'm over it. I did a little in the film that I don't normally do.*

*Q: Have any of you been in the military?*

*Paul: It's not going in England anymore, is it? We've given up in England. We don't try to defend anything anymore. Anyone born after 1939, you're free. Come to England.*

*Q: They gave you a ride in Indianapolis…how was the tour?*

*Ringo: It was about a three-hour ride. They wanted to show me the town. We went to breakfast and that consisted of scotch and Seven-up, and then we drove back. Nice fellows.*

*Q: Would you like to see Milwaukee that way?*

*Ringo: All depends, if we get a chance.*

*Q: Mr. Harrison, do you sing on "Can't Buy Me Love?"*

*George: You can call me George. Yes, we made the length of the song to fit in exactly with the police chase in the movie.*

*Q: How do you compare your type of music with Elvis Presley?*

*Paul: The type of music? I don't see any difference in the type of music. It's terrible trying to categorize music all the time. I don't think we're rhythm and blues or anything. We're a pop group and that's what Elvis is. We just play the kind of music we like. It's more rock and roll than anything and that's what Elvis is playing.*

*Q: What will you do after the tour?*

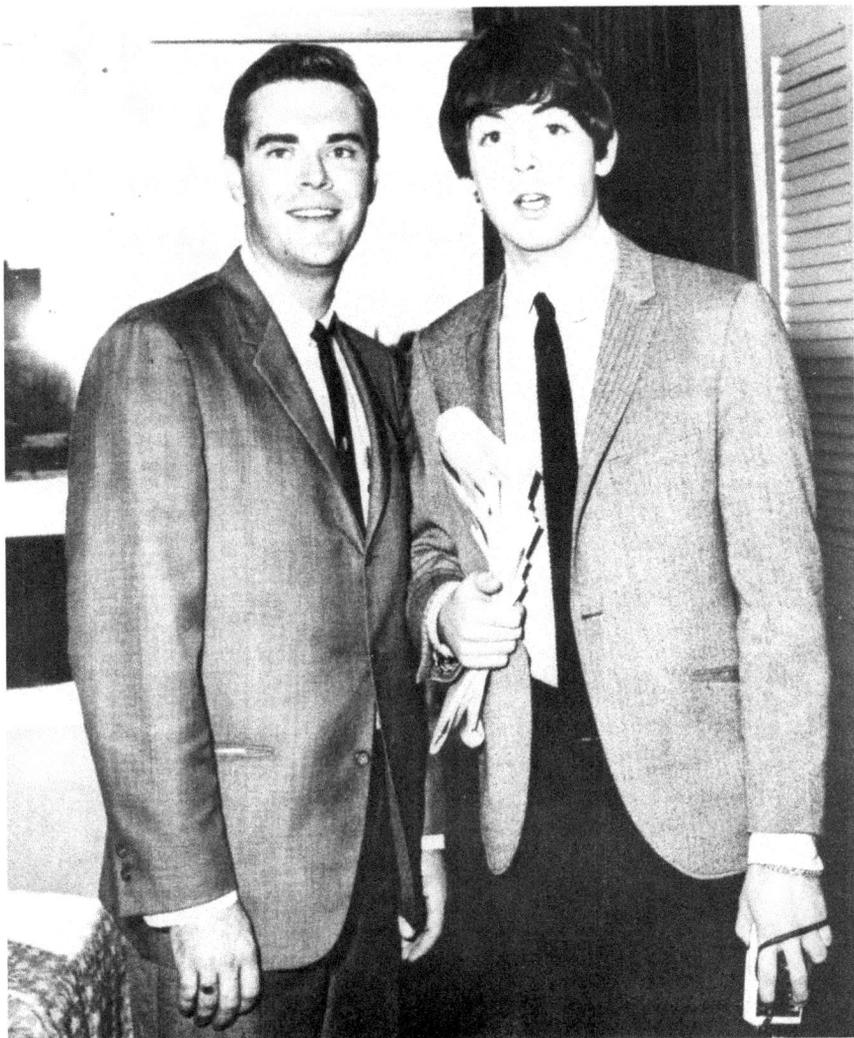

That's me with Beatle Paul McCartney at the Coach House Inn on the morning after the Milwaukee concert.

*George: We'll go back to England. We have a couple days off and then we'll go into the recording studio. And then we go on a tour of Great Britain.*

*Q: Who was your biggest influence in American rock and roll?*

*Paul: Elvis originally in the beginning because we've got all his early records, and Carl Perkins and later on American colored groups like Marvin Gaye.*

*Q: What about the songs that you've written for other groups, like "World Without Love"?*

*Paul: We wrote it years ago, and I felt it was no good.*

*Ringo: I used to like it.*

*Paul: Ringo was the only one who liked it until Peter and Gordon asked to record it. And we said sure, because we don't want it.*

*George: We laughed it off, because of the first line, "Please lock me away." We laughed.*

*Q: What types of books do you read?*

*George: We don't have a lot of time to read, but we read culture books.*

*Ringo: That's what he reads. I read the comics.*

*Q: What do you think of being referred to as a sociological phenomenon instead of a musical group?*

*Paul: A sociological phenomenon instead of a group of musicians? I don't even understand it.*

*Q: Does it bother you to be called that?*

*Paul: No, we're just a band. It doesn't worry us a lot, what people think of us.*

*George: It's just that people write that. It worries them, not us, and it shouldn't worry the people.*

*Q: Paul, when you and John write the songs, is one of you the lyricist and the other the composer?*

*Paul: No, sometimes John will write a line, and I'll write the next line, then I'll write the music and then write the next line.*

*Q: What do you think of other groups copying your style?*

*George: It's flattering when somebody copies you. We don't mind. The most successful ones aren't copying.*

*Q: Do you have any say in the articles that are written about you?*

*Paul: No, and that's why such rubbish is written. Most of it is a lie.*

*Q: Have any of you thought of writing about yourselves?*

*George: No, because none of us like to put ourselves up as idols to be worshiped. I hate that.*

*Paul: I have never liked anyone in entertainment who preached. It's not our job to preach, it's our job to entertain.*

*Q: Do you think you can maintain the balance you have?*

*George: We can maintain that balance because there's four of us all together.*

*Q: Tonight you'll be getting out on stage, and you'll be greeted by screaming and shrieks. How do you feel about that?*

*George: We like it. It's really great for an atmosphere you know.*

*Q: Do you prefer girls to wear dresses or slacks?*
*Ringo: Dresses.*
*Q: How do you like your accommodations here in Milwaukee?*
*Paul: Very nice, how do you like yours?*
*Q: Do you think some of the fans' actions are ridiculous?*
*Paul: No, nothing is ridiculous when people are enjoying themselves.*
*Q: We heard that you cut your performances short?*
*George: No, we'd never do that. We have not done that since we arrived in America. We'd be unpopular if we had done that. About thirty to thirty-five minutes, but we don't use a stopwatch.*
*Paul: A man in Hollywood kept announcing that if everyone was quiet, we would play for an hour. We went out and did our normal set and the audience was very good and they thought we cheated them because he said that.*
*Ringo: We never play more than a half hour.*
*Interviewer: They said that you cut it to fifteen minutes in Atlantic City.*
*George: No, never. We may have played the numbers a little bit faster.*
*[laughter]*
*Q: Where would you like to live if you moved to the United States?*
*George: I wouldn't pick any city but would probably live in the state of Florida or California.*
*Q: What do you do with your free time?*
*We don't have any free time. When we do, we sit around the house, go out to restaurants and clubs, play records, see our friends, you know, just the general things.*

A little-known fact, while the Beatles were performing at the Arena, there was a concert for the overflow crowd at the Auditorium with Twistin' Harvey and the Seven Sounds, Galaxies, Mojo Men and the Pharaohs. Three thousand attended. The show was cut short by ninety minutes after a fight broke out.

I came very close to not making the Beatles concert. I was vacationing with my mother in California shortly before the concert and driving back at sixty miles per hour on a rainy, slippery Route 66. I had to swerve into a ditch to avoid a car that was stopped at the bottom of a hill due to a jackknifed truck blocking the path. I credit seat belts for saving us from serious injury.

The actual Milwaukee concert began when Bill Black's Combo stepped on the stage at 8:00 p.m., followed by Clarence "Frogman" Henry (who replaced the Righteous Brothers), the Exciters and Jackie DeShannon.

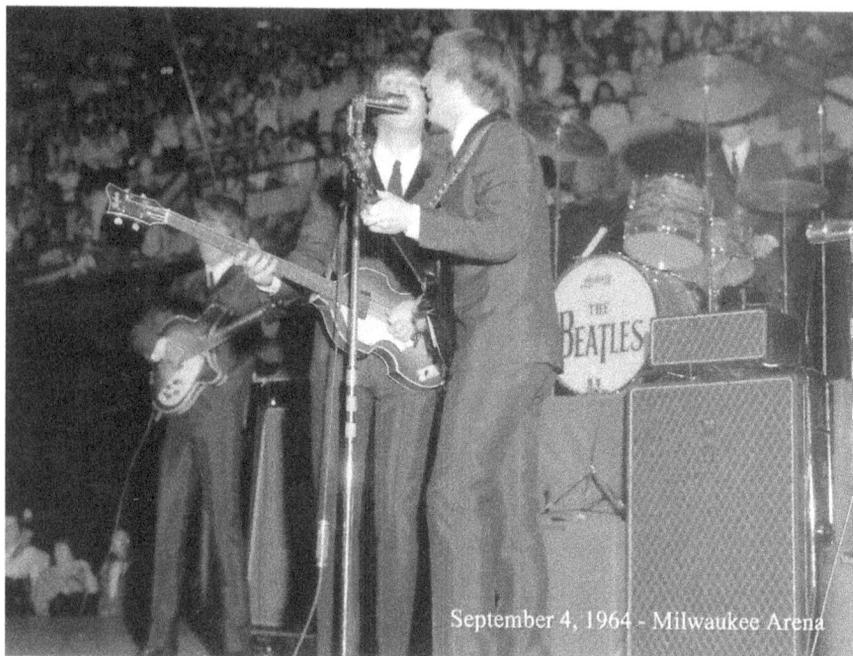

What more can I say? The world's greatest songwriting duo, Paul McCartney and John Lennon, plus George and Ringo—the Beatles on stage at the Milwaukee Arena.

Jackie told me that she did an up-tempo set so the kids could sing along and release some of the energy they had built up for the Beatles. She said, "These screaming girls came to see the Beatles, so you had better be a good warm-up for their idols." She added, "Some of the other acts felt hurt because I was given special treatment, playing monopoly with George Harrison and spending time with Paul McCartney during the tour."

Gerald Kloss, *Milwaukee Journal* reporter, said:

> *Their performance was something. You could hear very little of the actual sound because as soon as they started singing, as soon as they did anything, the emotion, the screams of joy of those watching, were overwhelming the sound of the music and just every once in a while you could hear a word or two which would give you a hint as to what the song was. I was getting help from people around me. It was a thing to be at rather than a thing to hear. Then the show was over, and I can remember a moment of panic, as there was a rush toward the front because the rumor was that the car would be out there and maybe they could touch the*

*Beatles. So there was almost a stampede to get out the front entrance. A son of mine, who was with me, got pretty scared because any small kid could be trampled by the crowd.*

Photographer Bob Lewis, who took all the professional photos during the Beatles' stay in Milwaukee, said,

*After it was all over and you think about it, oh my God, it's just unbelievable, how did I get the chance to be with the Beatles? It was something that I never forgot. They got a ton of gifts, stuffed animals, cases of champagne, lots of cakes. They could have had a semi out there with all the gifts and all the stuff that they got. It was so much; I had never seen anything like it.*

Girls lined up at the Arena at 4:00 a.m. for the sold-out show just to be near to where the Beatles would be. Some fans tried to hide in the Arena the week before the concert. The Beatles came in a limo through the east stage door at Fourth and State Streets. Ushers, police and Arena security guards stood shoulder to shoulder in front of the entrance. The Red Cross volunteers brought in twenty cots and two hundred pounds of ice. That was a good thing because ten girls were treated for fainting and hysteria and seven for blisters, cuts and nosebleeds. One of the girls who attended the concert told me that she did crazy things before the show, like buying a new outfit and putting her hair up in curlers the night before: "We had to look perfect that night because the Beatles might see us."

On the Arena stage, right after Jackie DeShannon ended her set with one of her hits, "Needles and Pins," the Beatles' road manager told me to take the stage. I came out in a five-star tux from Sherkow's Formal Wear and, with adrenaline flowing, proceeded to fill about fifteen minutes (seemed like hours) talking about the mop-haired guys from Liverpool and all the cities they were touring, what they ate, drank and anything else I could think of. Every time I mentioned the word *Beatles* or one of their names, the crowd of mostly young teen girls screamed at the top of their lungs. I also laid down the rules to be followed if they wanted the show to go on. (Local promoter Nick Topping was worried about injuries.) Finally, at 9:10 p.m., the Beatles came out on the stage in the dark. The lights went on before they were completely up the steps. They were wearing blue silk suits and high-heeled boots. I yelled, "The Beatles," but no one heard me. You couldn't imagine the screaming. If there is one thing I would have done differently at this concert and the many other music venues I emceed,

I would have worn earplugs. I lost a lot of my hearing being so close to those powerful pulsating speakers.

Beatles fan Nancy McLaughlin remembered, "There was electricity surging through the room. You could feel it. It passed right through your body. The mounting tension that we had felt all these months had to come out and it came out at that time. This was Beatlemania! You felt it and you lived it." Nancy was one of the most devoted Beatle fans in Wisconsin, and when the group stopped touring, she decided to go to them. She worked very hard, saving as much as she could from $1.40-an-hour jobs to go to England. She was there for the opening of the Beatles' Apple shop in London. The gutsy young woman even visited Kinfauns, the George Harrison estate, and was able to spend some time with George. And before she left London, she managed a chance few minutes with Paul McCartney at the London Pavilion before the showing of *Here We Go Round the Mulberry Bush*.

The sound of the crowd's screams made it feel like the Arena would explode. It was so loud that some of the teens put fingers in their ears. Some tried to stand on the back of the seats, but the ushers were continuously telling them to get down. The Beatles opened the thirty-two-minute set with "I Saw Her Standing There." They followed that with "All My Loving," "Can't Buy Me Love," "A Hard Day's Night," "If I Fell," "Long Tall Sally," "You Can't Do That" "She Loves You," "Things We Said Today," "Roll Over Beethoven," "I Want to Hold Your Hand," and "Boys." They usually began their concerts with "Twist and Shout," a song first recorded by the Isley Brothers. They couldn't do that song because John sang lead, and he had a bad case of laryngitis—not that the teens would even notice if he was singing with all the screaming and carrying on. One girl told me she spent the entire concert crying because she couldn't hear them sing. Not only was there a constant flow of screaming throughout the concert, the Arena soundman also remembered a continuous stream of flashing lights.

I think all of the kids had cameras, and they were taking pictures during the entire concert. They lit up the Arena. The Electric Company could have turned off the lights, and we wouldn't have noticed. I watched the concert from the side of the stage with Jackie DeShannon, and watch is all we could do because the noise was so amazing that you couldn't hear the Beatles performing. Even the front rows could not hear them. Occasionally, we could pick up a few seconds of one of their songs when the crowd would take a breath. Jackie told me this happened wherever they played. The noise blew out the microphone in my recorder sitting

next to the stage, so I only got a few seconds at the beginning of the concert. I guess it served me right because there was no professional photography or audio recording allowed. If there had been windows in the Arena, I'm sure they would have been blown out by the sheer volume and pitch of the noise. Our ears were ringing for hours after the concert, but I don't think anyone was upset with the noise. It was just the excitement of being there. One teen said they didn't go to hear them; they could always listen to their records.

Some of the teens screamed through the entire concert, and others cried the whole time. There was shouting, gasping, jumping up and down and throwing of jelly beans, flash bulbs, hair rollers and pins—hoping to get the attention of one of the Fab Four. It was bedlam. I don't think there will ever be any entertainers who will reach the plateau of the Beatles during that performance. It was no wonder that so many girls were treated at the concert for nosebleeds and bruises. The "no photos allowed" warning was ignored, as flashbulbs went off constantly from all over the packed Arena. It was as bright as daylight or a giant strobe light. With the quality of the inexpensive film cameras of that day, I doubt if any worthwhile photos were developed. I haven't seen any. A *Sentinel* reporter said the glare could be likened to that seen on films accompanying a nuclear explosion. The Beatles loved hamming it up for the cameras. All of the girls were wearing Beatles pins, and some waved blue scarves because blue was Paul's favorite color. Some fans dressed just for their favorite Beatle, thinking he would pick them out in the crowd. One fan said she borrowed $5.50 for the ticket from her parents, and her mother told her that was a lot of money. She said she had to babysit for weeks to make that money. "But if I wouldn't have gone, I would have felt like I lost the world," she explained. One girl was so hysterical that she broke out in hives. She called the hives her Beatles bumps.

After the Milwaukee concert, the Brits ran off the stage, jumped into limos that were waiting inside the Arena and were whisked to their hotel with a nine-motorcycle police escort. The limo decoys that preceded did not deter some of the girls from banging on the car they were in, screaming their names as they hung on to the doors for a few seconds. Back in the Arena, some girls tried to touch the stage, but police held them back. They were grabbing up anything left near the stage, thinking maybe the Beatles touched it. When I left the Arena, the girls rushed me with all their questions and tore the buttons off my coat, snatching my cufflinks and a couple of shirt studs. That night, girls were going up the fire escape at the

Coach House Motor Inn. A couple of them got locked up on the roof, and they had to open the roof to get them. If someone hadn't heard them, they would have spent the entire night there.

To get rid of the many fans, employees of the hotel cut up pieces of old rugs and told them that it was from the Beatles' suite. And when the breakfast cart was wheeled out of their room, they grabbed pieces of toast and cigarette butts. I wish I could have saved all the stuff that was sent to the station by Capitol Records, plus the Beatle wigs, which became the best-selling novelty since yo-yos. Anyone who wore one became the life of the party. I admit to putting one on at a couple of my appearances. You could go to Woolworth's and other stores to buy Beatles alarm clocks, nighties, bubble bath, sneakers, sweatshirts, plates, lunchboxes, games, loose-leaf binders, pillows, purses and wallets, stationery, toys, jewelry, knick-knacks and junk food. There were buttons, scrapbooks, Beatle boots, dolls, talcum powder, hairspray, headphones, tons of magazines and lots of records, many worth plenty today. I gave a lot of it away at appearances.

Before I left the Arena, the Beatles' press secretary told me to be at the Coach House Inn at ten o'clock the next morning for what turned out to be the only private radio or TV interview they would do. Paul was the easiest to talk to, a real pro. Ringo loved to clown around, and you never got a straight answer from him. George was very quiet and sincere. John was the most serious of the four, possibly because he still wasn't feeling well. As we were having our pictures taken, in a room near theirs, due to the mess in their room (a tornado-like disaster with empty Coke bottles, half-eaten food, pillow feathers, crumpled-up clothing and bedding all over the room), my tape recorder with the interview was stolen from outside the door. Our ultra-dramatic newsman Raymond E. Spencer got on the air along with the GM and co-owner of WOKY, Rosa Bartell, pleading with the Beatle burglar to return the goods and promising that the station would not prosecute. Within the hour, we got a call from a nun at a convent, the Sisters of St. Francis. Someone had left the machine in a pew in the chapel.

Following my two days with the group, the newspaper referred to me as Beatle Bob or the Fifth Beatle. Factually, I was really the thirteenth "Fifth Beatle." I was the thirteenth emcee of their concerts in the United States. All of the jocks introducing them were referred to as the Fifth Beatle.

The fans for the most part had behaved fairly well up until the day the Beatles were scheduled to leave Milwaukee. They knew that the Beatles might never come back to see them, so this was their last chance. The group left the Coach House in four black limos and was escorted to Mitchell Field

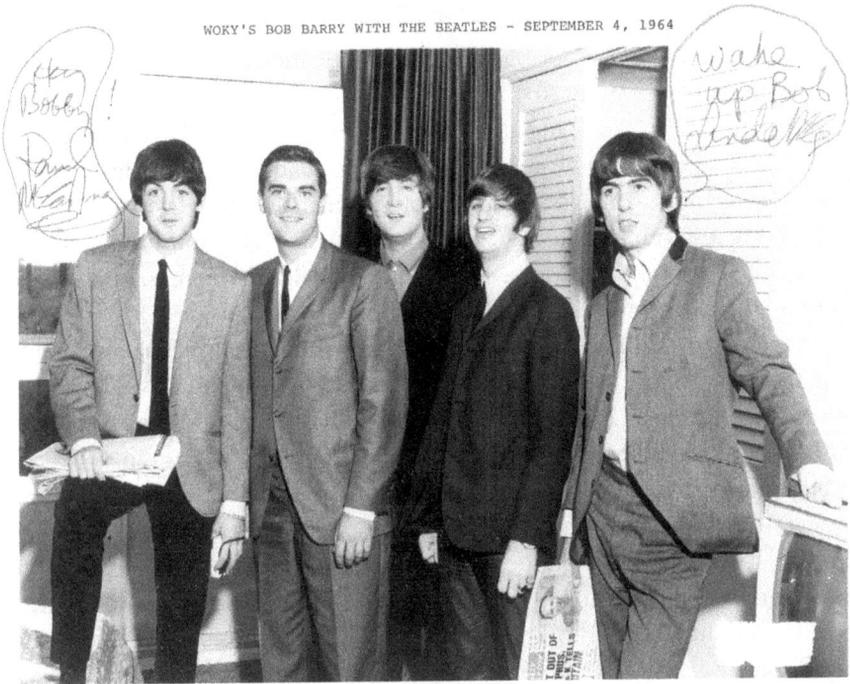

Here I am with the Beatles at their hotel the morning after the concert, September 5, 1964. The headline on the *Daily Mirror* newspaper that George Harrison is holding says "Get Out of Cyprus, Mr. K Tells Britain." Paul and Linda McCartney signed the photo in 1977.

by four police motorcycles. Jim Andrus, the Beatles' limo driver, remembered the day they left town, September 5, 1964:

> *When we came out of the motel to go to the airport, Wisconsin Avenue was lined up with kids on both sides. They had a wall of policemen in front of them, and I remember this motorcycle policeman telling me whatever you do, don't stop. Just get on the street and keep going. We had an escort to the airport, but the kids knocked the cops down as the limo crossed the sidewalk to get to Wisconsin Avenue. The kids jumped on the limo. The policemen then knocked some of the kids down right in the middle of Wisconsin Avenue. We got calls for a week or so afterward, wanting to know if we had cigarette butts or what-have-you in the car. They would come to our building touching the limo, wiping the dust off with a handkerchief that they would then keep.*

After the Beatles left Milwaukee, I followed them to Chicago and reported live from there. When I got back, we aired "Beatle reports" every night as the group went from city to city, finishing up their American tour in New York at the Paramount Theatre. The station sponsored a Beatles poem contest that elicited 4,000 responses and a popularity poll on each Beatle. Paul McCartney won with 34,367 votes, with George Harrison a close second. We also ran a contest to write the word *Beatles* the most times. Three girls worked a total of six days, or 143 hours or 8,607 minutes, and several ballpoint pens died for a record 143,456 times.

Jill Geisler of WITI-TV told me that she wrote Paul McCartney's name four thousand times in a "Paul contest" in 1964 when she was a fourteen-year-old freshman at Audubon Junior High School. She said she lost but got an A in penmanship class.

The station received so many requests for the picture of the Beatles and myself, they signed my name with a stamp instead of having me sign each picture. I wasn't the only one who got mail for the Beatles. Elmer Krahn, manager of the Milwaukee Auditorium-Arena, got lots of mail from all over the country. I had to keep an unlisted phone number. At one point, the Robert Barrys in the phone book complained about calls they received from young girls at one and two o'clock in the morning. I went on the air and asked the girls to cease and desist.

The group was so popular that WOKY put up the money to send me to Chicago and Minneapolis in 1965 to cover their concerts. The Beatles decided to skip Milwaukee on this trip. This time, I was wearing Nehru jackets, had a Beatles haircut and sported a WOKY belt buckle and a collection of medallions around my neck. What a trip! At the press conference on August 21 in Metropolitan Stadium in Minneapolis, someone asked for a big welcome, and John yelled, "How about a big sandwich?" Another radio station rep gushed, "We're going to play your record." John replied, "That's jolly decent of you." One woman asked if they wore wigs. Ringo whined, "Aw, gee lady! Don't ask that." Then they asked her if she was wearing a wig, and Paul said, "You all have your own teeth, do you?" Another reporter asked how long their contract would last with Capitol. John answered, "I don't know. I don't even remember signing it." "When you write a song, how do you decide who's going to sing lead?" John quipped, "Yeah, how do we decide that? I think whoever knows most of the words by the time we record it." And still another reporter added, "I understand that all four of you Beatles are good friends of Elvis Presley." Paul and George answered, "We've

never met him." "You don't want to believe all those radio stations, now do you?" Ringo added, "Paul has spoken to him on the telephone and we've had a telegram once and that's about it. It's as close as we've got." One Minneapolis radio station's DJ kept repeating their call letters every time he would ask a question. John finally said, "What did you say the name of your station was? I didn't quite catch it." A young boy, who was probably some big wig's son, told Ringo that he started playing drums after he heard the Beatles drummer play. Ringo told him, "Ah, you'll never get anywhere if you listen to me."

Every year when September 4 came around, newspapers and TV stations would call, asking for interviews about the Beatles' 1964 Milwaukee concert. Twenty-five years later, in 1989, a Channel 12 film crew followed me to the Coach House Inn, where we went to the room where the Beatles stayed, knocked on the door and told the girl who was renting the room, now a dorm for Marquette University, that this is where the Beatles stayed. We showed her the picture of the five of us with the Pabst Mansion in the background. I think she is still walking around in shock. Was she excited!

September 21–23, 1990, twenty-six years after the Beatles appeared in our city, sell-out crowds witnessed Newton Wayland conducting the Milwaukee Symphony Orchestra in *Pops Goes the Beatles* at the Performing Arts Center. We all wore tuxedos and, during intermission, viewed slides from the Beatles' Milwaukee appearance.

In 2004, on the fortieth anniversary of the Beatles' appearance in Milwaukee, the Wisconsin Historical Society asked me to host "Meet Them Again" at the Wisconsin Historical Museum in Madison. The Sting Rays gave a live performance, re-creating the Beatles' 1964 Milwaukee concert, and I told stories, showed a film and slides and played audio clips. They also had a display of Beatles memorabilia. There was a packed house, proving once again that Beatlemania will never die.

Forty-five years after their appearance, I was asked to emcee *RAIN: A Tribute to the Beatles* at the Milwaukee Theatre. The show was a near-sellout and included many fans who had seen the Milwaukee concert in 1964 and some who were not even born then. I had shoes that were older than the tribute group. The concert was staged just down the street from where it originally took place.

To this day, the Beatles still have many fans of all ages. Nancy McLaughlin said it best: "Beatlemania is a chronic disease; you take it to your grave."

Not everyone was a fan. On August 9, 1966, WITI-TV's general manager Roger LeGrand got on the air to read an editorial condemning the Beatles:

*How do you feel about the mouthing off the Beatles have been doing lately? First it was John Lennon who said the Beatles are more popular than Jesus now. After everyone got into an uproar about that remark, the Beatles' manager rushed to New York to quiet the storm and explain that Lennon was quoted out of context. In any event, we feel a personality like John Lennon may be an expert in turning out teenage music, but is surely no expert on Christianity. He should have kept his mouth shut. Now another remark. This one from Beatle Paul McCartney. Paul was looking ahead to the Beatles' return to America later this week for appearances across the country. He doesn't relish the trip, he says, because of this country's attitude. McCartney dislikes the way Americans pursue the dollar. "Sort of frightening" he says, "money is everything to these crazy Americans." Yet, the Beatles have never been known to turn down that American money, have they? Millions of teenagers in this country have bought their albums... patronized their movies...and sent them off to the bank of England with millions of those distasteful American dollars. They were actually decorated by the Queen for bringing all that money to Britain. Those appearances they're about to again make in the U.S.A will surely not be a public service. They'll be back for more of the teenagers' money. Like you teenagers, we enjoy the music of the Beatles. But, they've hit a sour note with their unqualified remarks about Christianity...and their hypocritical statements about those awful money-hungry Americans. Another Beatle ... George Harrison...fears the teenage crowds. He sighs and says, "We've got to be beaten up again." Well, no not really. TV6 has the perfect solution for the Beatles. They don't have to be beaten up. They don't have to put up with all those money-mad Americans. They can stay at home...and count their money.*

WITI-TV news director Carl Zimmermann asked me to take a copy of the editorial to give to the Beatles in Chicago, which I did. He said that I could get their reaction and use it as an editorial reply. That never happened.

Tom Shanahan, music director of station WEMP, commented, "We don't play many of their recordings. I don't have any comment about what the Beatles have to say about music or religion. I think that they are incompetent in both fields." Bishop Hallock of the Milwaukee Episcopal diocese said, "These kind of nuisance fads come and go all the time and I don't take them seriously. They are an annoyance to the longhaired and to elders, but it is a form of revolt we have to live with. Their statement in relation to Jesus is asinine, but banning their records won't accomplish anything." King

Zbornik, WRIT music director, said, "I can't believe he said it. I've been upset with them ever since their latest album came out with a terrible cover on it" (Butcher cover, showing them in butcher garb with cleavers in hand and severed doll parts). "The way these guys have been acting lately is a real letdown for our kids. If they're going to take all the American kids' money, at least they could be gentlemen about it." Bill James, program director of station WOKY, had this to say:

> *I don't know what the interview was all about. The statement could have been taken out of context. On its face value I deplore the quotation and the comparison between popular music and religion. I do not anticipate that we will ban Beatles recordings on the basis of these quotations. If it becomes evident that an overall philosophy by the Beatles is in bad taste and becomes a standard of their performance, then we might reconsider the situation.*
> [WRIT and WOKY did not ban Beatle records at any time.]

The most interesting comment was from Father Gabriel Hafford, from the Milwaukee Catholic Archdiocese: "This is a tempest in a teapot. The Beatles won't last very long. Our Lord will be with us forever. I wouldn't get excited about this."

In June 2014, WMVS Channel 10 recorded a PBS show that aired the week of the fiftieth anniversary. (The program is available to view online.) Raul Galvan produced the program and conducted interviews in my office, the Milwaukee Arena and the Coach House. The Arena is almost the same as it was fifty years ago. The Coach House is a Marquette University dormitory. Others interviewed who were there for the Beatles' stay in Milwaukee in 1964 included the director of sports and entertainment sales at the Wisconsin Center District, Tony Dynicki. Tony was at the concert, sitting in the upper parquet way in the back of the Arena. He said he didn't hear anything I said or the Beatles sang.

This whole experience for me over the past fifty-plus years has been incredible: "Sometimes you will never know the true value of a moment until it becomes a memory."

# CONCLUSION

## IT WAS NICE BEING HAD

I t was nice having you" was the way I would close my show every morning. And then I used a recorded celebrity saying, "It was nice being had." I'm reminded of the many times when listeners from the '60s and '70s tell me that they remember where they were or what they were doing when I played a certain song or interviewed one of their favorite artists. They tell me how much they enjoyed listening. That's the way I would like to be remembered. That's what it's all about. And that's why it was so nice being had.

# INDEX

# Y

# Z

# ABOUT THE AUTHOR

B ob Barry is best remembered as a legendary Milwaukee disc jockey. He introduced the Beatles during their only Milwaukee appearance and was the only local personality to spend time privately with them. Through his successful *Bob Barry Calls the World* show, he interviewed famous and infamous celebrities, including Bob Hope, Sophia Loren, Ron Howard, Elton John, Cher and more. During his career, he received numerous industry awards, chief among them "Billboard Magazine Top 40 Air Personality of the Year" in 1975. In 2001, Bob was inducted into the Wisconsin Broadcasters Hall of Fame.

www.ingramcontent.com/pod-product-compliance
Lightning Source LLC
Chambersburg PA
CBHW070838100426
42813CB00003B/669